POCKET
Visual Encyclopedia

T0168279

Chinese & Japanese Art
Chinesische und Japanische Kunst
Chinese en Japanse kunst
Arte chino y japonés

SCALA

Contents

Inhalt

Inhoudsopgave

Índice

Introduction

The extreme eastern part of the Asian continent represents a relatively homogenous region in art history, rich with unique aspects.

The immense country of China undoubtedly influenced the area due to its antiquity and the exceptional nature of its art, decisively marking the regions subject to its cultural influence and often its political dominance. In the same way, Japan and Korea assimilated these influences, modifying them partially with their own traditions.

Each country has a personal and undeniable contribution to the world of art: China with its multi-faceted production, which today holds a place of exceptional importance in museum collections and art galleries worldwide; Japan, with a clear influence – which arose starting halfway through the 19th century – on the figurative arts, graphic arts and aesthetics of the West; Korea with its ancient ceramic and calligraphy tradition.

Buddhist religious and cultural traditions, introduced originally in China at the beginning of the Christian age, then spreading to the surrounding areas, extended to the arts and to craftwork, merging with indigenous religious practices: Taoism and the cult of ancestors in China, Shintoism in Japan, and shamanism in Korea.

Einführung

Der im äußersten Osten gelegene Teil des asiatischen Kontinents stellt in der Kunstgeschichte ein relativ homogenes Gebiet dar, das viele verschiedene und besondere Aspekte vorweist.

Das gewaltige China hat zweifelsohne durch seine traditionellen und außergewöhnlichen Erscheinungsformen einen so großen Einfluss ausgeübt, dass die seinen kulturellen Einwirkungen und oft auch seiner politischen Vorherrschaft unterworfenen Gebiete entschieden geprägt wurden. Genauso haben Japan und Korea diese Einwirkungen aufgenommen, in dem sie sie zum Teil nach der eigenen Tradition verarbeitet haben. Jedes Land hat einen eigenen und unbestreitbaren Beitrag zur internationalen Kunst geleistet: China nimmt mit seiner facettenreichen Produktion heutzutage einen besonders hervorgehobenen Platz in den Museen, Sammlungen und Kunstgalerien der Welt ein; Japan mit seinem in der Mitte des 19. Jahrhunderts einsetzenden, klar ersichtlichen Einfluss auf die bildenden Künste und zuletzt Korea mit seiner antiken Tradition in der Kunst der Keramik und Kalligrafie.

Auch die religiös-kulturelle Tradition des Buddhismus, die ursprünglich in China zu Beginn der christlichen Ära eingeführt und von dort in die angrenzenden Regionen verstreut wurde, geht auf Künste und das Handwerk über, wobei diese mit den alteingesessenen religiösen Praktiken verschmelzen: Taoismus und Ahnenkult in China, Shintoismus in Japan und Schamanismus in Korea.

Introductie

Het uiterste oosten van het Aziatische continent vertegenwoordigt in de geschiedenis van de kunst een regio die relatief homogeen en rijk aan details is. Het immense China heeft ongetwijfeld een enorme invloed uitgeoefend, door de oudheid en uniciteit van de uitingen, evenals door regio's vastberaden onder zijn culturele invloed te plaatsen, en vaak ook onder zijn politieke dominantie.

Op dezelfde manier hebben ook Japan en Korea onder deze invloed gestaan die zij gedeeltelijk geassimileerd hebben in overeenstemming met de traditties.

Elk land heeft zijn persoonlijke en onmiskenbare bijdrage aan de wereldkunst geleverd: China met zijn veelsoortige productie die nu een plaats van eminent belang in musea, collecties en galerieën in de wereld inneemt; Japan met de duidelijke invloed - zoals blijkt sinds het midden van de negentiende eeuw- op de beeldende kunst, op de grafische kunst en op de esthetiek van het westen, en, ten slotte, Korea, met zijn oude traditie in keramiek en kalligrafie.

Zelfs de religieuze en culturele tradities van het boeddhisme, die oorspronkelijk geïntroduceerd werd in China al aan het begin van onze jaartelling, en van daaruit is het verspreid in de aangrenzende regio's, strekt zich uit tot de kunsten en ambachten samenvoegend met inheemse religieuze praktijken: het taoïsme en voorouderverering in China, het Shintoïsme in Japan en het sjamanisme in Korea.

Introducción

La zona más oriental del continente asiático representa en la historia del arte una región relativamente homogénea y rica en aspectos particulares. La inmensa China indudablemente ha ejercido, por antigüedad y por excepcionalidad, un influjo capaz de marcar de manera determinante a las regiones sometidas a su influencia cultural y, frecuentemente, también a su dominio político.

Del mismo modo, Japón y Corea han asimilado estas influencias reelaborándolas y parte según su propia tradición.

Cada país ha contribuido con un aporte personal e innegable al arte mundial: China, con su producción multiforme que hoy ocupa un lugar de excepcional relevancia en museos, colecciones y galerías de arte del mundo; Japón, con la evidente influencia –manifestada a partir de la mitad del siglo XIX– sobre las artes figurativas, la gráfica y la estética de Occidente; y, finalmente, Corea, con su antigua tradición en el arte de la cerámica y la caligrafía.

También la tradición religioso-cultural del budismo, introducido originalmente en China ya desde el comienzo de la era cristiana, y propagado desde aquí a las regiones contiguas, se extiende a las artes y al artesanado, fundiéndose con las prácticas religiosas autóctonas: taoísmo y culto de los antepasados en China; sintoísmo en Japón; chamanismo en Corea.

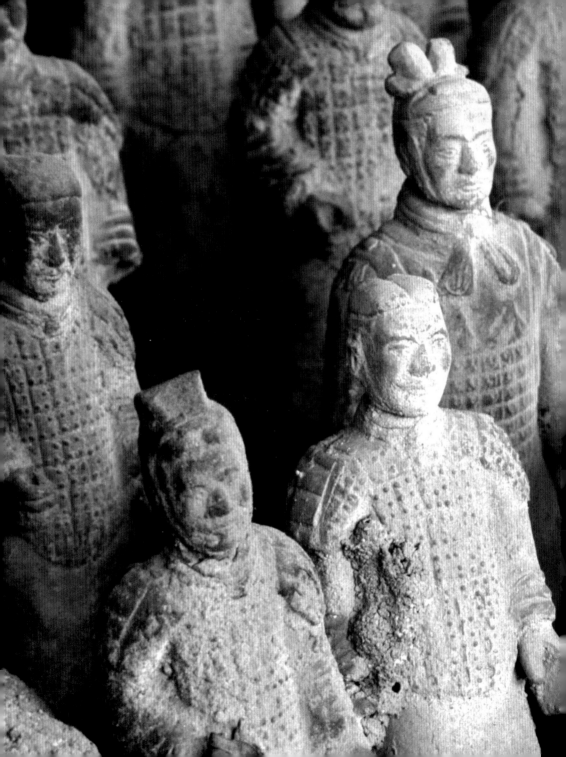

CHINA
One thousand reigns at the dawn of history

The five thousand years during which the history of China has unraveled almost seem to be lost in legend. The system of dominion and the records of dynastic events represent a sort of network on which China weaves its history, preading its most characteristic artistic and cultural expressions. During the time of the dynasties (from the Shang Dynasty 1500-1050 BCE to the Sui Dynasty 581-618 CE), a practical and refined art took shape, in a constant and profitable exchange between court and popular styles, without ignoring the external world.

CHINA
Tausend Reiche in der Frühzeit der Geschichte

Die Fünftausend Jahre, die die Geschichte Chinas gezählt hat, scheinen nahezu im Mythos zu verschwinden.
Das Herrschaftssystem und die dynastische Tradition bilden eine Art Netz, mit dem China seine eigene Geschichte verknüpft und besonders charakteristische künstlerischen und kulturelle Phänomene verbreitet. Während dieser Dynastien (von der Shang-Dynastie, 1500-1050 v. Chr., bis zur Sui-Dynastie, 581-618 n. Chr.) bildet sich eine praktische und raffinierte Kunst, die ununterbrochen und dazu ausgesprochen gewinnbringend zwischen dem höfischen Stil und der Volkskunst vermittelt, ohne dabei die Außenwelt aus dem Blickwinkel zu verlieren.

1

CHINA
Duizend koninkrijken in de vroege geschiedenis

De vijfduizend jaar waarin de Chinese geschiedenis zich ontvouwt lijkt bijna verloren te gaan in de mythe. Het overheersingssysteem en de registratie van dynastieke gebeurtenissen geven een soort netwerk weer, waarin China zijn geschiedenis weeft, daarmee zijn meest kenmerkende artistieke en culturele expressies onthullend. In de plot van de dynastieën (de Shang 1500-1050 v. Chr. tot de Sui 581 tot 618 na Chr.), krijgt kunst praktische en verfijnde vorm, in een permanente en vruchtbare uitwisseling tussen de expressies aan het hof en de expressies van het volk, zonder de buitenwereld te negeren.

CHINA
Mil reinos en los albores de la historia

Los cinco mil años a lo largo de los que se extiende la historia china parecen prácticamente perderse en el terreno de lo mitológico. El sistema de dominio y el registro de los hechos de las dinastías representan una especie de red sobre la que China teje su propia historia, divulgando sus expresiones artísticas y culturales más características.
En la trama de las dinastías (de la Shang 1500-1050 a.C. a la Sui 581- 618 d.C.) va tomando forma un arte práctico y refinado, en un intercambio constante y provechoso entre expresiones reales y expresiones populares, sin dejar de lado el mundo externo.

Chinese Dynasties / Dynastien in China
Chinese dynastieën / Dinastías Chinas

2207 - 1766 BCE
Xià (夏)

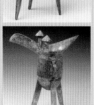

1766 - 1027 BCE
Shang (商)

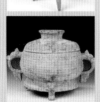

1027 - 771 BCE
Western Zhou
Westliche Zhou
Westelijke Zhou
Zhou Occidentales
(西周)

770 - 221 BCE
Eastern Zhou
Östliche Zhou
Oostelijke Zhou
Zhou Orientales
(東周)

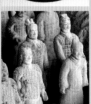

221 - 207 BCE
Qin (秦)

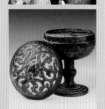

206 BCE - 8 CE
Western Han
Westliche Han
Westelijke Han
Han Occidentales
(西漢)

25 - 220
Eastern Han
Östliche Han
Oostelijke Han
Han Orientales
(東漢)

9 - 23
Xin (新)

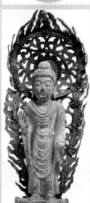

220 - 280
Period of the Three Kingdoms
Zeit der Drei Reiche / Periode van
drie Koninkrijken / Período de los
Tres Reinos (三國):
Wei (**220 - 263**)
Shu Han (**220 - 265**)
Wu (**220 - 280**)

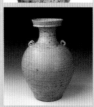

265 - 317
Western Jin
Westliche Jin
Westelijke Jin
Jin Occidentales
(西晉)

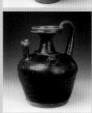

317 - 420
Eastern Jin
Östliche Jin
Oostelijke Jin
Jin Orientales
(東晉)

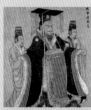

420 - 589
Southern and Northern Dynasties /
Dynastien des Südens und des
Nordens / Dynastie van Zuid
en Noord / Dinastías Meridionales
y Septentrionales (南北朝)

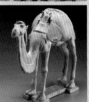

581 - 618
Sui (隋)

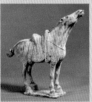

618 - 907
Tang (唐)

907 - 960
Period of the Five Dynasties
and Ten Kingdoms / Zeit der Fünf
Dynastien und der Zehn Reiche
Periode van de Vijf Dynastieën
en Tien Koninkrijken / Período
de las Cinco Dinastías y de los
Diez Reinos (五代十國)

916 - 1125
Liao (遼)

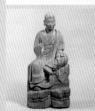

960 - 1127
Northern Song
Song des Nordens
Song van het Noorden
Song del Norte
(北宋)

1127 - 1279
Southern Song
Song des Südens
Song van het Zuiden
Song del Sur
(南宋)

1032 - 1227
Western Xia
Westliche Xia
Westelijke Xia
Xia Occidentales
(西夏)

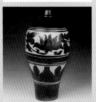

1115 - 1234
Jin (金)

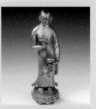

1279 - 1368
Yuan (元)

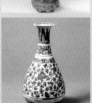

1368 - 1644
Ming (明)

1644 - 1911
Qing (清)

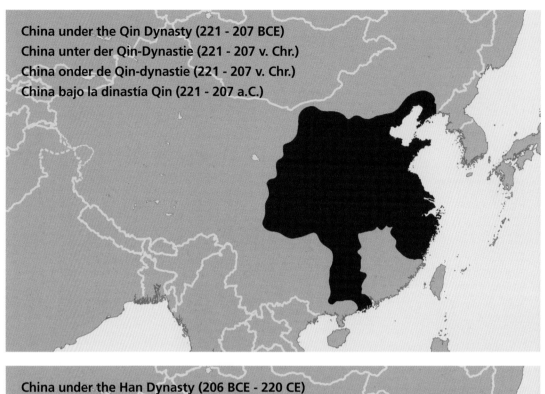

China under the Qin Dynasty (221 - 207 BCE)
China unter der Qin-Dynastie (221 - 207 v. Chr.)
China onder de Qin-dynastie (221 - 207 v. Chr.)
China bajo la dinastía Qin (221 - 207 a.C.)

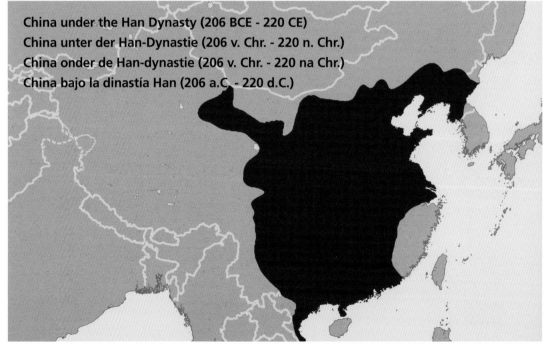

China under the Han Dynasty (206 BCE - 220 CE)
China unter der Han-Dynastie (206 v. Chr. - 220 n. Chr.)
China onder de Han-dynastie (206 v. Chr. - 220 na Chr.)
China bajo la dinastía Han (206 a.C. - 220 d.C.)

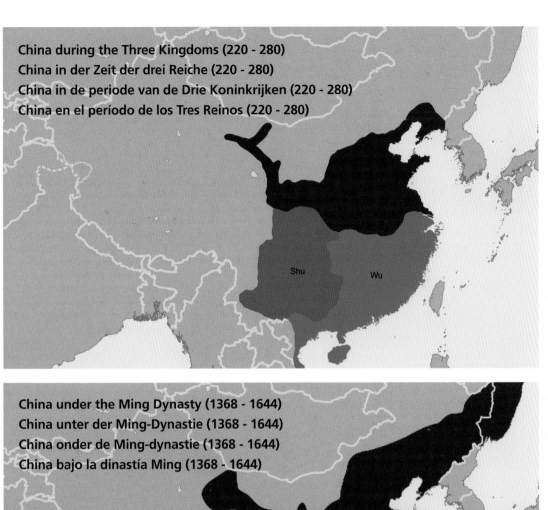

China during the Three Kingdoms (220 - 280)
China in der Zeit der drei Reiche (220 - 280)
China in de periode van de Drie Koninkrijken (220 - 280)
China en el período de los Tres Reinos (220 - 280)

Shu

Wu

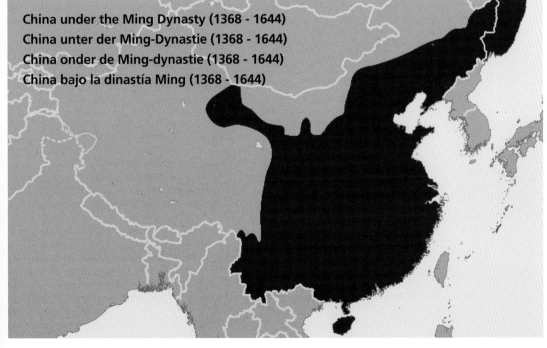

China under the Ming Dynasty (1368 - 1644)
China unter der Ming-Dynastie (1368 - 1644)
China onder de Ming-dynastie (1368 - 1644)
China bajo la dinastía Ming (1368 - 1644)

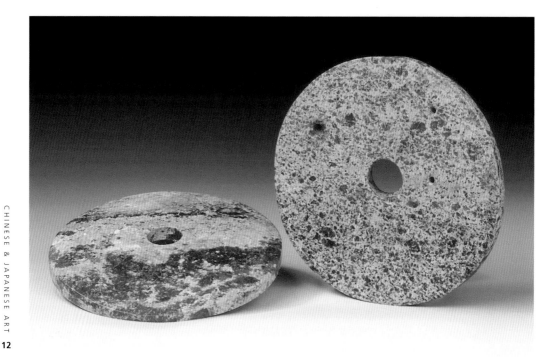

Pair of disks going back to the Neolithic, stone
Auf die Jungsteinzeit zurückgehendes
Scheibenpaar, Stein
Stel platen uit het Neolithicum, steen
Pareja de discos que data del Neolítico, piedra
3400-2250 BCE
Museum of East Asian Art, Bath

Disk belonging to the Liangzhu culture, stone
Zur Liangzhu-Kultur gehörende Scheibe, Stein
Plaat afkomstig uit de Liangzhu-cultuur, steen
Disco perteneciente a la cultura de Liangzhu, piedra
3200-2200 BCE
Victoria & Albert Museum, London

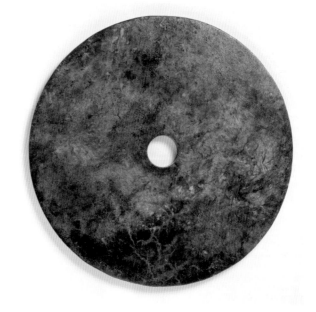

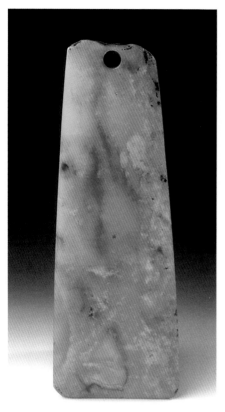

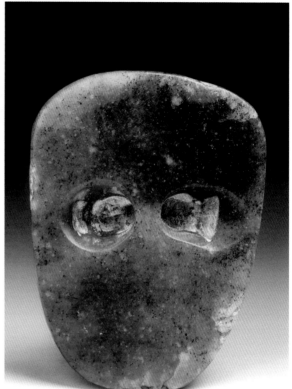

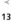

▌ Jade (Yu) had quite a special role in Chinese tradition. Associated with beauty and purity, its use is documented from the fifth millennium BCE, both in ritual and artisanal and artistic settings.
▌ Die Jade (Yu) hat in der chinesischen Tradition eine ganz besondere Rolle inne. Sie wird gemeinhin mit Schönheit und Reinheit assoziiert und seit dem 5. Jahrtausend v. Chr. sowohl bei Riten, als auch in Kunst und Kunsthandwerk verwendet.
▌ De jade (Yu) speelt een zeer bijzondere rol in de Chinese traditie. Deze edelsteen staat synoniem voor schoonheid en puurheid en het gebruik ervan wordt vanaf het vijfde millennium v. Chr. bij rites, in de ambacht en kunst geregistreerd.
▌ La tinaja (Yu) tiene un rol muy particular en la tradición china. Relacionada con la belleza y la pureza, su uso está registrado desde el quinto milenio a.C., tanto en el ámbito ritual, como en el campo artesanal y artístico.

Axe blade of the Liangzhu culture, jade
Axtklinge aus der Liangzhu-Kultur, Jade
Bijlblad van de Liangzhu-cultuur, jade
Hoja de hacha de la cultura de Liangzhu, jade
3400-2250 BCE
Museum of East Asian Art, Bath

Human mask of the neolithic culture of Hongshan, Northern China, jade
Menschliche Maske aus der jungsteinzeitlichen Kultur der Hongshan, Nordchina, Jade
Masker van een mensengezicht van de neolithische cultuur uit Hongshan, Noord-China, jade
Máscara humana de la cultura neolítica de Hongshan, China septentrional, jade
ca. 3500-2200 BCE
Museum of East Asian Art, Bath

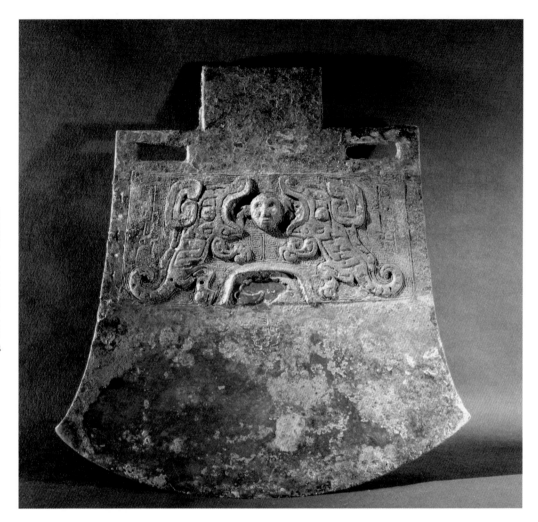

Ceremonial axe, bronze
Zeremonienaxt, Bronze
Ceremoniële bijl, brons
Hacha ceremonial, bronce
1200-1000 BCE
National Museum of China, Beijing

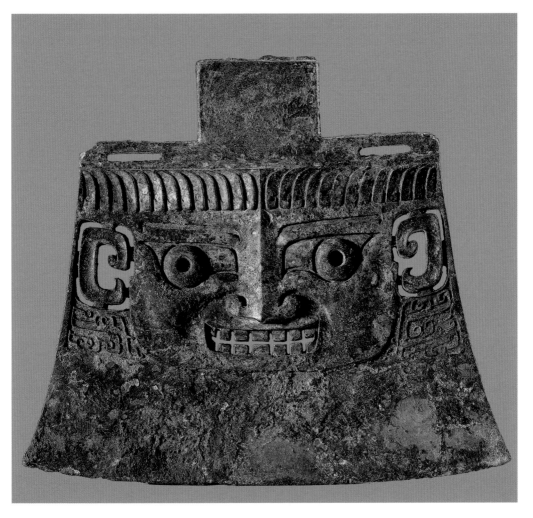

Ceremonial axe, bronze
Zeremonienaxt, Bronze
Ceremoniële bijl, brons
Hacha ceremonial, bronce
1200-1000 BCE
Museum für Asiatische Kunst, Östasiatische Kunstsammlung, Berlin

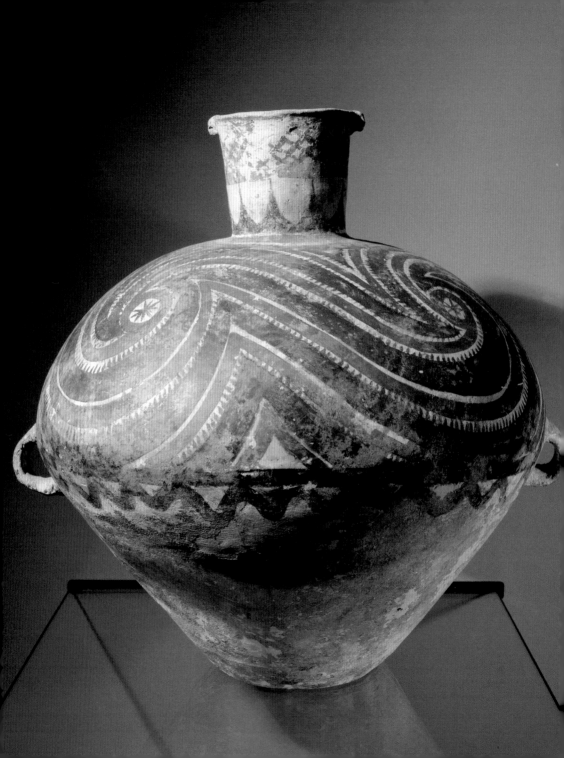

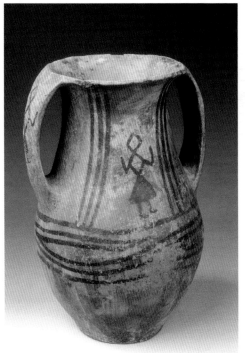

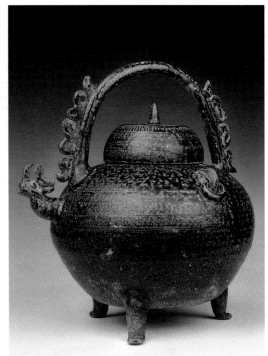

Two-handled glass with dancing figure of the Xindian culture
Gläser mit zwei Henkeln und tanzender Figur aus der Xindian-Kultur
Glas met twee handvaten met dansend figuur uit de Xindian-cultuur
Vaso con dos asas, con figuras danzantes de la cultura Xindian
ca. 2000 - ca. 1500 BCE
Museum of East Asian Art, Bath

◀ Vase with spiral geometric motifs from the necropolis of
Banshan, terracotta
Spiralenförmige Vase mit geometrischen Motiven aus der
Nekropolis Banshan, Terrakotta
Vaas met geometrische motieven en spiralen uit de necropolis van
Banshan, terracotta
Jarrón con motivos geométricos en forma de espiral de la
necrópolis de Banshan, terracota
2800-2500 BCE
Musée Cernuschi, Paris

Crockery from the beginning of the Warring States Period, terracotta
Geschirr aus den Anfängen der Zeit der kämpfenden Staaten, Terrakotta
Vaatwerk uit de beginperiode van de strijdende Staten, terracotta
Vajilla de Comienzos del período de los Estados Combatientes, terracota
ca. 500-400 BCE
Museum of East Asian Art, Bath

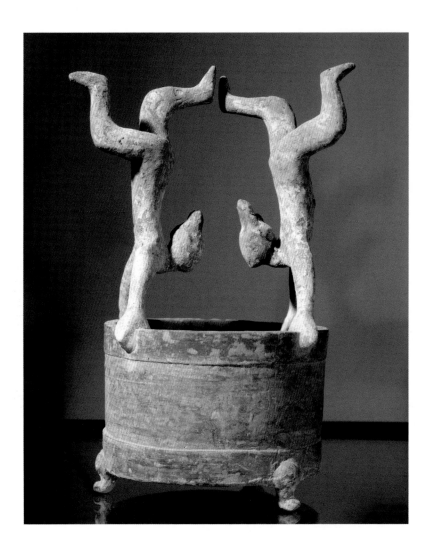

Vase with two acrobats of the Han Dynasty, terracotta
Vase mit zwei Akrobaten aus der Han-Epoche, Terrakotta
Vaas met twee acrobaten uit de Han-periode, terracotta
Jarrón con dos acróbatas del período Han, terracota
209-6 BCE
Musée Cernuschi, Paris

▶ *Hu* vase with cloud designs, terracotta
Hu-Vase mit Wolkenzeichnungen, Terrakotta
Hu-vaas met tekeningenn van wolken, terracotta
Jarrón *hu* con dibujos de nubes, terracota
200-100 BCE
Museum of East Asian Art, Bath

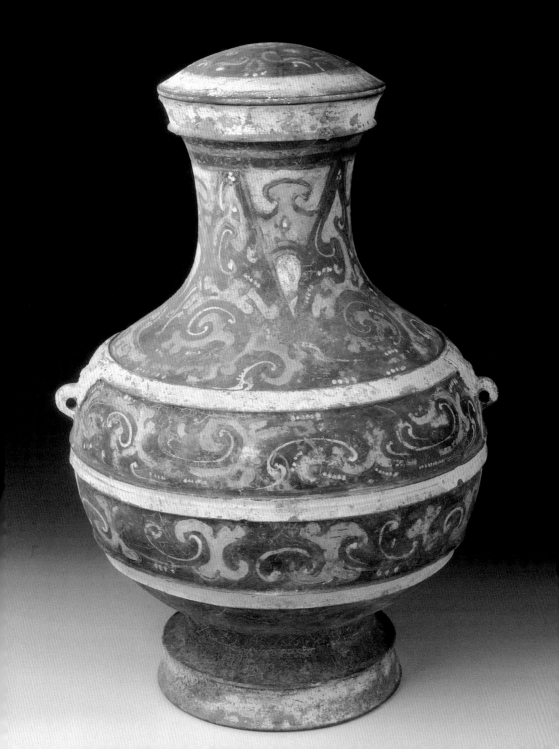

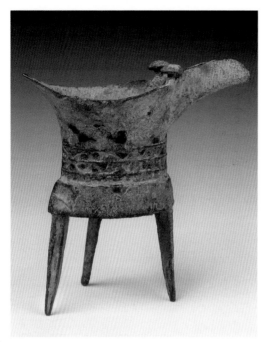 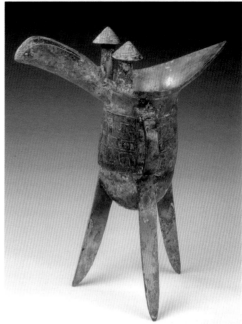

■ *Arriving in the 3ʳᵈ century BCE, Buddhism, even though with alternating success at court, provided China with a series of fundamental cues also in the artistic setting and represented an important vehicle of contact with other civilizations.*
■ *Seit seiner Entstehung im 3. Jahrhundert v. Chr. hat der Buddhismus, obgleich seines wechselnden Anklangs am Hofe, China auch auf dem Gebiet der Kunst einige wesentliche Anstöße gegeben und ein wichtiges Kontaktmedium zu anderen Kulturen dargestellt.*
■ *Het boeddhisme heeft bij zijn opkomst in de 3ᵉ eeuw v. Chr. ook in de kunst fundamentele bijdragen geleverd en speelde een belangrijke rol bij het onderhouden van contacten met andere beschavingen.*
■ *Llegado a China en el siglo III a.C., el budismo, a pesar de haber contado con suerte dispar en la corte, ha dado a esta nación una serie de inspiraciones fundamentales también en el ámbito artístico, y ha representado un importante vehículo de contacto con otras civilizaciones.*

Jue, container for wine resting on three legs of the Erlitou culture, bronze
Jue, Weingefäß mit drei Füßen der Erlitou-Kultur, Bronze
Jue, wijnhouder op drie poten uit de Erlitou-cultuur, brons
Jue, recipiente para el vino apoyado sobre tres patas de la cultura de Erlitou, bronce
ca. 1600 BCE
Museum of East Asian Art, Bath

Jue with the traditional round base of the Anyang Period, bronze
Jue mit der traditionellen runden Basis aus der Anyang-Epoche, Bronze
Jue met de traditionele ronde basis uit de Anyang-periode, brons
Jue con la tradicional base redonda del período Anyang, bronce
1200 BCE
Museum of East Asian Art, Bath

▶ Stele of the Thousand Buddhas of the Zhou Period, stone
Grabstele der Tausend Buddha aus der Zhou-Epoche, Stein
Grafzuil van de Duizend Boeddha's uit de Zhou-periode, steen
Estela de los Mil Budas del período Zhou, piedra
1100-300 BCE
Art and History Museum, Shanghai

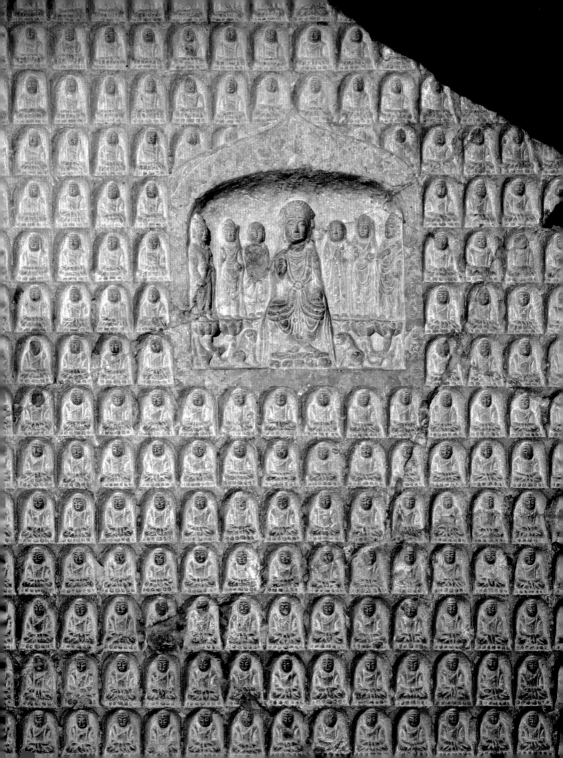

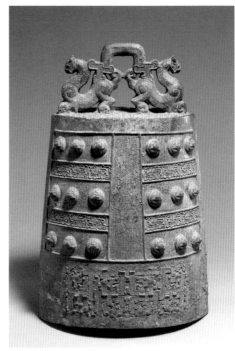

Bell, Eastern Zhou Dynasty, bronze
Glocke, Dynastie der östlichen Zhou, Bronze
Klok, oostelijke Zhou-dynastie, brons
Campana, dinastía Zhou Oriental, bronce
ca. 500 BCE
The Metropolitan Museum of Art, New York

◀ Spearhead, bronze
Lanzenspitze, Bronze
Speerpunt, brons
Punta de lanza, bronce
800 BCE
Museum of East Asian Art, Bath

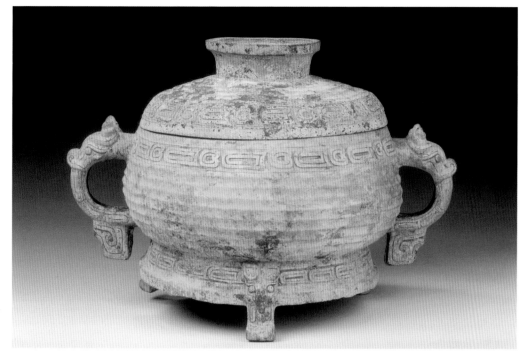

Gui, container for food with handles of animal heads, Western Zhou Dynasty, bronze
Gui, Speisenbehältnis mit Tierkopfhenkel, Westliche Zhou-Dynastie, Bronze
Gui, voedselschaal met handvaten in de vorm van dierenhoofden, westelijke Zhou-dynastie, brons
Gui, recipiente para alimentos con asa en forma de cabeza de animal, dinastía Zhou Occidental, bronce
900-800 BCE
Museum of East Asian Art, Bath

Applique with drawing of tigers and boars, bronze
Applikation mit Tigern und Wildschweinen, Bronze
Tekening met tijgers en zwijnen, brons
Aplicación con dibujo de tigres y jabalíes, bronce
500 BCE
Museum of East Asian Art, Bath

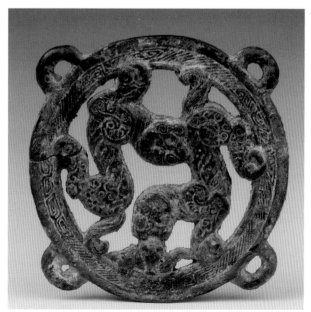

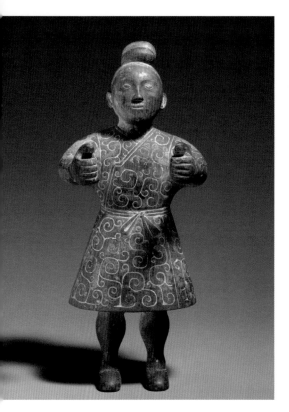

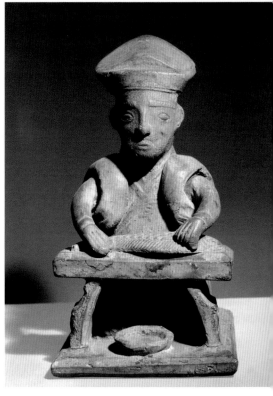

The cook, Han Dynasty, terracotta
Koch, Han-Dynastie, Terrakotta
De kok, Han-dynastie, terracotta
El cocinero, dinastía Han, terracota
25-210
Musée Cernuschi, Paris

Figurine of charioteer, Eastern Zhou Dynasty, bronze
Fuhrmann, Östliche Zhou-Dynastie Orientali, Bronze
Voermanfiguur oostelijke Zhou-dynastie, brons
Estatuilla de auriga, dinastía Zhou Oriental, bronce
400-300 BCE
The Metropolitan Museum of Art, New York

▶ Horse and rider, Han Dynasty, terracotta
Pferd und Reiter, Han-Dynastie, Terrakotta
Paard en ruiter, Han-dynastie, terracotta
Caballo y jinete, dinastía Han, terracota
209-6 BCE
Musée Cernuschi, Paris

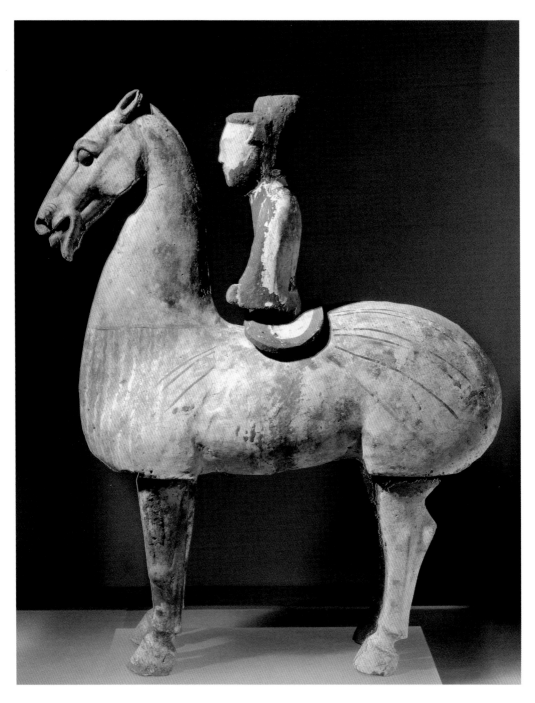

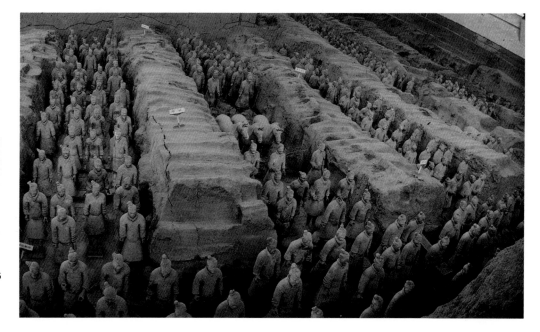

■ *Fruit of a rather evolved technique, in addition to the work of hundreds of workers and technicians, the Terracotta Army of Warriors, destined to protect the tomb of Emperor Qin Shi Huang at Xi'an, stands out because of its impressiveness among the artistic displays of Imperial China.*

■ *Als Ergebnis einer sehr entwickelten Technik und der Arbeit von abertausenden von Arbeitern und Fachleuten sticht die Armee der Terrakotta-Krieger, die das Grabmal des Kaisers Qinshihuang in Xi'an beschützen sollte, aufgrund ihrer beachtlichen Ausmaße innerhalb der künstlerischen Darbietungen des kaiserlichen Chinas hervor.*

■ *De terracotta oorlogsstrijders waren niet alleen het werk van honderdduizenden arbeiders en technici, maar waren ook het resultaat van behoorlijk geëvolueerde technieken. Deze beelden werden gebruikt om het graf van keizer Qinshihuang in Xi'an te beschermen en komen in al hun grandeur op als één van de kunstuitingen van keizerlijk China.*

■ *Fruto de una técnica muy evolucionada, y también del trabajo de centenares de miles de obreros y técnicos, el ejército de guerreros de terracota, destinado a proteger la tumba del emperador Qinshihuang a Xi'an, destaca por su imponencia entre las manifestaciones artística de la China imperial.*

The Xi'an Army, Qin Dynasty, terracotta
Die Armee von Xi'an, Qin-Dynastie, Terrakotta
Leger van Xi'an, Qin-dynastie, terracotta
El ejército de Xi'an, dinastía Qin, terracota
ca. 211-206 BCE
Terra-Cotta Warriors and Soldiers Museum, Xi'an

▶ Detail of statue of infantrymen of the Xi'an Army, terracotta
Detail einer Statue eines Infanteristen des Xi'an-Heers, Terrakotta
Beelden van infanteristen van het leger van Xi'an, terracotta
Detalle de estatuas de soldados de infantería del ejército de Xi'an, terracota
ca. 211-206 BCE
Terra-Cotta Warriors and Soldiers Museum, Xi'an

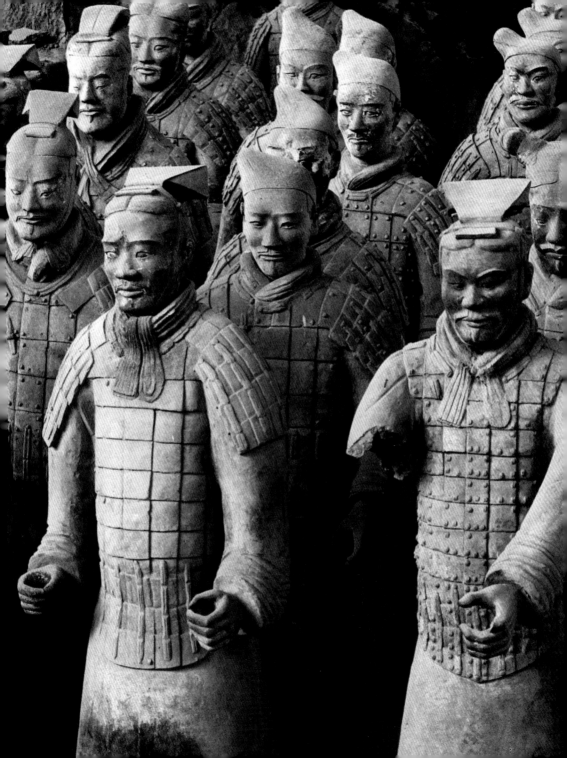

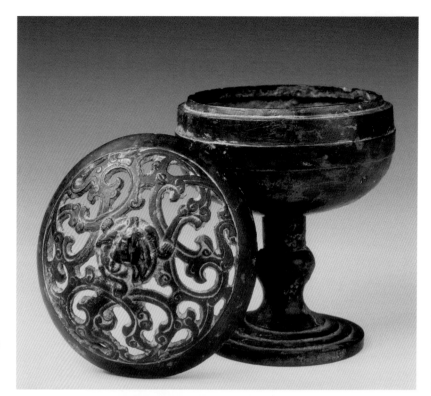

Incense burner, bronze
Rauchfass, Bronze
Wierookvat, brons
Inciensarios, bronce
200-100 BCE
Museum of East Asian Art,
Bath

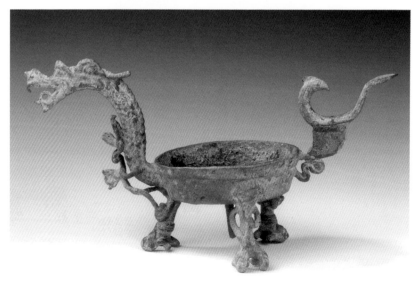

Lamp in the shape of a
dragon, bronze
Lampe in Drachenform,
Bronze
Draakvormige lamp, brons
Lámpara en forma de
dragón, bronce
200-100 BCE
Museum of East Asian Art,
Bath

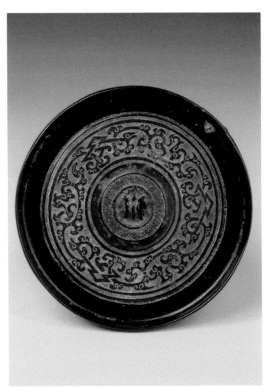

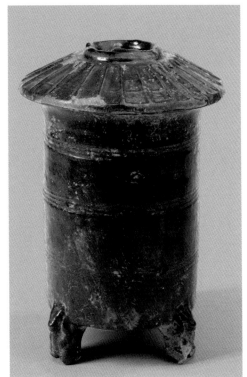

Mirror with *Kui* dragon motif, bronze
Spiegel mit *Kui*-Drachenmotiv, Bronze
Spiegel met *Kui* draakmotieven, brons
Espejo con motivo de dragones *Kui*, bronce
200 BCE
Museum of East Asian Art, Bath

Model of granary, Eastern Han Dynasty, bronze
Getreidespeichermodell, Östliche Han-Dynastie, Bronze
Graanschuur, westelijke Han-dynastie, brons
Modelo de granero, dinastía Han Oriental, bronce
100-300
Victoria & Albert Museum, London

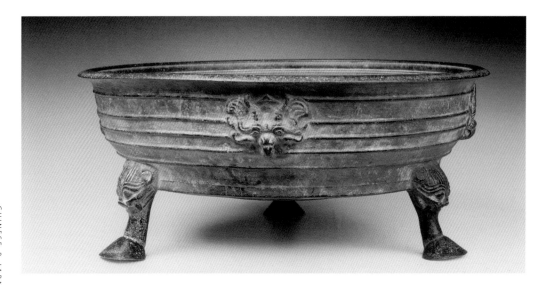

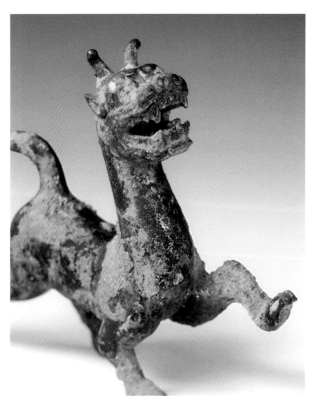

Washbasin with *Taotie* masks, Six Dynasties
Period, bronze
Becken mit *Taotie*-Maske, Zeitalter
der Sechs Dynastien, Bronze
Wasbekken met *Taotie*-maskers, periode
van de Zes Dynastieën, brons
Cuenco con máscaras *Taotie*, período
de las Seis Dinastías, bronce
200-400
Museum of East Asian Art, Bath

Chimera, gilt bronze
Chimäre, vergoldete Bronze
Chimère, verguld brons
Quimera, bronce dorado
400
Museum of East Asian Art, Bath

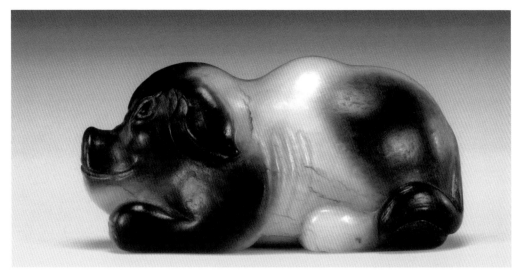

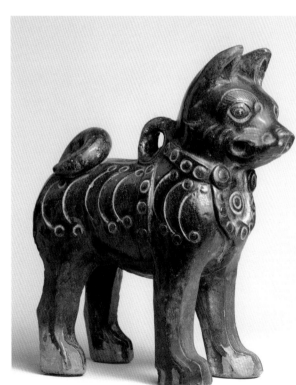

Courching pig, Six dynasties Period, jade
Geducktes Schwein, Zeitalter der Sechs Dynastien, Jade
Ineengedoken varken, periode van de Zes Dynastieën, jade
Cerdo agazapado, período de las Seis Dinastías, jade
220-586
Museum of East Asian Art, Bath

Figure of dog, Eastern Han Dynasty, pottery
Hundefigur, Östliche Han-Dynastie, Keramik
Hondenfiguur, oostelijke Han-dynastie, keramiek
Figura de perro, dinastía Han Oriental, cerámica
25-220
The Metropolitan Museum of Art, New York

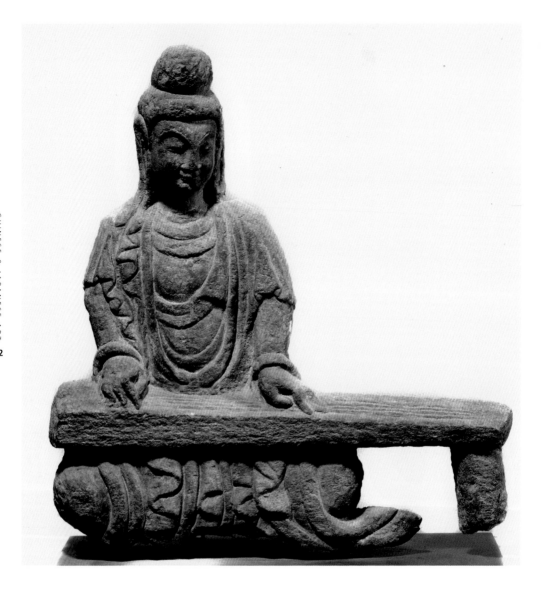

Lyre player, Wei Period, stone
Zitherspielerin, Wei-Epoche, Stein
Citerspeelster, Wei-periode, steen
Intérprete de cítara, período Wei, piedra
386-534
Musée Guimet, Paris

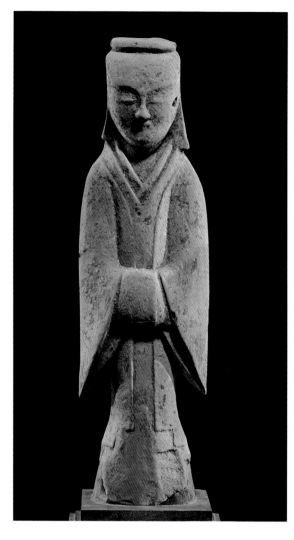

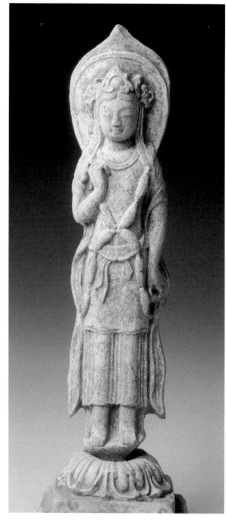

Female figure of the Han Period, terracotta
Weibliche Figur der Han-Epoche, Terrakotta
Vrouwelijke figuur uit de Han-periode, terracotta
Estatuilla femenina del período Han, terracota
200-300
Museum of Fine Arts, Boston

Avalokitesvara, pottery
Avalokiteshwara, Keramik
Avalokiteshwara, keramiek
Avalokiteshwara, cerámica
ca. 563
Museum of East Asian Art, Bath

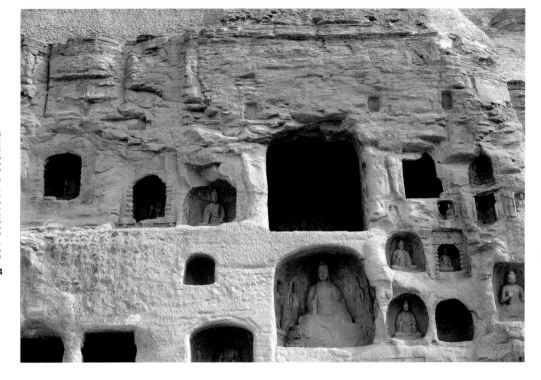

▮ *The Yungang Grottoes, excavated mainly during the Wei Dynasty, house the oldest examples of Buddhist cave art. The complex includes 252 grottoes with over 50,000 statues.*
▮ *Die Yungang-Grotten, die hauptsächlich während der Wei-Dynastie gegraben wurden, beherbergen die ältesten Vorbilder buddhistischer Kunst am Felsen. Der Komplex umfasst 252 Höhlengänge mit mehr als 50.000 Statuen.*
▮ *De Yungang-grotten zijn hoofdzakelijk tijdens de Wei-dynastie uitgegraven en herbergen de oudste exemplaren van de boeddhistische rotskunst. Het complex heeft 252 grotten met meer dan 50.000 beelden.*
▮ *En las grutas de Yungang, excavadas principalmente durante la dinastía Wei, se hallan los más antiguos ejemplos de arte rupestre budista. El complejo comprende 252 cavernas con más de 50.000 estatuas.*

Datong
Detail of Grotto 11 of Yungang
Detail der Yungang-Grotte 11
Grot 11 van Yungang
Detalles de la gruta 11 de Yungang
460-525

▶ **Datong**
Colossal Buddha in Grotto 18 of Yungang
Riesenbuddha der Yungang-Grotte 18
Kolossale Boeddha in grot 18 van Yungang
Buda colosal en la gruta 18 de Yungang
460-525

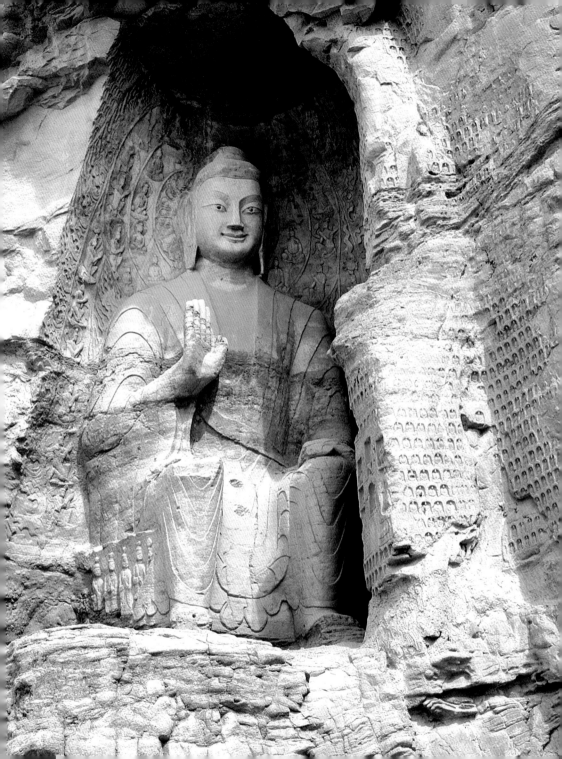

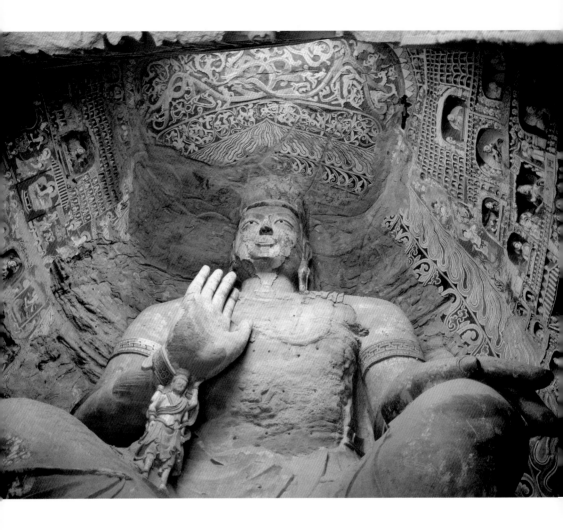

Datong
Colossal Buddha of Grotto 13 of Yungang
Riesenbuddha der Yungang-Grotte 13
Kolossale Boeddha van grot 13 van Yungang
Buda colosal de la gruta 13 de Yungang
460-494

▶ Buddhist stele from the Stele Forest of Shaanxi
Buddhistische Grabstele aus dem Stelenwald von Shaanxi
Boeddhistische grafzuil uit het Bos van de Grafzuilen van Shaanxi
Estela budista del Bosque de las Estelas de Shaanxi
Shaanxi Provincial Museum, Xi'an

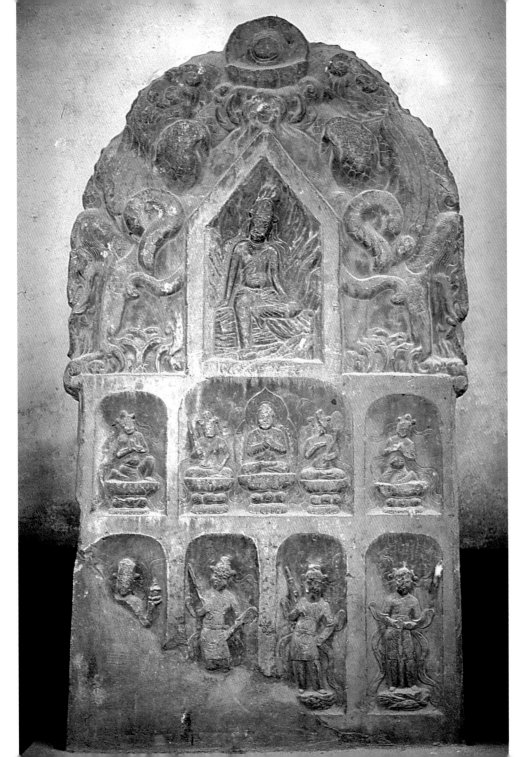

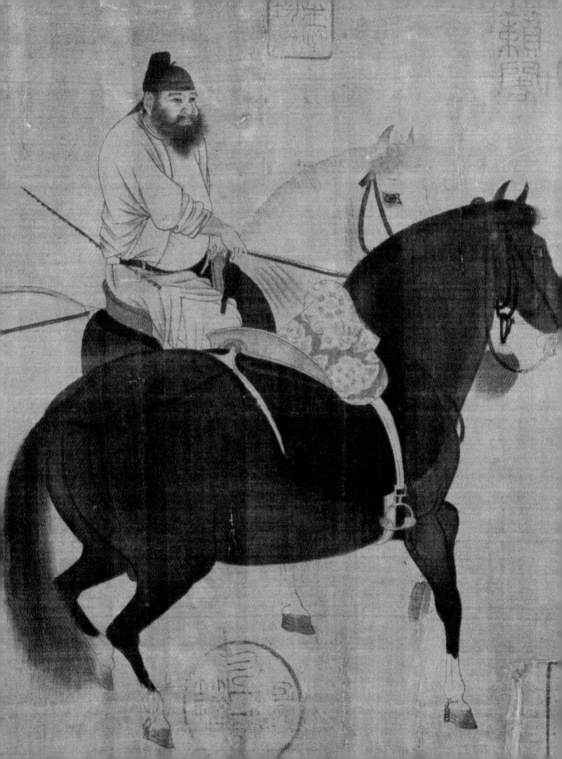

The creativity of the Middle Kingdom

With the consolidation of the state following the peace obtained after subduing the neighboring populations, Chinese art flourished and influenced the conquered people. Buddhism certainly also acted as a bridge between different cultural and political realities for art, including Japan, Korea, Vietnam, Tibet, Mongolia. Trade with Europe played a similar role, which took place along the Silk Road, and which remained intense at least until the fall of the Tang Dynasty (907 CE).

Die Kreativität des Reichs der Mitte

Nach der Konsolidierung des Staatsgefüges in Folge des durch Unterwerfung der angrenzenden Bevölkerungen erhaltenen Friedens kam es in China zu einer außergewöhnlichen Blütezeit der Kunst, die dem Staat erlaubte, Einfluss auf die eroberten Völker auszuüben. Sicherlich trug auch der Buddhismus dazu bei, in der Kunst eine Brücke zwischen den unterschiedlichen kulturellen und politischen Realitäten zu schlagen: Japan, Korea, Vietnam, Tibet und Mongolei. Eine ähnliche Rolle spielten die durch die Seidenstraße entstandenen Handelskontakte mit Europa, welche auf jeden Fall bis zum Ende der Tang-Dynastie (907 v. Chr.) bestanden.

2

De creativiteit van het Middenrijk

Tijdens de staatsstructuur opgericht na de vrede door de onderwerping van de naburige volkeren, kende China een uitzonderlijke artistieke bloei waardoor ze haar invloed op de veroverde volkeren kon uitoefenen Zeker heeft ook de boeddhistische religie geholpen bij de bouw van een brug van de kunst tussen de verschillende culturele en politieke realiteiten: Japan, Korea, Vietnam, Tibet, Mongolië.
In een soortgelijke rol ontwikkelde zich de handelsuitwisseling met Europa, die actief werd langs de Zijderoute en intens is gebleven door de tijd heen, ten minste tot de val van de Tang (907 na Chr.).

La creatividad del Imperio del Medio

Una vez consolidada la estructura estatal después de la paz obtenida con el sometimiento de los pueblos vecinos, China vivió un excepcional florecimiento artístico que le permitió ejercer su influencia sobre los pueblos conquistados. Indudablemente, también la religión budista contribuyó a tender un puente en el campo artístico entre realidades culturales y políticas distintas: Japón, Corea, Vietnam, Tíbet y Mongolia. El mismo papel tuvieron los intercambios de mercancías con Europa que se generaron a través de la Ruta de la Seda y que mantuvieron su intensidad con el pasar del tiempo, al menos hasta la caída de los Tang (907 d.C.).

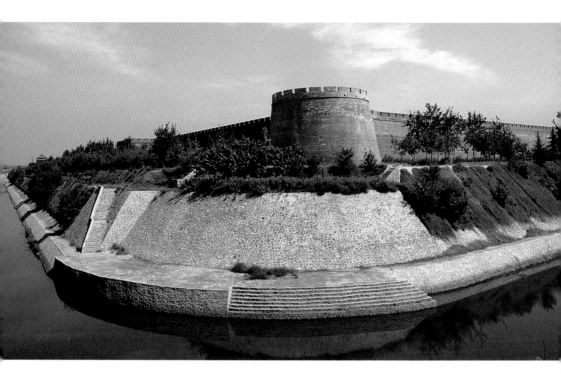

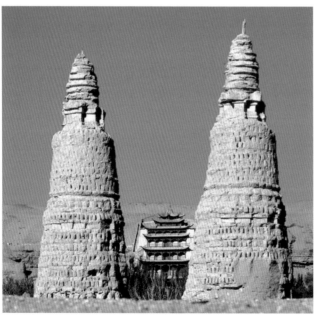

Xi'an

The walls that follow the ancient outline of the imperial capital, Chang'an, under the Tang dynasty
Alte Stadtmauern entlang der ehemals kaiserlichen Hauptstadt Chang'an unter der Tang-Dynastie
De muren die het oude tracé volgen van Chang'an, de hoofdstad van het keizerrijk tijdens de Tang-dynastie
Los muros que siguen el antiguo trazado de la ciudad imperial Chang'an bajo la dinastía Tang
618-904

Pagodas at Dunhuang, important centre on the Silk Road and in the spread of Buddhism
Pagode in Dunhuang, wichtiges Zentrum an der Seidenstraße und für die Verbreitung des Buddhismus
Pagode in Dunhuang, belangrijk boeddhistisch centrum aan de zijderoute
Pagodas en Dunhuang, importante centro de la Ruta de la Seda y de difusión del budismo
700-800

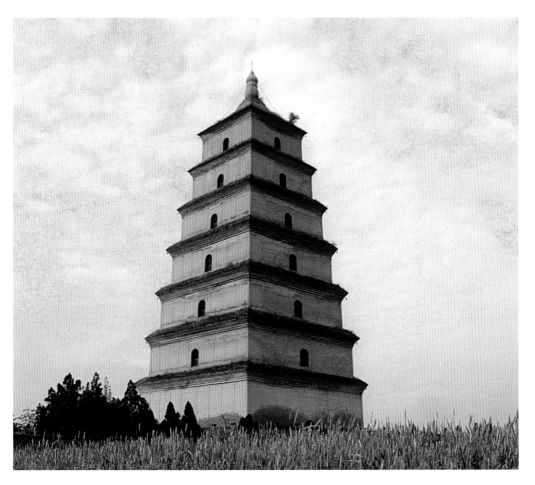

Xi'an
The Giant Wild Goose Pagoda
Die große Pagode der Wildente
De grote wilde gans-pagode
La Gran Pagoda de la Oca Salvaje
652

❚ *In the Giant Wild Goose Pagoda, the monk Xuan Zang started a centre of translation into Chinese of the original Buddhists texts.*
❚ *In der große Pagode der Wildente baute der Mönch Xuan Zang ein chinesisches Übersetzungszentrum von buddhistischen Originaltexte.*
❚ *In de Grote Wilde Gans Pagode zette monnik Xuan-Zang een Chinees vertaalcentrum op voor het vertalen van originele boeddhistische teksten.*
❚ *En la Gran Pagoda de la Oca Salvaje, el monje Xuan Zang puso en marcha un centro de traducción al chino de los textos budistas originales.*

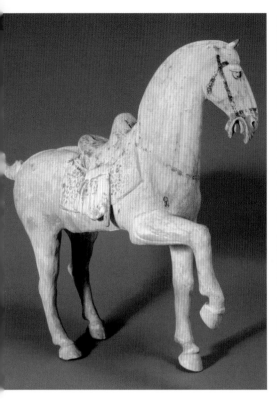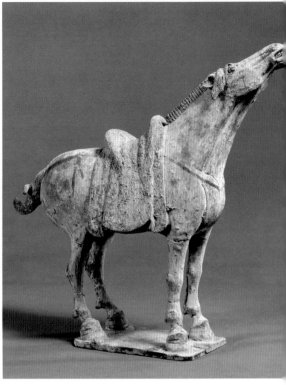

▌ *In its expansion to the West, the Tang Empire occupied Bactria (the area between the Hindu Kush and the Amu Darya River), finding horses of great stamina and beauty which the art of the period made the subject of innumerable works.*
▌ *Bei der Westerweiterung besetzte das Tang-Reich Baktrien (das Gebiet zwischen dem Hindu Kush und dem Fluss Amu Darya) und fand dort Pferde von großer Stärke und Schönheit vor, welche die Kunst jener Zeit zum Gegenstand von zahlreichen Werken machte.*
▌ *Het Tang-keizerrijk breidde zich richting het Westen uit en bezette Bactrië (gebied tussen Hindoekoesj en Amu Darja) waar zich zeer sterke en mooie paarden bevonden die in de kunst van die periode in ontelbare werken verwerkt zijn.*
▌ *En su expansión hacia Occidente, el imperio Tang ocupó la Bactriana (el área comprendida entre el Hindu Kush y el río Amu Darya), encontrando allí caballos de enorme fortaleza y belleza que el arte de la época tomó como temática de innumerables obras.*

Horse pawing the ground, Tang Dynasty, pottery
Trampelndes Pferd, Tang-Dynastie, Keramik
Trappend paard, Tang-dynastie, keramiek
Caballo dando coces, dinastía Tang, cerámica
700-800
Victoria & Albert Museum, London

Horse with head raised, Tang Dynasty, pottery
Pferd mit erhobenem Kopf, Tang-Dynastie, Keramik
Paard met opgeheven hoofd, Tang-dynastie, keramiek
Caballo con cabeza levantada, dinastía Tang, cerámica
700-800
Museo Missionario-Etnologico, Città del Vaticano

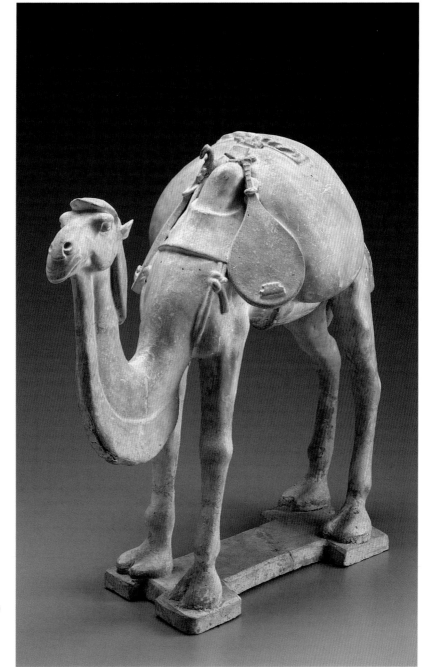

Camel with musical
instrument, Sui Dynasty,
polychrome pottery
Kamel mit
Musikinstrument, Sui-
Dynastie, mehrfarbige
Keramik
Kameel met
muziekinstrument,
Sui-dynastie, keramiek
polychroom
Camello con instrumento
musical, dinastía Sui,
cerámica polícroma
ca. 600-620
Museum of Fine Arts,
Boston

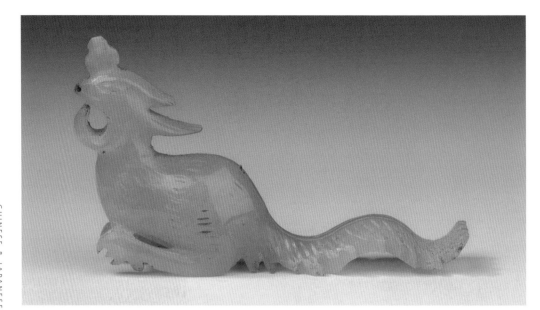

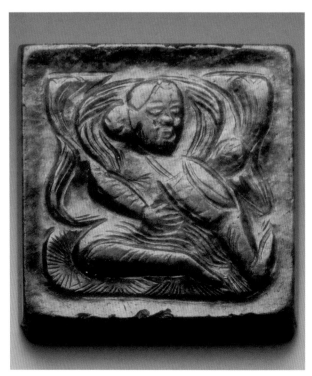

Miniature of pheonix, Tang Period, jade
Phönix-Miniatur, Tang-Epoche, Jade
Fenix miniatuur, Tang-periode, jade
Miniatura de fénix, período Tang, jade
618-907
Museum of East Asian Art, Bath

Belt plate with drum player in relief, black jade
Gürtelschnalle mit reliefartigem Trommler, Schwarze Jade
Riemplaat met trommelspeler in reliëf, zwarte jade
Placa de cinturón con un músico que toca el tambor en relieve, jade negro
618-907
Museum of East Asian Art, Bath

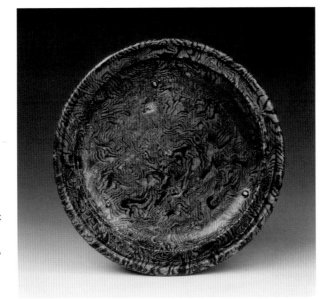

Tray for offerings, pottery
Opfergabengefäß, Keramik
Dienblad voor de offertes,
keramiek
Bandeja para las limosnas,
cerámica
684-756
Museum of East Asian
Art, Bath

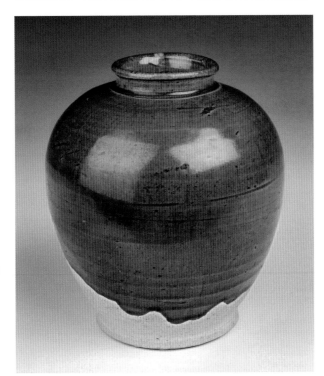

Wan nian jar with brown
glaze, pottery
Großer *wan nian*-Krug mit
brauner Glasur, Keramik
Aarden *wan nian*-kruik
met bruine glazuur,
keramiek
Tinaja vidriada marrón
wan nian, cerámica
600-800
Museum of East Asian
Art, Bath

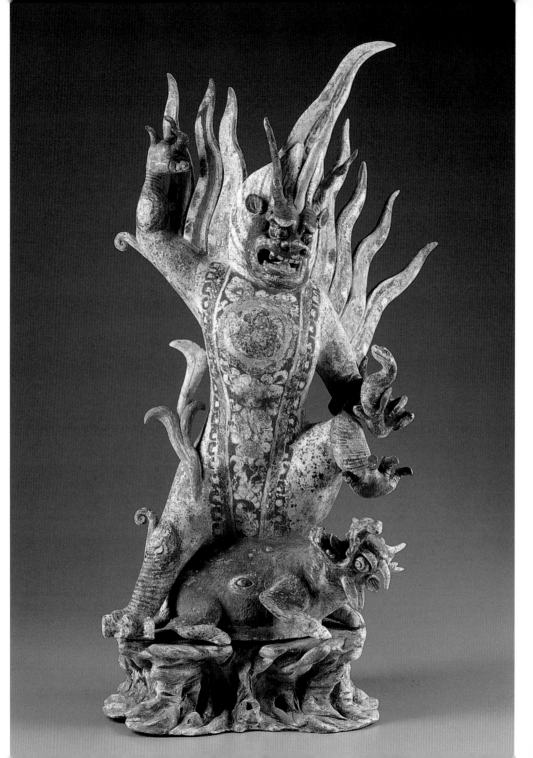

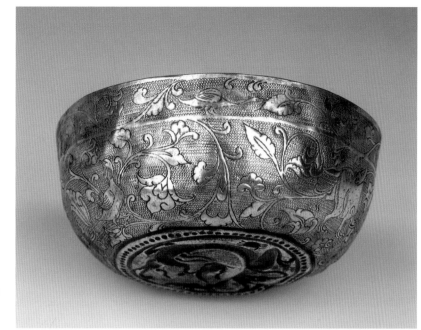

Bowl with plant and
animal motifs, silver
Schale mit Pflanzen-
und Tiermotiven, Silber
Bakje met bloem- en
diermotieven, zilver
Cuenco con motivos
vegetales y animales, plata
700
Museum of East Asian Art,
Bath

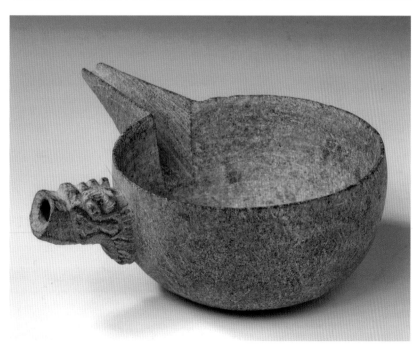

Bowl with handle of a
dragon's head, stone
Schale mit
Drachenkopfgriff, Stein
Bakje met handvat in de
vorm van een drakenhoofd,
steen
Cuenco con asa en forma
de cabeza de dragón,
piedra
618-907
Museum of East Asian Art,
Bath

◀ Spirit of the earth,
pottery
Erdgeist, Keramik
Landgeest, keramiek
Espíritu de la tierra,
cerámica
ca. 700-750
Kimbell Art Museum,
Fort Worth

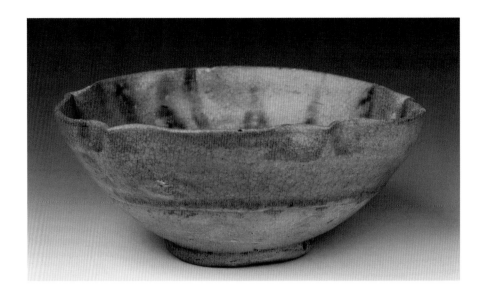

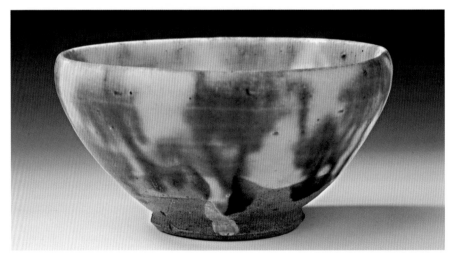

Bowl of Changsha of the Five Dynasties Period, pottery
Changsha-Schale aus dem Zeitalter der Fünf Dynastien, Keramik
Changsha-bakje uit de periode van de Vijf Dynastieén, keramiek
Cuenco de Changsha del período de las Cinco Dinastías, cerámica
ca. 900
Museum of East Asian Art, Bath

Bowl with green glaze, Liao Dynasty, pottery
Schale mit grüner Glasur, Liao-Dynastie, Keramik
Bakje met groene glazuur, Liao-dynastie, keramiek
Cuenco vidriado verde, dinastía Liao, cerámica
1000-1100
Museum of East Asian Art, Bath

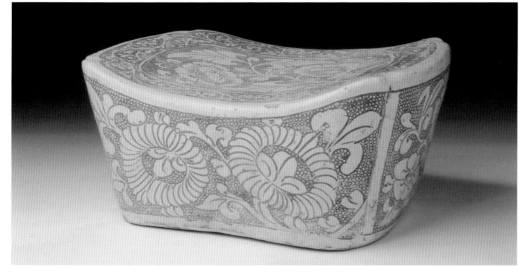

▌ The techniques of Chinese ceramics, certainly one of the most advanced in the world for many centuries, reached not only results of excellence, but were also imitated and copied by neighboring cultures.

▌ Die Techniken der chinesischen Keramik, mit Sicherheit viele Jahrhunderte lang die ausgefeiltesten der ganzen Welt, erzielten nicht nur hervorragende Ergebnisse, sondern wurden auch von den umliegenden Kulturen imitiert oder aufgenommen.

▌ De technieken van de Chinese keramiek waren eeuwenlang zonder twijfel de meest geavanceerde ter wereld. De resultaten waren niet alleen buitengewoon maar ze werden ook door de nabijgelegen beschavingen nagemaakt of overgenomen.

▌ Las técnicas de la cerámica china, ciertamente las más avanzadas del mundo por muchos siglos, no sólo alcanzaron resultados de excelencia, sino que fueron también imitadas o retomadas por las civilizaciones vecinas.

Cizhou cushion, pottery
Cizhou-Kissen, Keramik
Cizhou-kussen, keramiek
Almohada cizhou, cerámica
900-1100
Museum of East Asian Art, Bath

Yue vase, pottery
Yue-Vase, Keramik
Yue-vaas, keramiek
Jarrón yue, cerámica
900
Museum of East Asian Art, Bath

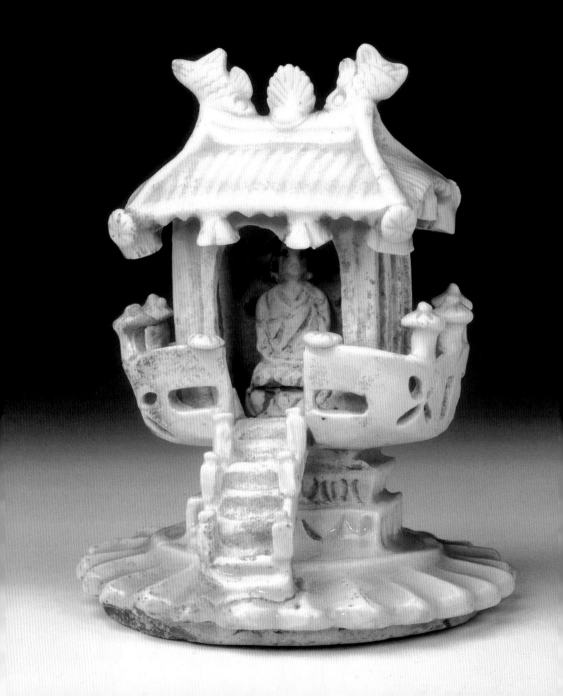

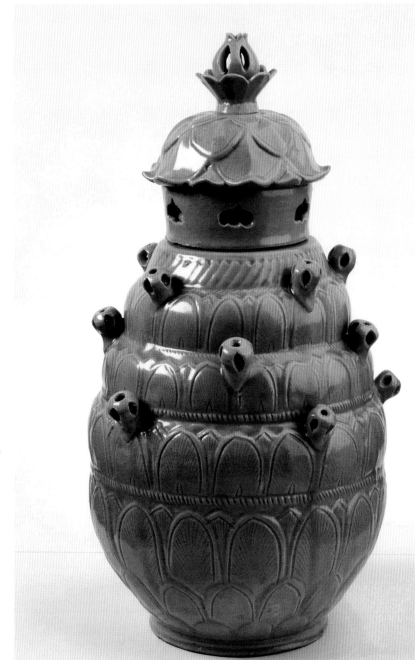

Funerary urn, celadon pottery
Graburne, Keramik celadon
Grafurn, celadon keramiek
Urna funeraria, cerámica
celadon
910-1100
Victoria & Albert Museum,
London

◄ Small temple with white
glaze, pottery
Kleiner Tempel mit weißer
Lasur, Keramik
Kleine tempel met witte
glazuur, keramiek
Templete vidriado blanco,
cerámica
1000
Museum of East Asian Art,
Bath

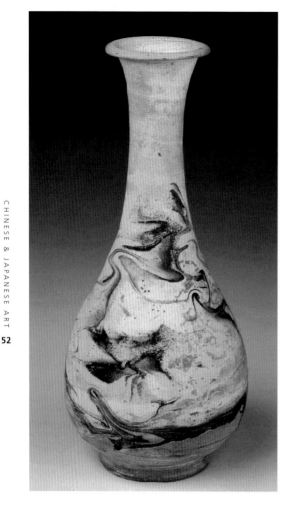 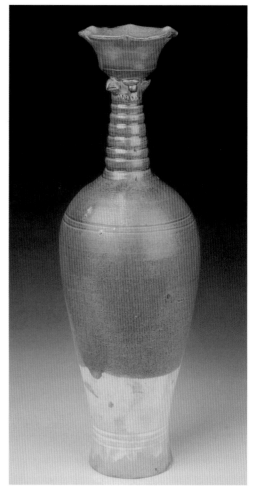

Cizhou vase in the shape of a pear, pottery
Cizhou-Vase in Birnenform, Keramik
Peervormige cizhou-vaas, keramiek
Jarrón cizhou en forma de pera, cerámica
ca. 1000
Museum of East Asian Art, Bath

Vase with head of phoenix, Liao Dynasty, pottery
Vase mit Phönixkopf, Liao-Dynastie, Keramik
Vaas met fenixhoofd, Liao-dynastie, keramiek
Jarrón con cabeza de fénix, dinastía Liao, cerámica
900-1100
Museum of East Asian Art, Bath

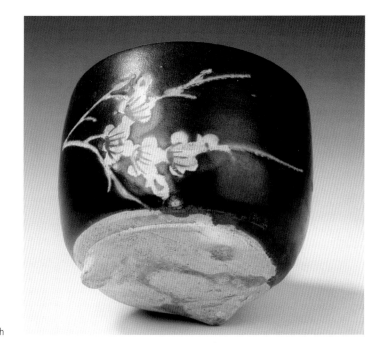

Jizhou vase, Southern Song Period, pottery
Jizhou-Vase, Epoche der Südlichen Song, Keramik
Jizhou-vaas, Zuidelijke Song-periode, keramiek
Jarrón *jizhou*, período de los Song Meridionales, cerámica
1200
Museum of East Asian Art, Bath

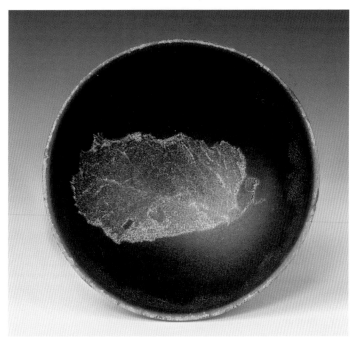

Jizhou bowl with design of the skeleton of a leaf, pottery
Jizhou-Schale mit Blattmuster, Keramik
Jizhou-bakje met tekening van een bladskelet, keramiek
Cuenco *jizhou* con dibujo del esqueleto de una hoja, cerámica
1100
Museum of East Asian Art, Bath

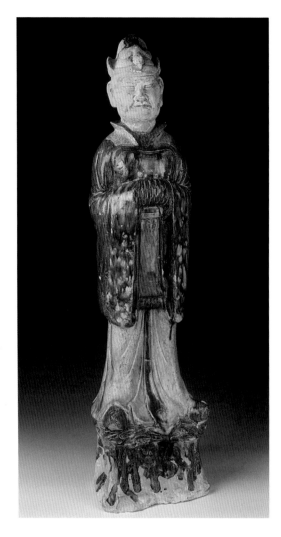

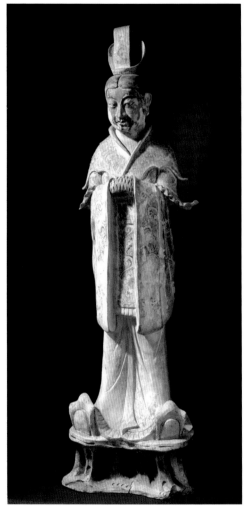

Figure of Khotan-type official, pottery
Figur eines Beamten des Khotanese-Typs, Keramik
Figuur van een officier van het Khotan-type, keramiek
Figura de un oficial del tipo khotanés, cerámica
684-756
Museum of East Asian Art, Bath

Model of a courtier of the Tang Dynasty
Modell einer Kurtisane aus der Tang-Dynastie
Model van een hoveling van de Tang-dynastie
Modelo de un cortesano de la dinastía Tang
618-907
Victoria & Albert Museum, London

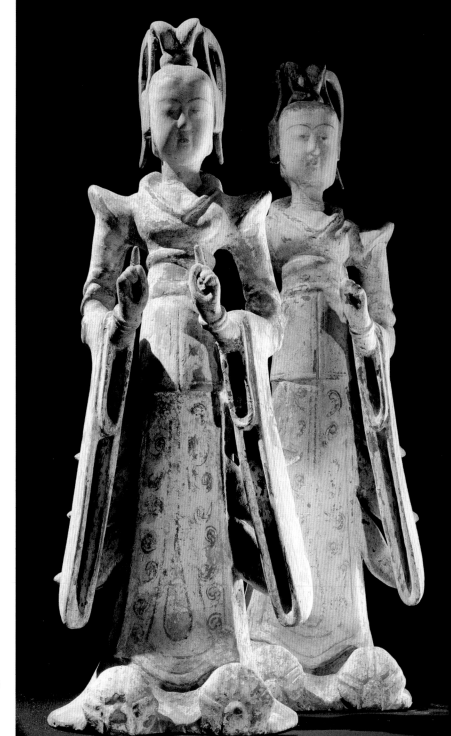

Two models of Tang
princesses, pottery
Zwei Modelle von Tang-
Prinzessinen, Keramik
Twee modellen van
Tang-prinsessen,
keramiek
Dos modelos de
princesas Tang, cerámica
618-907
Art Gallery of New South
Wales, Sydney

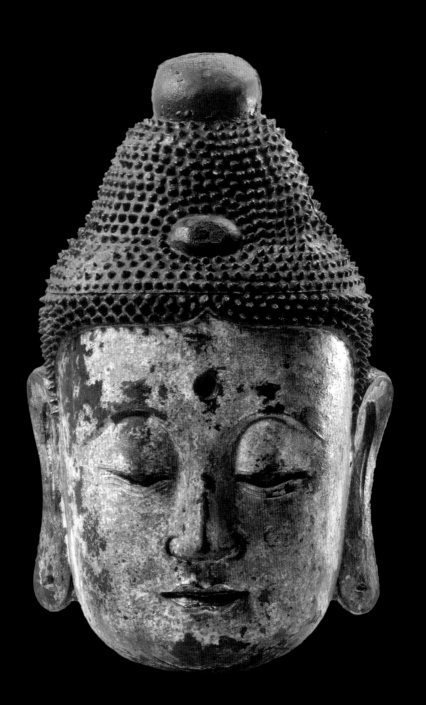

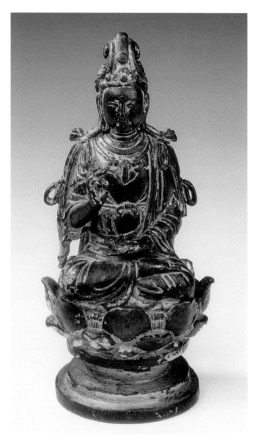
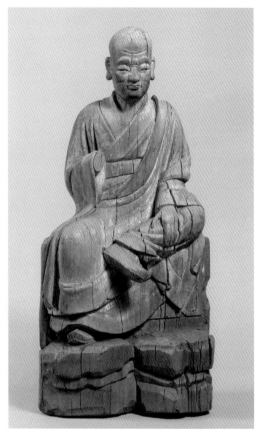

Statue of Bodhisattva seated on a lotus, Liao Dynasty, gilt bronze
Bodhisattva-Statue, auf einem Lotus sitzend, Liao-Dynastie,
vergoldete Bronze
Beeld van Bodhisattva zittend op een lotuszetel, Liao-dynastie,
verguld brons
Estatua de Bodhisattva sobre un asiento de lotos, dinastía Liao,
bronce dorado
ca. 1050
Museum of East Asian Art, Bath

◀ Head of Buddha, bronze and kaolin
Buddhakopf, Bronze und Kaolin
Boeddhahoofd, brons en kaolien
Cabeza de Buda, bronce y caolín
700-900
Victoria & Albert Museum, London

Buddhist monk, Song Dynasty
Buddhistischer Mönch, Song-Dynastie
Boeddhistische monnik, Song-dynastie
Monje budista, dinastía Song
960-1279
Museo Nazionale d'Arte Orientale "G. Tucci", Roma

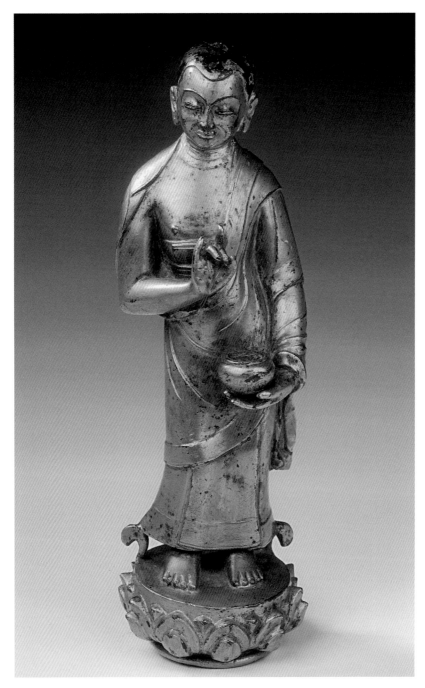

Monk with bowl for
begging, Yuan Dynasty,
gilt bronze
Mönch mit Almosenschale,
Yuan-Dynastie, vergoldete
Bronze
Monnik met een
bedelbakje, Yuan dynastie,
verguld brons
Monje con cuenco para
las limosnas, dinastía
Yuan, bronce dorado
1300
Museum of East Asian
Art, Bath

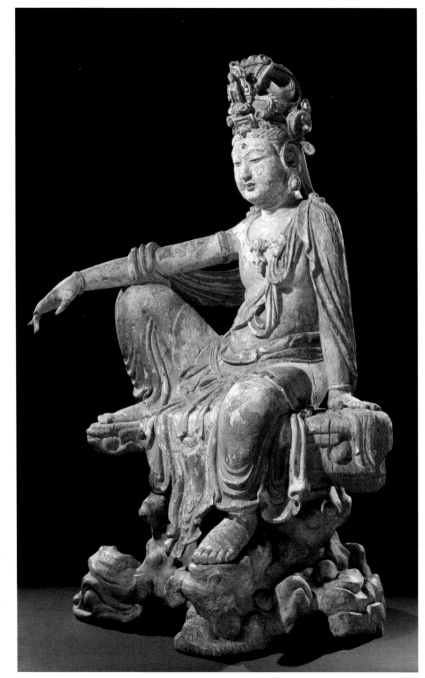

The Bodhisattva Guanyin,
lacquered wood
Der Bodhisattva
Guanyin, lackiertes Holz
De Bodhisattva Guanyin,
gelakt hout
El Bodhisattva Guanyin,
madera lacada
1115-1234
Victoria & Albert
Museum, London

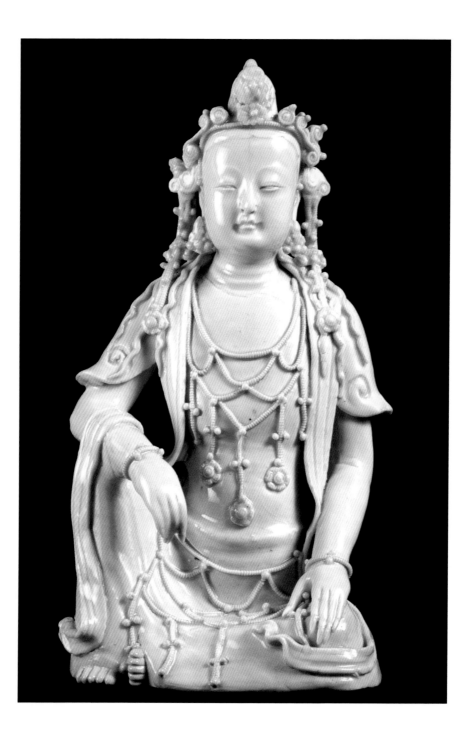

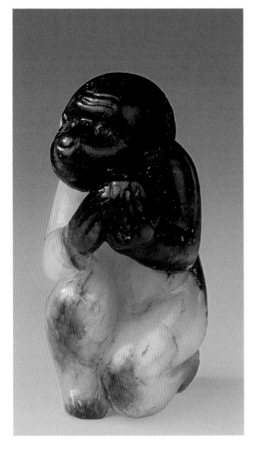

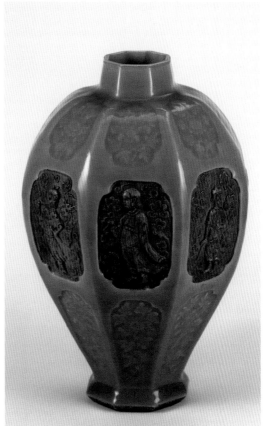

Monkey with a peach, jade
Affe mit einem Pfirsich, Jade
Aap met een perzik, jade
Mono con un melocotón, jade
1200-1400
Museum of East Asian Art, Bath

◀ Guanyin, the Bodhisattva of compassion, pottery
Guanyin, der Bodhisattva der Barmherzigkeit, Keramik
Guanyin, de Bodhisattva van de genade, keramiek
Guanyin, el Bodhisattva de la misericordia, cerámica
1300-1400
Victoria & Albert Museum, London

Vase depicting the Eight Immortal Taoists, pottery
Vase mit Darstellung der acht taoistischen Unsterblichen, Keramik
Vaas met de Acht Onsterfelijke Taoïsten, keramiek
Jarrón con imágenes de los Ocho Inmortales taoístas, cerámica
ca. 1350
Philadelphia Museum of Art, Philadelphia

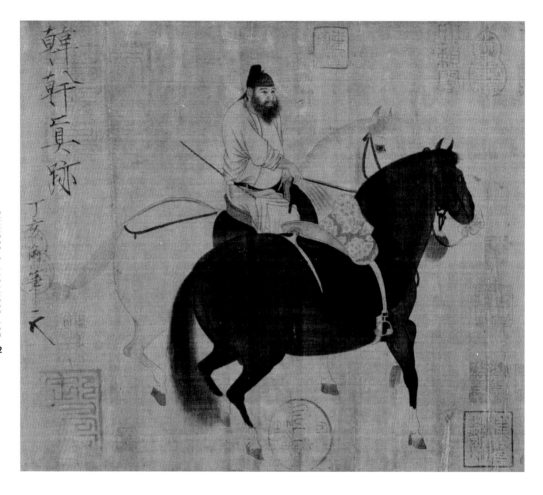

Two horses and a groom
Zwei Pferde und ein Reitknecht
Twee paarden een een palfrenier
Dos caballos y un palafrenero
ca. 700-800
National Palace Museum, Taiwan

▌ *Han Gan, painter at the Tan Court, known for his Buddhist-inspired works, is remembered especially for his paintings of horses, source of inspiration for many subsequent artists.*
▌ *Han Gan, der für seine buddhistisch inspirierten Werke bekannte Hofmaler der Tang, wird vor allem wegen seiner Pferdegemälde erwähnt, welche vielen späteren Künstlern als Inspirationsquelle dienten.*
▌ *Han Gan, de schilder aan het Tang-hof staat bekend voor zijn boeddhistisch geïnspireerde werken en wordt voornamelijk herinnerd voor zijn schilderijen van paarden, inspiratiebron voor vele volgende kunstenaars.*
▌ *Han Gan, pintor en la corte de los Tang, conocido por sus obras de inspiración budista, es recordado sobre todo por sus pinturas de caballos, fuente de inspiración para muchos artistas que lo sucedieron.*

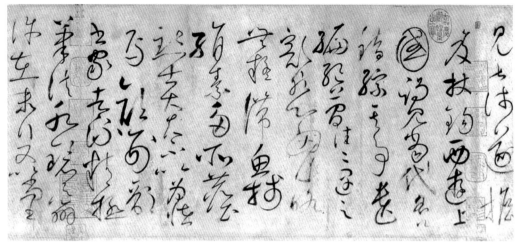

Autobiographical paper
Autobiografische Schrift
Autobiografisch geschrift
Escrito autobiográfico
ca. 777
National Palace Museum, Taiwan

Section of a scroll with cursive style writing
Teil einer Rolle mit Kalligrafie in Kursivschrift
Deel van een rol met in cursief geschreven tekst
Parte de un rollo con caligrafía en estilo cursivo
ca. 750-800
National Palace Museum, Taiwan

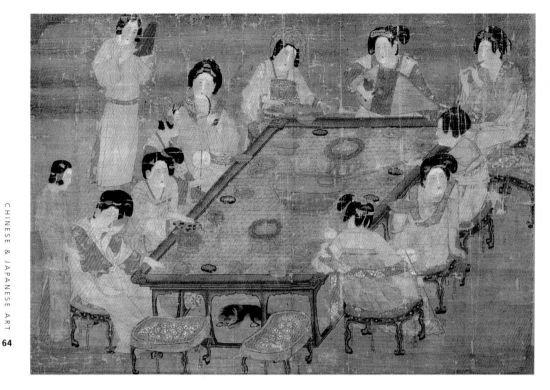

▌ *As for many other aspects of civilian and religious reality, painting generously provides the opportunity to understand the life of the Imperial Court and the nobility.*
▌ *Wie für viele weitere Aspekte des bürgerlichen und religiösen Lebens liefert die Malerei eine Vielzahl von Möglichkeiten, das Leben am kaiserlichen Hof und des Adels nachzuvollziehen.*
▌ *Net zoals vele andere aspecten van het gewone leven en de religie, kan het leven aan het keizerlijk hof en van de adel via de schilderkunst beter begrepen worden.*
▌ *Como en muchos otros aspectos de la realidad civil y religiosa, la pintura ofrece con generosidad la posibilidad de comprender la vida de la corte imperial y de la nobleza.*

Banquet and concert at the Imperial Tang Court
Bankett und Konzert am kaiserlichen Hof der Tang
Banket en concert aan het keizerlijke Tang-hof
Banquete y concierto en la corte imperial Tang
900-1000
National Palace Museum, Taiwan

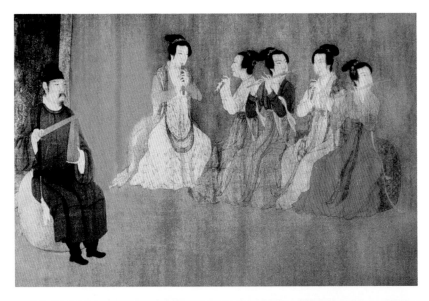

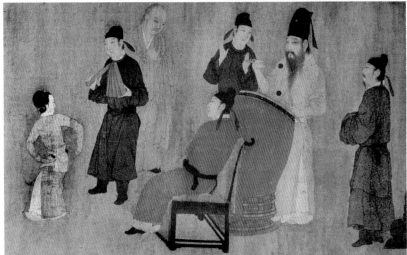

Gu Hongzhong
The Night Revels of Han Xizai, detail with flute players
Die Nachtfeier von Han Xizai, Detail mit Flötenspielerinnen
Nachtelijke Feesten van Han Xizai, detail met fluitspeelsters
La Fiesta Nocturna de Han Xizai, detalle con flautistas
907-960
Palace Museum, Beijing

Gu Hongzhong
The Night Revels of Han Xizai, detail showing the dance of Wang Wushan
Die Nachtfeier von Han Xizai, Detail, das den Tanz von Wang Wushan darstellt
Nachtelijke Feesten van Han Xizai, detail van de dans van Wang Wushan
La Fiesta Nocturna de Han Xizai, detalle que muestra la danza de Wang Wushan
907-960
Palace Museum, Beijing

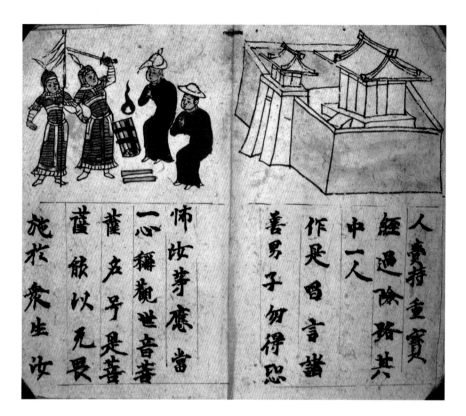

■ *The Mogao Grottoes, at Dunhuang, oasis on the Silk Road, form a system of 492 temples and Buddhist shrines built over the span of a millennium starting in 366 CE.*
■ *Die Mogao-Grotten in Dunhuang, Oasen an der Seidenstraße, bilden ein System aus 492 buddhistischen Tempeln und Heiligtümern, die innerhalb eines Jahrtausend seit 366 gebaut wurden.*
■ *De Mogao-grotten in Dunhuang, oase aan de Zijderoute, vormen vanaf het jaar 366 een millennium lang een geheel van 492 tempels en boeddhistische heiligdommen.*
■ *Las grutas de Mogao, en Dunhuang, oasis sobre la Ruta de la Seda, forman un sistema de 492 templos y sagrarios budistas construidos a lo largo de un milenio a partir del 366 d.C.*

Two monks pleading for their life, from *The Lotus Sutra*
Zwei Mönche beweinen das eigene Leben, aus dem *Lotos-Sutra*
Twee monniken smeken voor hun eigen leven, uit de *Lotus Sutra*
Dos monjes imploran por su propia vida, del *Sutra del Loto*
900
British Library, London

▶ **Dunhuang**
Fresco from the Grottoes of Mogao depicting the *Thousand Buddhas*
Fresko aus den Grotten von Mogao, das die *Tausend Buddha* darstellt
Fresco van de Mogao-grotten van de *Duizend Boeddha's*
Fresco de las grutas de Mogao que representa los *Mil Budas*
1100

*Clear autumn sky on valleys
and mountains*, ink and
paint on silk
Klarer *Herbsthimmel
über Berg und Tal*, Tinte
und Malerei auf Seide
*Heldere herfsthemel boven
valleien en bergen*, inkt en
verf op zijde
*Límpido cielo de otoño
sobre valles y montañas*,
tinta y pintura sobre seda
1072
Smithsonian Institution,
Freer Gallery of Art,
Washington D.C.

Mongol rider following a horse, Yuan Dynasty
Mongolischer Reiter, der ein Pferd verfolgt, Yuan-Dynastie
Mongoolse ruiter die een paard volgt, Yuan-dynastie
Jinete mongol persiguiendo a un caballo, dinastía Yuan
1206-1368
Musée Guimet, Paris

The Dragon King paying tribute to the Buddha, ink and paint on silk
Der Drachenkönig ehrt Buddha, Tinte und Malerei auf Seide
Drakenkoning eert Boeddha, inkt en verf op zijde
El Rey Dragón rinde homenaje al Buda, tinta y pintura sobre seda
ca. 1300
Museum of Fine Arts, Boston

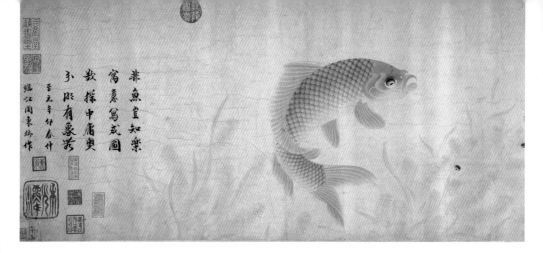

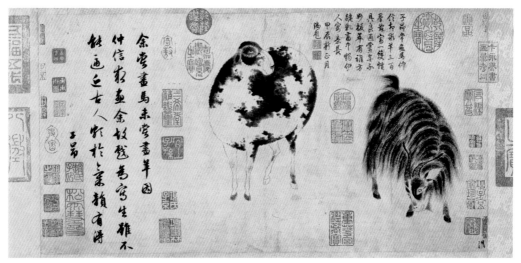

▌ The depictions of animals, linked to astrology, mythology and also daily life reach great subtlety and precision in Chinese art, the fruit of careful observation of nature.

▌ Die Darstellungen von Tieren in Verbindung mit der Astrologie, der Mythologie und auch des alltäglichen Lebens erreichen in der chinesischen Kunst ein Höchstmaß an Raffinesse und Präzision, was vor allem an der aufmerksamen Naturbeobachtung liegt.

▌ De dierenafbeeldingen zijn verbonden met de astrologie, mythologie en ook met het dagelijkse leven. De geraffineerde en nauwkeurige weergave hiervan is in de Chinese kunst het resultaat van het nauwkeurig observeren van de natuur.

▌ Las representaciones animales, vinculadas a la astrología, la mitología y también a la cotidianeidad, alcanzan en el arte chino un gran refinamiento y precisión, fruto de la observación atenta de la naturaleza.

The enjoyment of the fish, detail
Die Freude der Fische, Detail
Het plezier van de vissen, detail
El placer de los peces, detalle
1291
The Metropolitan Museum of Art, New York

Sheep and goat and detail, ink on paper
Schaf und Ziege und Detail, Tinte auf Papier
Schaap en geit en detail, inkt op papier
Oveja y cabra y detalle, tinta sobre papel
ca. 1300
Smithsonian Institution, Freer Gallery of Art, Washington D.C.

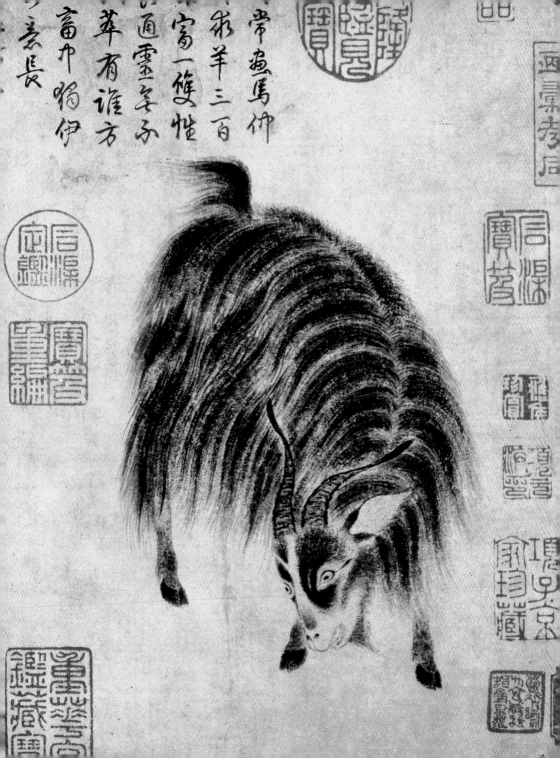

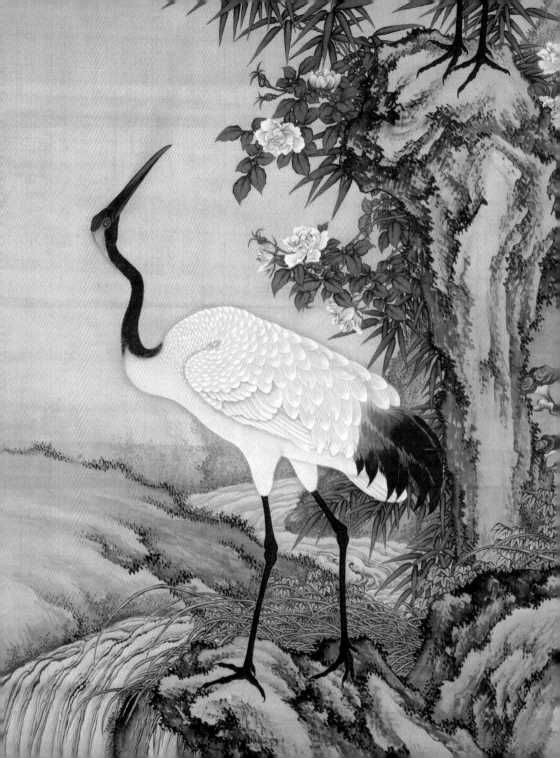

The clash and encounter of civilizations

For many years and also today, China's image in the West has corresponded to the Ming Dynasty (1368-1644). It is during this period that China, which was always at the center of Western political and commercial interests, became the subject of intense trade with Portuguese merchants (1557) from the Macao area. At the time, each year numerous ships departed. They were loaded with porcelain, some of which was sold in Asia, while the rest was sold in Europe. Ceramics, porcelain, painting and lacquer art became highly refined.

Miteinander und Gegeneinander der Kulturen

Lange Zeit und zum größten Teil auch noch heute entspricht das Bild, das man im Westen von China hat, dem der Ming-Dynastie (1368-1644). Eben in dieser Epoche wurde das chinesische Territorium, das schon immer im Mittelpunkt der gewerblichen und politischen Interessen des Westens war, nämlich Gegenstand intensiver Handelsverbindungen mit der Konzession des Gebiets von Macao an die portugiesischen Kaufleute (1557). Diesen Hafen verließen jedes Jahr zahlreiche mit Porzellan beladene Schiffe, das zum Teil in den asiatischen Gebieten veräußert wurde und zum Teil bis nach Europa gelangte. Die Keramik, das Porzellan und die Lackkunst erreichten ein Niveau von großer Raffinesse.

3

Botsing en ontmoeting van de samenleving

Lange tijd, en grotendeels nog steeds, komt het beeld van China in het Westen overeen met die van de Ming-dynastie (1368-1644). Het is in die tijd, in feite, dat het Chinese grondgebied, altijd al het centrum van de commerciële en politieke belangen van het Westen, het onderwerp werd van intense handel door de toekenning van de Portugese handelaars (1557) op het grondgebied van de Macau. Vanaf daar vertrekken ieder jaar een deel van de vele boten beladen met porselein, waarvan sommige handelden in de Aziatische gebieden en een deel ging terug naar Europa. Keramiek, porselein, schilderkunst en de kunst van het lakken bereikte niveaus van grote verfijning.

Choque y encuentro de civilizaciones

Durante un largo tiempo, y en buena medida todavía hoy, la imagen de China en Occidente corresponde a la de la dinastía Ming (1368-1644). Y es justamente en dicha época que el territorio chino, desde siempre en el centro de los intereses comerciales y políticos de Occidente, se convirtió en objeto de intensos intercambios comerciales con la concesión a los mercaderes portugueses (1557) del territorio de Macao. Desde allí partían cada año numerosas naves cargadas de porcelanas, que en parte eran vendidas en los territorios asiáticos, y en parte llegaban a Europa. La cerámica, la porcelana, la pintura y el arte de la laca alcanzaron niveles de gran refinamiento.

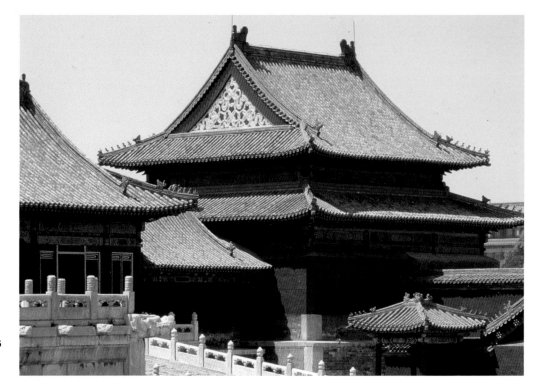

■ The Forbidden City, in Peking (Beijing), Imperial seat of the Ming and Qing Dynasties, represents the high point of Chinese nobiliary architecture and an example for similar architectures in China and Eastern Asia.
■ Die Verbotene Stadt in Peking (Beijing), der kaiserliche Sitz der Dynastie Ming und Qing stellt den Höhepunkt der chinesischen, adeligen Architektur dar und ein Vorbild für entsprechende Architekturen in China und Ostasien.
■ De Verboden Stad in Peking (Beijing), de plaats waar de keizers tijdens de Ming- en Qing-dynastie het rijk bestuurden, wordt beschouwd als het toppunt van de Chinese adellijke architectuur en dient als voorbeeld voor vergelijkbare architecturen in China en Oost-Azië.
■ La Ciudad Prohibida, en Pekín (Beijing), sede imperial de las dinastías Ming y Qing, representa el punto más alto de la arquitectura nobiliaria china y al mismo tiempo un ejemplo para obras de arquitectura similares en China y en el Asia Oriental.

◀ Beijing
Pavilions of the Forbidden
City, Imperial seat for five
centuries
Pavillone der Verbotenen
Stadt, Sitz des Kaisers für
fünf Jahrhunderte
Paviljoen van de Verboden
Stad, vijf eeuwen lang de
keizerlijke zetel
Pabellones de la Ciudad
Prohibida, sede imperial
durante cinco siglos

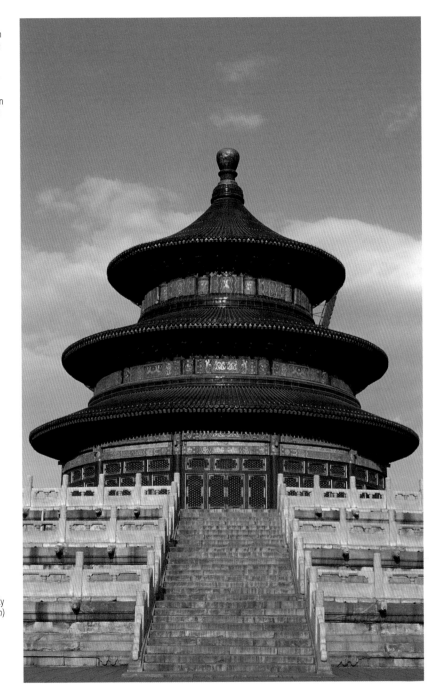

Beijing
Temple of Heaven (*Tian
Tan*) in the Forbidden City
Himmelstempel (*Tian Tan*)
in der Verbotenen Stadt
Hemeltempel (*Tian Tan*)
in de Verboden Stad
Templo del Cielo
(*Tian Tan*) en la Ciudad
Prohibida

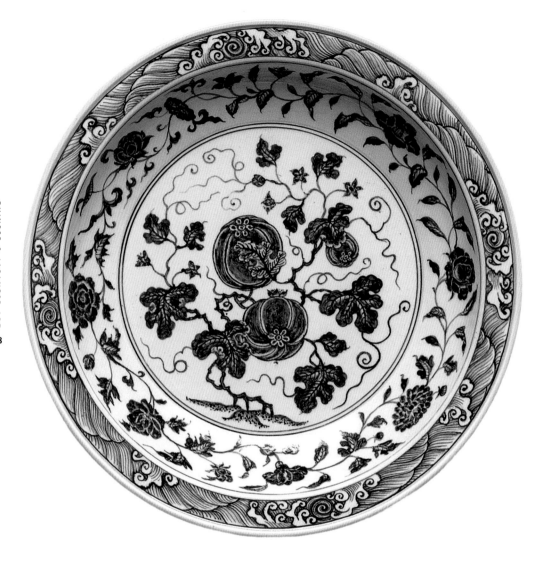

Plate with melon design of the Ming Period, pottery
Teller mit Melonenmuster aus der Ming-Epoche, Keramik
Bord met tekening van meloenen uit de Ming-periode, keramiek
Plato con dibujo de melones del período Ming, cerámica
ca. 1400-1410
Kimbell Art Museum, Fort Worth

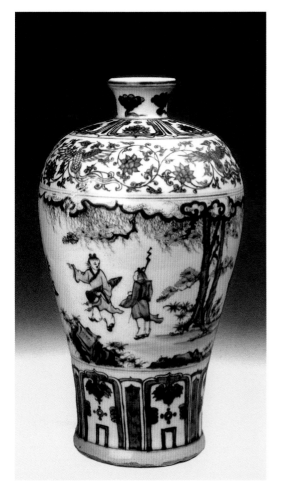

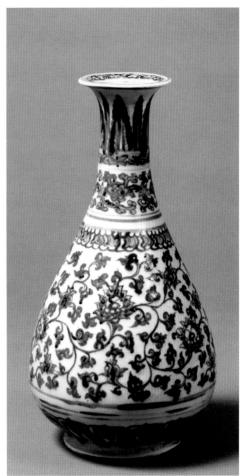

Meiping vase, pottery
Meiping-Vase, Keramik
Meiping-vaas, keramiek
Jarrón *meiping*, cerámica
ca. 1450
Museum of East Asian Art, Bath

White and blue vase of the Ming Period, porcelain
Weiße und blaue Vase aus der Ming-Epoche, Porzellan
Witte en blauwe vaas uit de Ming-periode, porselein
Jarrón azul y blanco del período Ming, porcelana
ca. 1500-1525
Museo degli Argenti, Palazzo Pitti, Firenze

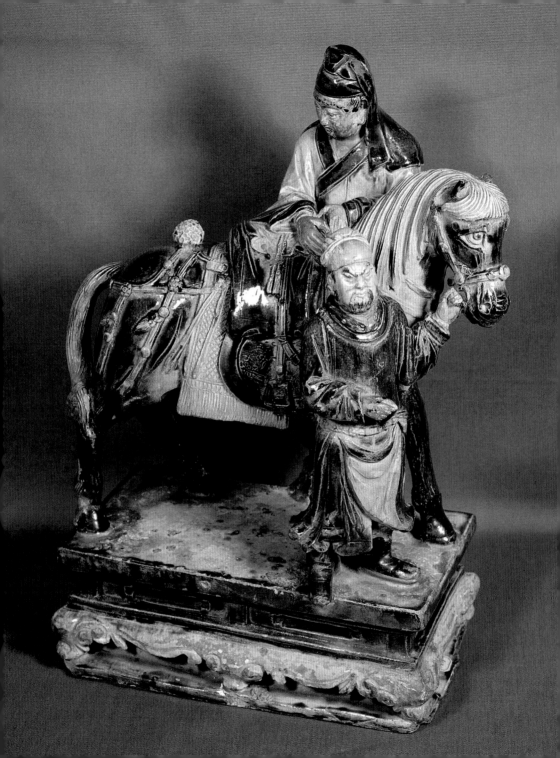

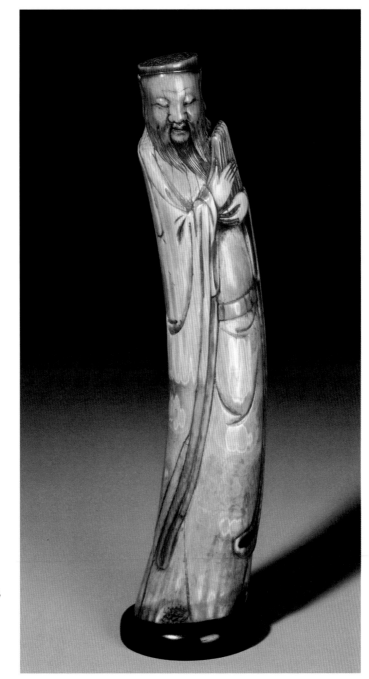

Immortal Taoist with
flute, ivory
Taoistischer
Unsterblicher mit Flöte,
Elfenbein
Onsterfelijke taoïst met
fluit, ivoor
Inmortal taoísta con
flauta, marfil
ca. 1550-1644
Museum of East Asian
Art, Bath

◀ Horseman of the
Ming Period, porcelain
Reiter der Ming-Epoche,
Porzellan
Ruiter uit de Ming-
periode, porselein
Caballero del período
Ming, porcelana
ca. 1600-1644
Musée Guimet, Paris

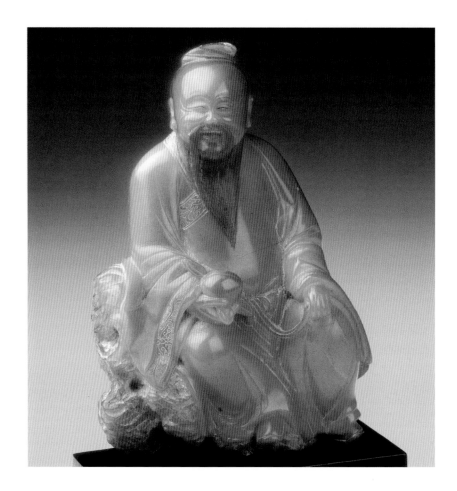

Yuxuan Yang
(1600)
Figure of Dongfang Shuo, scholar of the Han Period, soapstone
Dongfang Shuo, Schriftsteller der Han-Epoche, Seifenstein
Figuur van Dongfang Shuo, letterkundige uit de Han-periode, zeepsteen
Figura de Dongfang Shuo, literato del período Han, esteatita
1630-1680
Museum of East Asian Art, Bath

▶ Lady dreaming on a bench, pottery
Träumende Dame auf einer Bank, Keramik
Dromende dame op een bank, keramiek
Dama soñando sobre un banco, cerámica
1700-1800
Musée Guimet, Paris

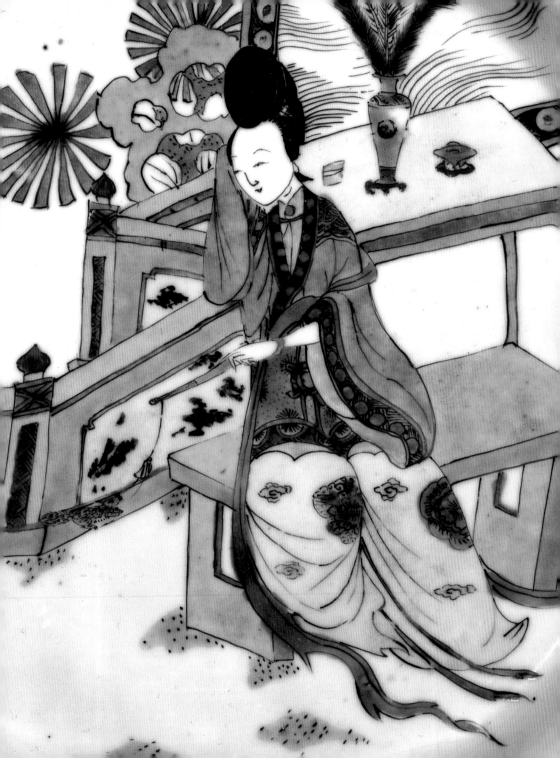

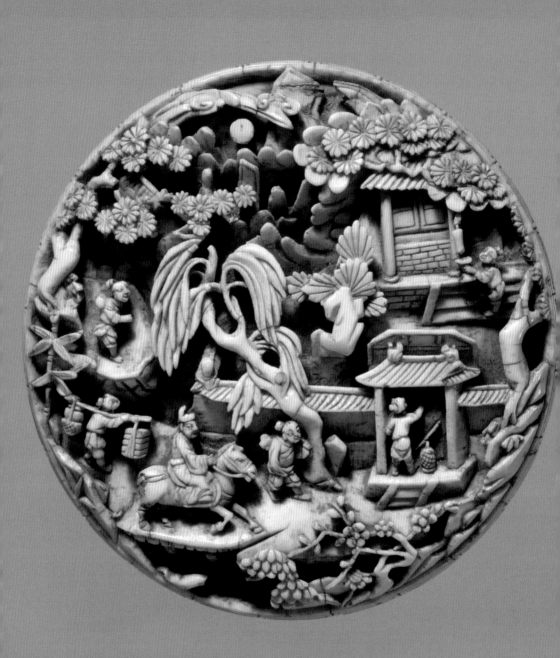

▌ *Allegories, mythological references, caricatures fuel the liveliness of the representations which, together with technical mastery, attract enthusiasts and collectors to Chinese art.*
▌ *Allegorien, mythologische Bezüge und karikative Elemente bereichern die Lebendigkeit der Darstellungen, die - im Bund mit technischer Meisterschaft - Liebhaber und Sammler für die chinesische Kunst gewinnen.*
▌ *Allegorieën, verwijzingen naar de mythologie, karikaturen zorgen voor levendige afbeeldingen die samen met technisch meesterschap gepassioneerden en verzamelaars naar de Chinese kunst aantrekken.*
▌ *Alegorías, referencias mitológicas y elementos caricaturescos alimentan la vivacidad de las representaciones que, junto a la pericia técnica, atraen a los apasionados y a los coleccionistas al arte chino.*

◀ Medallion, ivory
Medaillon, Elfenbein
Medaillon, ivoor
Medallón, marfil
ca. 1580-1620
The Metropolitan Museum of Art, New York

Medallion, ivory
Medaillon, Elfenbein
Medaillon, ivoor
Medallón, marfil
ca. 1580-1620
The Metropolitan Museum of Art, New York

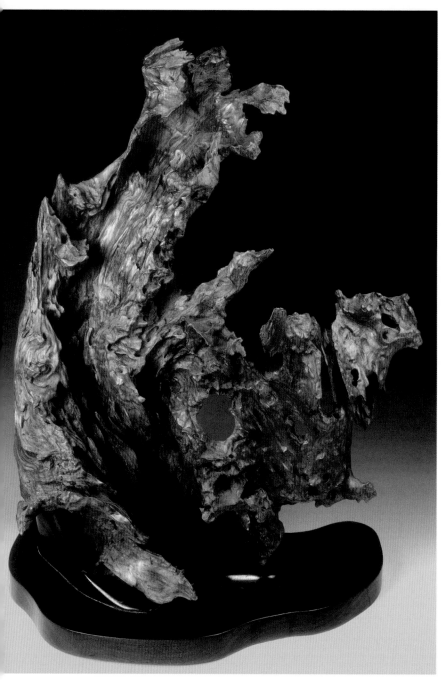

Sculpture in natural
wood of the Qing Period
Skulptur aus Naturholz
der Qing-Epoche
Sculptuur van natuurlijk
hout uit de Qing-periode
Escultura en madera
natural del período Qing
1644-1912
Museum of East Asian
Art, Bath

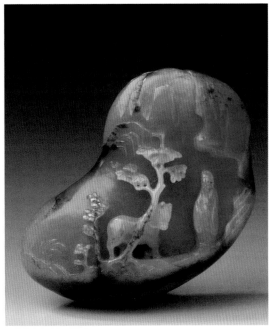

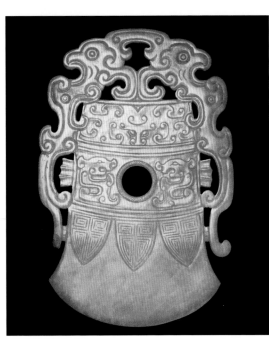

Stone with Bodhidharma, Indian Buddhist monk, jade
Kieselstein mit Darstellung des Bodhidharma, indischer
buddhistischer Mönch, Jade
Steen met Bodhidharma, Indiase boeddhistische monnik, jade
Guijarro con Bodhidharma, monje budista hindú, jade
1662-1772
Museum of East Asian Art, Bath

Carved stone, jade
Gemeißelter Kieselstein, Jade
Ingesneden steen, jade
Guijarro tallado, jade
ca. 1680-1700
Museum of East Asian Art, Bath

Plate in the shape of an axe, jade
Relief in Axtform, Jade
Plaat in bijlvorm, jade
Placa en forma de hacha, jade
1700-1800
Victoria & Albert Museum, London

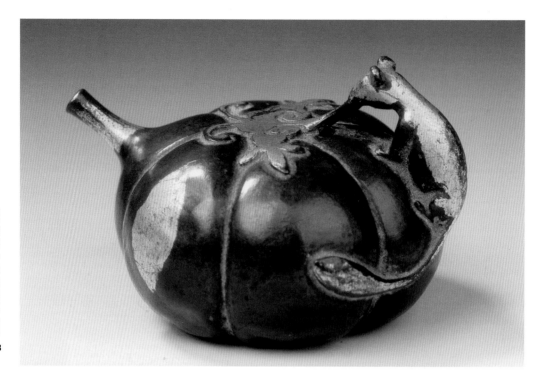

▶ Container for water with boy on the edge, bronze
Wasserbehältnis mit Jüngling am Rand, Bronze
Waterbak met jongen die de rand vasthoudt, brons
Recipiente para el agua con muchacho en el borde, bronce
ca. 1500-1510
Museum of East Asian Art, Bath

Jug for water, gilt bronze
Wasserkessel, vergoldete Bronze
Watergieter, verguld brons
Jarra para el agua, bronce dorado
1600-1644
Museum of East Asian Art, Bath

▶ Box decorated with a crane among the clouds, gilt bronze
Schatulle mit Darstellung eines Kranichs zwischen den Wolken, vergoldete Bronze
Versierd doosje met een kraanvogel in de wolken, verguld brons
Caja decorada con una grulla entre las nubes, bronce dorado
ca. 1550-1600
Museum of East Asian Art, Bath

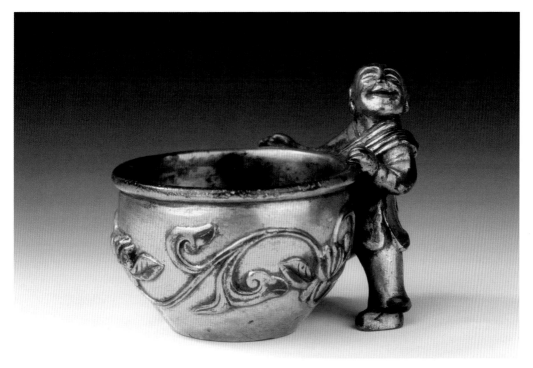

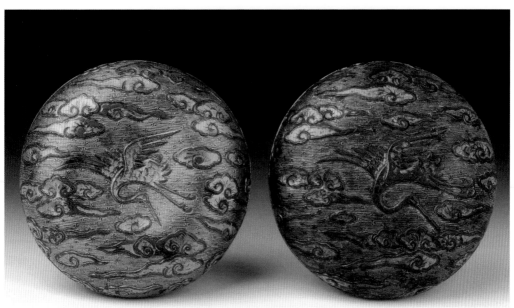

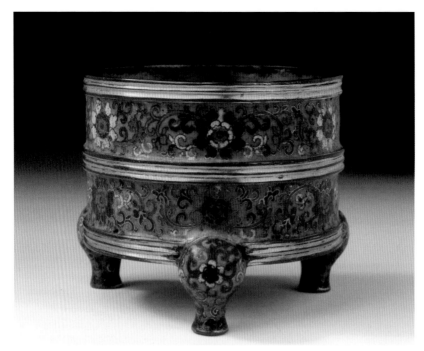

Tripod incense burner,
Qing Dynasty, copper
and enamel
Rauchfass mit drei
Füßen, Qin-Dynastie,
Kupfer und Email
Drievoets wierookvat,
Qing-dynastie, koper en
email
Inciensario con base
trípode, dinastía Qing,
cobre y esmalte
1700-1800
Museum of East Asian
Art, Bath

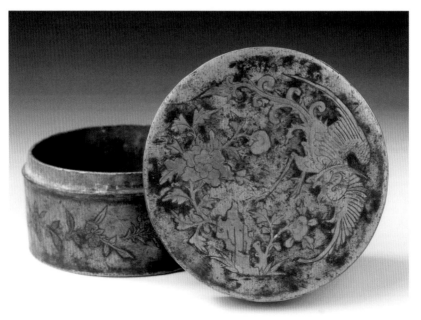

Box with lid, gilt pewter
Schatulle mit Deckel,
vergoldetes Zinn
Doos met deksel, verguld
engeltjestin
Caja con tapa, peltre
dorado
1650-1720
Museum of East Asian
Art, Bath

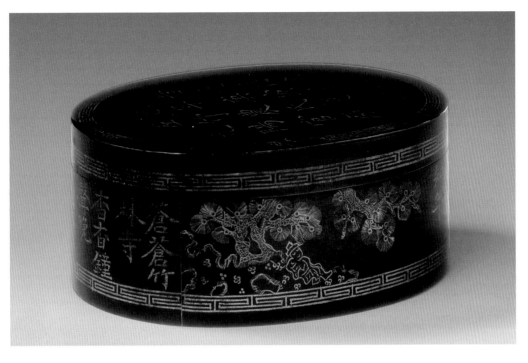

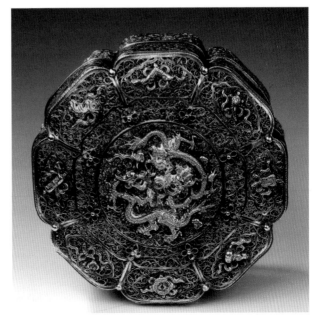

Ink box, pewter with silver inserts
Schatulle für Tinte, Zinn mit Silbereinfassungen
Inktdoos, engeltjestin met zilver
Caja para la tinta, peltre con incrustaciones de plata
1881
Museum of East Asian Art, Bath

Box with dragon motifs, silver filigree
Schatulle mit Drachenmotiven, Silberfiligranarbeit
Doos met drakenmotief, zilveren filigraan
Caja con motivos de dragones, filigrana de plata
ca. 1790-1810
Museum of East Asian Art, Bath

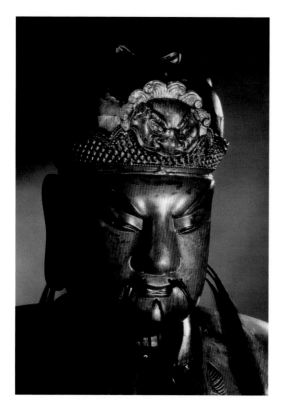

▋ The abilities of the Chinese sculptors and carvers found their greatest accomplishment, both in figurative and abstract themes, in wood, a malleable and readily available material.

▋ In Holz, einem leicht zu bearbeitenden und gut auffindbaren Material, konnten chinesische Bildhauer und Drucker die höchste Vollendung ihrer Fähigkeiten finden, sowohl in figürlichen, als auch in abstrakten Themen.

▋ De bekwaamheid van de Chinese beeldhouwers en graveurs wordt door het soepele en makkelijk vindbare hout voltooid, zowel in figuratieve als abstracte thema's.

▋ En la madera, material dúctil y fácilmente localizable, las capacidades de los escultores y grabadores chinos han encontrado su máxima expresión, tanto en temas figurativos como abstractos.

Guan Di, Taoist God of War, lacquered and gilt wood
Guan Di, taoistische Kriegsgottheit, lackiertes und vergoldetes Holz
Guan Di, taoïstische god van de oorlog, gelakt en verguld hout
Guan Di, divinidad taoísta de la guerra, madera lacada y dorada
1640-1700
Victoria & Albert Museum, London

Zhu Zhizheng
(1559 - 1619)
Incense holder, detail, bamboo
Räucherstäbchenhalter, detail, Bambus
Wierookhouder, detail, bamboe
Inciensario, detalle, bambú
1602
Museum of East Asian Art, Bath

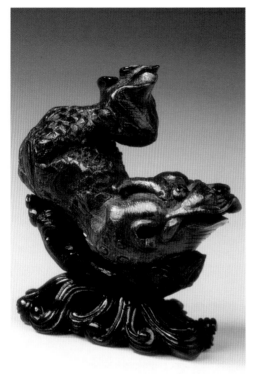

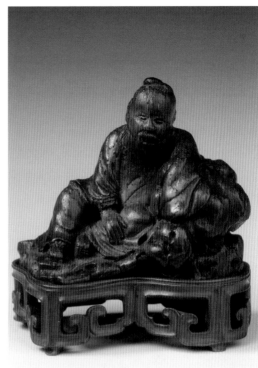

Carp carved into bamboo
Aus Bambus geschnitzter Karpfen
Een karper in bamboe uitgesneden
Carpa tallada en bambú
ca. 1650-1700
Museum of East Asian Art, Bath

Scholar leaning on a rock, bamboo
Gelehrter, an einen Felsen gelehnt, Bambus
Geleerde leunend op een rots, bamboe
Estudioso apoyado en una roca, bambú
ca. 1662 - *ca.* 1762
Museum of East Asian Art, Bath

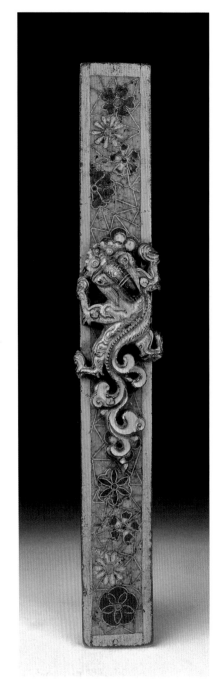

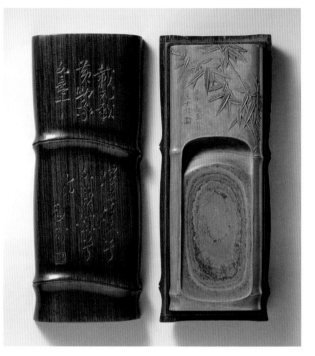

Ink stone with bamboo design, schist and wood
Tintenstein, Bambus, Schiefer und Holz
Inktsteen met bamboe-ontwerp , schist en hout
Piedra para tinta con dibujo de bambú, esquisto y madera
1702
The Metropolitan Museum of Art, New York

◀ Paperweight, Ming Dynasty, metal with enamel cloisonné and bronze
Briefbeschwerer, Ming-Dynastie, Metall mit Cloisonné und Bronze
Presse-papier, Ming-dynastie, metaal met email cloisonné en brons
Pisapapeles, dinastía Ming, metal con esmaltes cloisonné y bronce
ca. 1600
Museum of East Asian Art, Bath

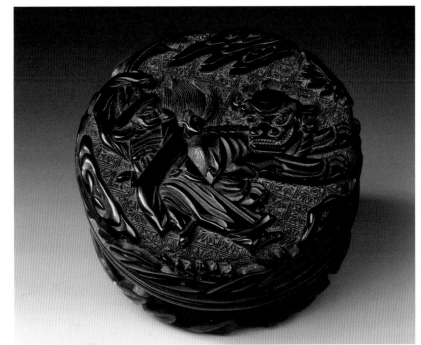

Lacquer box with decoration
Schatulle mit Lackverzierung
Doos met gelakte versiering
Caja con decoración en laca
ca. 1490-1510
Museum of East Asian Art,
Bath

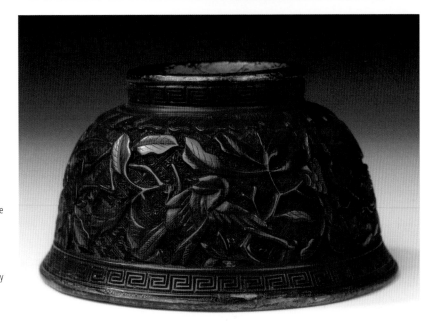

Bowl decorated with birds
between peonies, lacquer
and silver-plated bronze
Schatulle mit Vögeln
zwischen Pfingstrosen
verziert, Lack und versilberte
Bronze
Bakje versierd met vogels
temidden pioenrozen, lak
en verzilverd brons
Cuenco decorado con
pájaros entre peonias, laca y
bronce plateado
ca. 1600
Museum of East Asian Art,
Bath

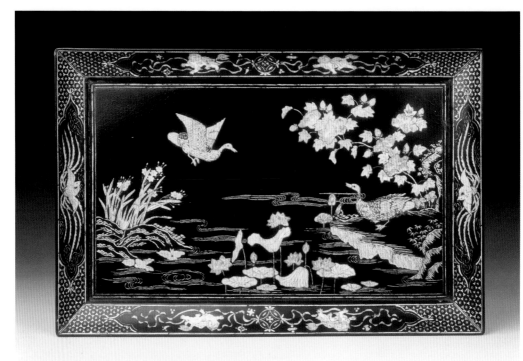

Tray with mother-of-pearl inlay, lacquer
Gefäß mit Perlmutteinlegearbeiten, Lack
Dienblad met parelmoer, lak
Bandeja con incrustaciones de madreperla, laca
1550-1600
Museum of East Asian Art, Bath

Lacquer plate with mother-of-pearl and gold inlay
Lackteller mit Perlmutt- und Goldeinlegearbeiten
Gelakt bord met parelmoer en goud
Plato en laca con incrustaciones en madreperla y en oro
1680-1700
Museum of East Asian Art, Bath

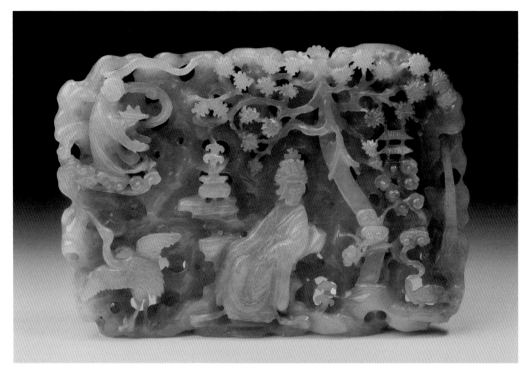

Plaque with Taoist paradise, jade
Plakette mit taostischem Paradies, Jade
Plaat met taoïstisch paradijs, jade
Placa con paraíso taoísta, jade
1600-1700
Museum of East Asian Art, Bath

Goblet depicting a scholar under a pine tree,
rhinoceros horn
Becher mit Darstellung eines Gelehrten und einer
Pinie, Horn des Nashorns
Beker met een geleerde onder een pijnboom,
hoorn van een neushoorn
Copa con imagen de un estudioso bajo un pino,
cuerno de rinoceronte
1600-1644
Museum of East Asian Art, Bath

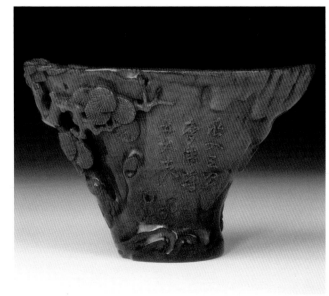

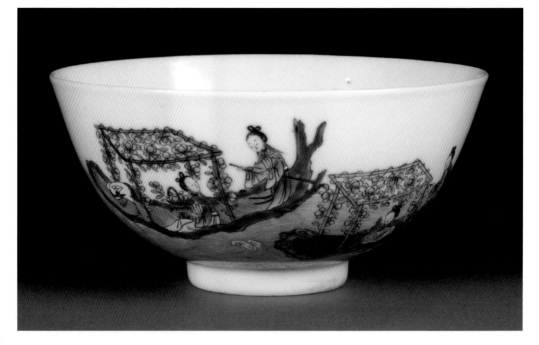

▌ *Ceramics and porcelain, highly prized and widespread in the Far East, from the time of the Tang they develop reaching unparalleled heights.*
▌ *Die Keramik und das Porzellan, zwei sehr angesehene und verbreitete Techniken im Fernen Osten, entwickeln sich seit der Tang-Epoche und erreichen unerreichte Perfektion.*

Jingdezhen cup, porcelain
Jingdezhen-Tasse, Porzellan
Jingdezhe-kopje, porselein
Taza *Jingdezhen*, porcelana
1821-1850
Victoria & Albert Museum, London

Cup with five lobes, lacquer and silver-plated bronze
Tasse mit fünf Lappen, Lack und versilberte Bronze
Kopje met vijf bogen, lak en verzilverd brons
Taza de cinco lóbulos, laca y bronce plateado
1700-1800
Museum of East Asian Art, Bath

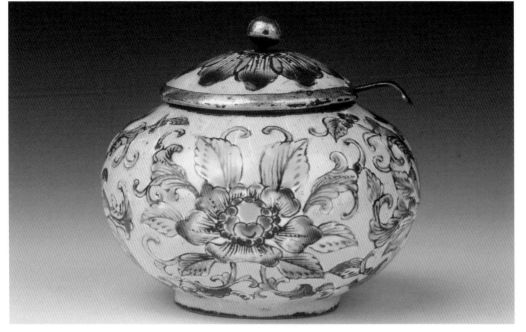

▌ *Keramiek en porselein zijn in het Verre Oosten gewaardeerde en verspreide technieken en vanaf de Tang-periode ontwikkelen deze zich verder tot een niet te evenaren niveau.*
▌ *La cerámica y la porcelana, técnicas muy apreciadas y difundidas en el Lejano Oriente, se desarrollan desde el período Tang alcanzando niveles inigualables.*

Vase for spices, enamelled pottery
Gewürzbehälter, Lasierte Keramik
Kruidenvaas, geëmailleerde keramiek
Jarrón para especias, cerámica esmaltada
1820-1840
Museum of East Asian Art, Bath

Small plate with bats amongst foliage, enamelled pottery
Tellerchen mit Fledermäusen zwischen Laubwerk, Lasierte Keramik
Bordje met vleermuizen tussen de bladeren, geëmailleerde keramiek
Platillo con murciélagos en el follaje, cerámica esmaltada
1700-1800
Museum of East Asian Art, Bath

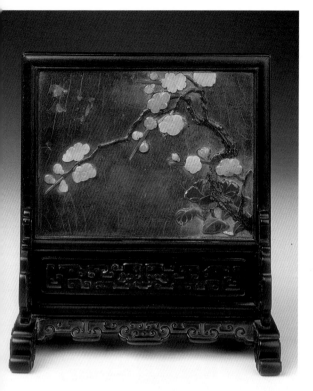

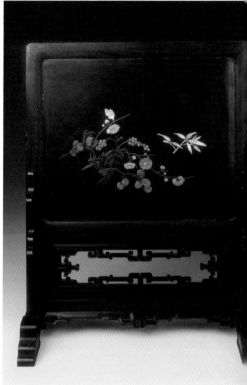

Tabletop screen, wood and lacquer
Tischparavent, Holz und Lack
Tafelscherm, hout en lak
Mampara de mesa, madera y laca
1700-1750
Museum of East Asian Art, Bath

▶ Lacquered plate mounted like a tabletop screen, wood and lacquer
Lackrelief, wie ein Paravent aufgebaut, Holz und Lack
Gelakte plaat als tafelscherm geplaatst, hout en lak
Placa lacada montada como una mampara, madera y laca
1700-1750
Museum of East Asian Art, Bath

Tabletop screen with lacquered plate, wood and lacquer
Tischparavent mit Lackrelief, Holz und Lack
Tafelscherm met gelakte plaat, hout en lak
Mampara de mesa con placa lacada, madera y laca
1600-1700
Museum of East Asian Art, Bath

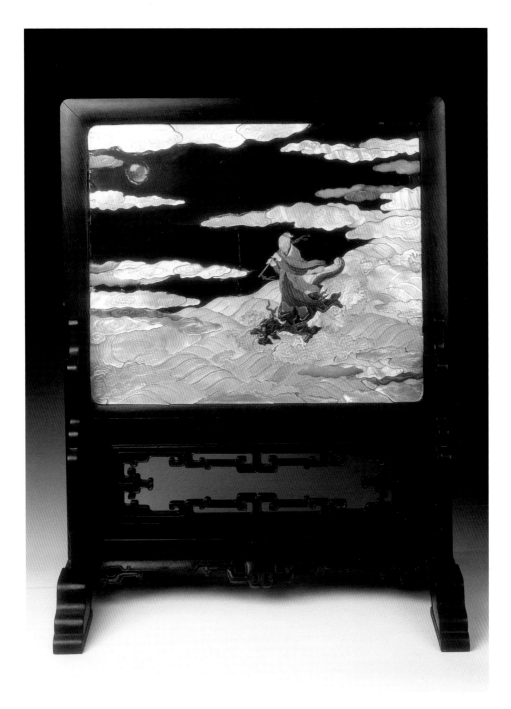

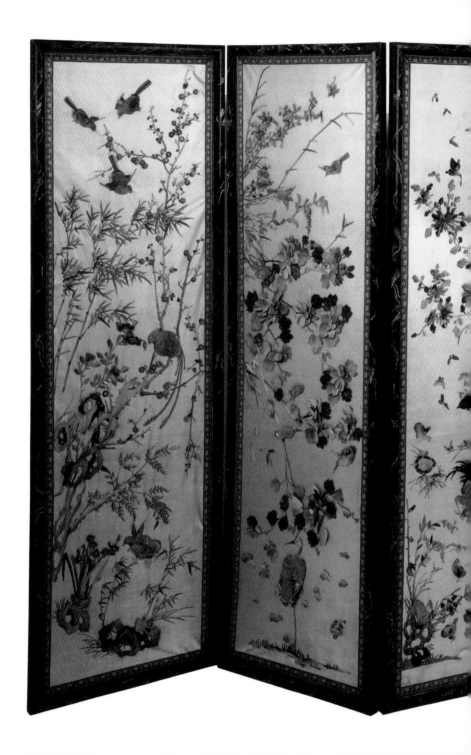

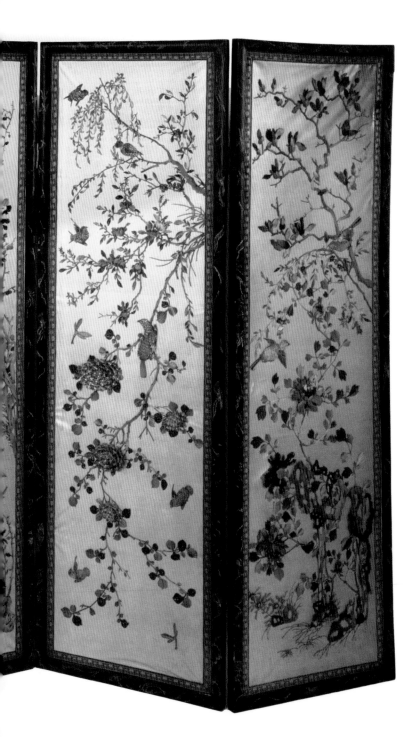

Folding screen, wood and silk
Zusammenfaltbarer Paravent,
Holz und Seide
Opvouwbaar tafelscherm,
hout en lak
Biombo, madera y seda
ca. 1825-1865
Victoria & Albert Museum,
London

Wang Zhao
*The Three Stars of Happiness,
Prosperity and Longevity*, ink and
paint on silk
*Die drei Sterne des Glücks,
Reichtums und des langen
Lebens*, Tinte und Farbe auf Seide
*De drie sterren van het Geluk,
Rijkdom en de Lange Levensduur*,
inkt en verf op zijde
*Las Tres Estrellas de la Felicidad,
de la Riqueza y de la Longevidad*,
tinta y color sobre seda
ca. 1500
Kimbell Art Museum, Fort Worth

Yin Hong
Birds and flowers in early spring, ink and pigments on silk
Vögel und Blumen zu Beginn des Frühlings, Tinte und Pigmente auf Seide
Vogels en bloemen aan het begin van de lente, inkt en pigment op zijde
Pájaros y flores de principios de la primavera, tinta y pigmentos sobre seda
ca. 1500
Kimbell Art Museum, Fort Worth

■ *As theatre of human events with allegoric significance and as absolute protagonist,*
Chinese nature plays an essential role in painting.
■ *Als allegorisch konnotiertes Theater menschlicher Ereignisse oder als einziger Darsteller spielt die chinesische Natur*
eine wesentliche Rolle in der Malerei.
■ *De Chinese natuur, die met haar allegorische betekenissen het theater van alledaagse gebeurtenissen vormt of daar de*
hoofdrol in heeft, speelt een essentiële rol in de schilderkunst.
■ *Como escenario de acontecimientos humanos con significado alegórico, o como protagonista absoluta,*
la naturaleza china juega un rol esencial en la pintura.

▶ **Xiang Shengmo**
(1597 - 1658)
Detail of painting from the album *Landscapes, flowers*
and birds, ink and paint on paper
Detail des Gemäldes aus dem Album *Landschaften,*
Vögel und Blumen, Tinte und Farbe auf Papier
Detail van een schilderij uit het album *Landschappen,*
bloemen en vogels, inkt en verf op papier
Detalle de una pintura del álbum *Paisajes, flores y*
pájaros, tinta y color sobre papel
1639
The Metropolitan Museum of Art, New York

Spring games in a Tang garden, ink and paint on silk
Frühlingsspiele in einem Tang-Garten, Tinte und Farbe auf Seide
Lentespelen in een Tang-tuin, inkt en verf op zijde
Juegos de primavera en un jardín Tang, tinta y color sobre seda
1500-1600
The Metropolitan Museum of Art, New York

Shitao (Zhu Ruoji)
(Guangxi 1642 - Yangzhou 1707)
Two paintings from the album *Colors of wild nature*, ink and paint on paper
Zwei Gemälde aus dem Album *Farben der Wildnis*, Tinte und Farbe auf Papier
Twee schilderijen uit het album *Kleuren van de wildernis*, inkt en verf op papier
Dos pinturas del álbum *Colores de la naturaleza salvaje*, tinta y color sobre papel
ca. 1700
The Metropolitan Museum of Art, New York

▶ Detail of screen depicting plants and birds, paint on silk
Detail eines Paravents mit Pflanzen- und Vogeldarstellungen, Farben auf Seide
Detail van een kamerscherm met planten en vogels, verf op zijde
Detalle de una mampara con imágenes de plantas y pájaros, colores sobre seda
1776
The Newark Museum, Newark

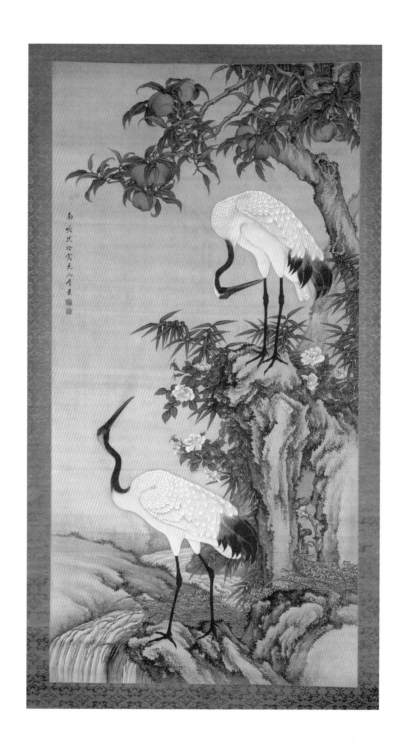

老梅愈老愈精神水店山樓芯
有人清到十分寒滿把始知明月
是前身

乙江外史畫詩書

十月十日

◄ **Shen Quan**
(1682 - 1758)
Crane, peach tree and Chinese roses, ink and paint on silk
Kranich, Pfirsich und chinesische Rosen, Tinte und Farbe auf Seide
Kraanvogels, perzikenboom en Chinese rozen, inkt en verf op zijde
Grulla, melocotonero y rosas chinas, tinta y color sobre seda
1700
The Metropolitan Museum of Art, New York

Jin Nong
(1687 - 1763)
Prune tree buds, ink on paper
Pflaumenknospen, Tinte auf Papier
Knoppen aan de pruimenboom, inkt op papier
Capullos de ciruelo, tinta sobre papel
1757
The Metropolitan Museum of Art, New York

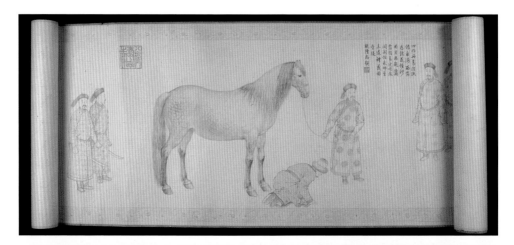

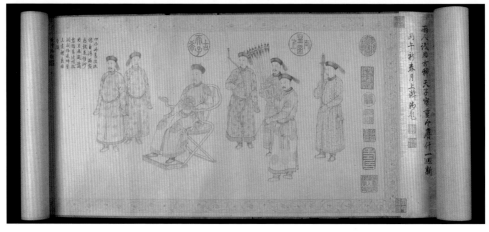

Giuseppe Castiglione (Lang Shi'ning)
(Milano 1688 - Beijing 1766)
Manchu scroll: *Two people and a horse,
Personages and Calligraphy*, ink on paper
Manciù-Rolle: *Zwei Personen und ein Pferd,
Personen und Kalligrafien*, Tinte auf Papier
Manciù-rol: *Twee personen en een paard* en
Personen en inscripties, inkt op papier
Rollo Manchú: *Dos personajes y un caballo y
Personajes y caligrafías*, tinta sobre papel
1700
Musée du quai Branly, Paris

❚ *Emperor Ming Qianlong bestowed the position of court painter on the
Jesuit Giuseppe Castiglione. The legacy of this portrait painter is vast and
reaches the pinnacle in the horses depicted according to Renaissance and
Chinese abstract taste.*

❚ *Dem Jesuiten Giuseppe Castiglione übertrug Kaiser Ming Qianlong das
Amt eines Hofmalers. Der Nachlass dieses Porträtisten ist umfassend, als
Höhepunkt seines Schaffens gelten die im Geschmack der Renaissance
und des chinesischen Abstraktismus gezeichneten Pferdedarstellungen.*

❚ *De jezuïet Giuseppe Castiglione werd door keizer Ming Qianlong
aangenomen als hofschilder. De erfenis van deze portretschilder is
omvangrijk met als hoogtepunt de paardenafbeeldingen die volgens het
Chinese abstractisme afgebeeld zijn met een renaissancistisch tintje.*

❚ *Al jesuita Giuseppe Castiglione, el emperador Ming Qianlong le
confirió el cargo de pintor de corte. El legado de este retratista es
amplio, y alcanza su ápice en los caballos representados según el gusto
renacentista y el arte abstracto chino.*

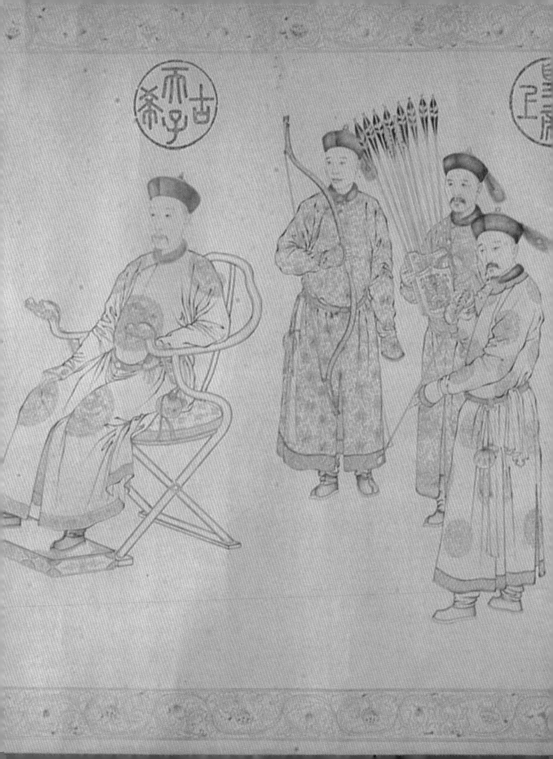

Painted scroll with
Confucian subjects
Mit konfuzianischen
Sujets bemalte Rolle
Rol beschilderd met
confucianistische
voorwerpen
Rollo pintado con temas
confucianos
ca. 1700
Victoria & Albert
Museum, London

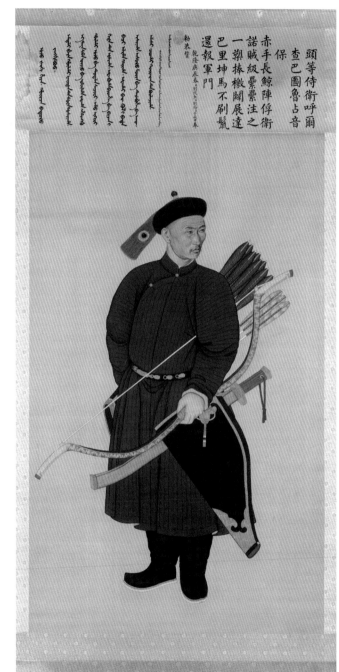

Portrait of the Imperial
Guard Zhanyinbao,
ink and paint on silk
Porträt der
kaiserlichen Wache
Zhanyinbao, Tinte
und Farbe auf Seide
Portret van de
keizerlijke bodyguard
Zhanyinbao,
inkt en verf op zijde
Retrato de guardia
imperial Zhanyinbao,
tinta y color sobre seda
1700-1800
The Metropolitan
Museum of Art,
New York

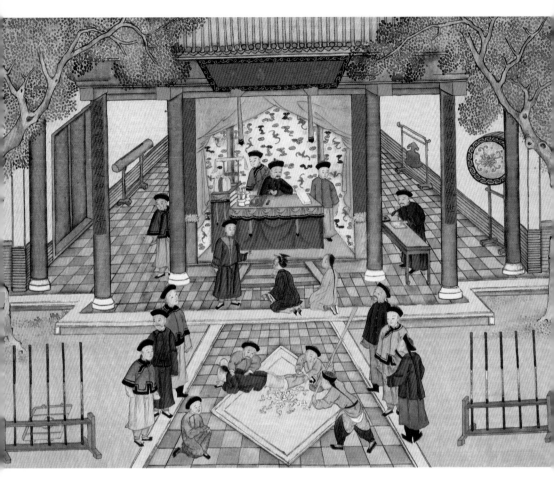

▌ The use of colors is another characteristic of Chinese painting. Over time, the artists developed particular colors and techniques to effectively depict reality, but also to express profound symbolism.

▌ Die Verwendung der Farben ist ein weiteres Merkmal der chinesischen Malerei. Im Laufe der Zeit haben die Künstler besondere Tinten und Techniken entwickelt, um die Realität wirksam wiederzugeben, aber auch um tiefgründige Symbolik auszudrücken.

▌ Nog een kenmerk van de Chinese schilderkunst is het gebruik van kleuren. De kunstenaars hebben met de tijd kleuren en bijzondere technieken ontwikkeld waarmee op doeltreffende wijze de werkelijkheid wordt weergegeven en diepgaand symbolisme wordt uitgedrukt.

▌ El uso de los colores es otra característica de la pintura china. Con el pasar del tiempo, los artistas han desarrollado tintas y técnicas particulares para representar con eficacia la realidad, pero también para expresar profundos significados simbólicos.

Punishment of a criminal at the court of an official, watercolor on silk
Bestrafung eines verdächtigen Kriminellen am Hofe eines Beamten, Aquarell auf Seide
Afstraffing van een verdachte aan het hof van een functionaris, aquarel op zijde
Castigo de un sospechoso de delito en la corte de un funcionario, acuarela sobre seda
1800-1900
Victoria & Albert Museum, London

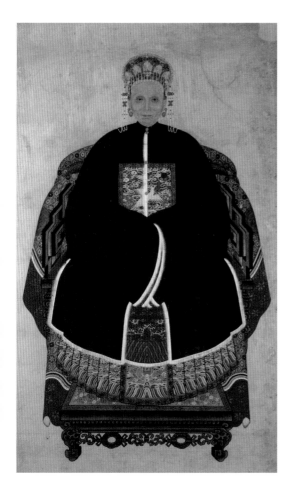

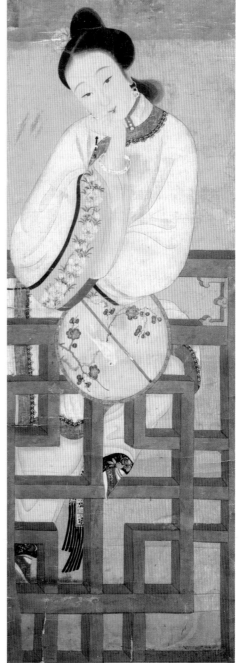

Scroll with portrait of the wife of a civilian official, ink and paint on paper
Rolle mit dem Porträt der Frau eines bürgerlichen Beamten,
Tinte und Farbe auf Papier
Rol met portret van de vrouw van een burgelijke functionaris,
inkt en verf op papier
Rollo con retrato de la mujer de un funcionario civil,
tinta y color sobre papel
ca. 1880-1900
The Newark Museum, Newark

Lady with fan, watercolor on silk
Dame mit Fächer, Aquarell auf Seide
Dame met waaier, aquarel op zijde
Dama con abanico, acuarela sobre seda
1800-1900
Victoria & Albert Museum, London

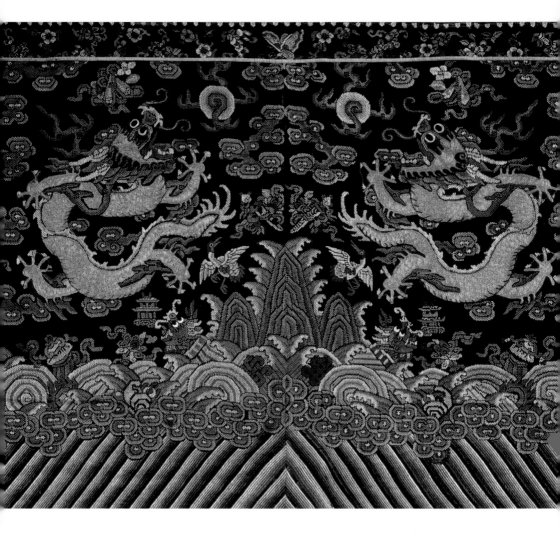

Detail of standard with dragons, mountains and sea, gold and silk on gauze
Detail eines Banners mit Drachen, Bergen und Meer, Gold und Seide auf Gaze
Detail van een vaandel met draken, bergen en zee, goud en zijde op gaas
Detalle de estandarte con dragones, montañas y mar, oro y seda sobre gasa
ca. 1880-1900
The Newark Museum, Newark

Detail of bride's bedspread, gold and silk on satin
Detail der Tagesdecke einer Braut, Gold und Seide auf Satin
Detail van een bedovertrek van de bruid, goud en zijde op satijn
Detalle de una colcha de novia, oro y seda sobre raso
1800-1900
The Newark Museum, Newark

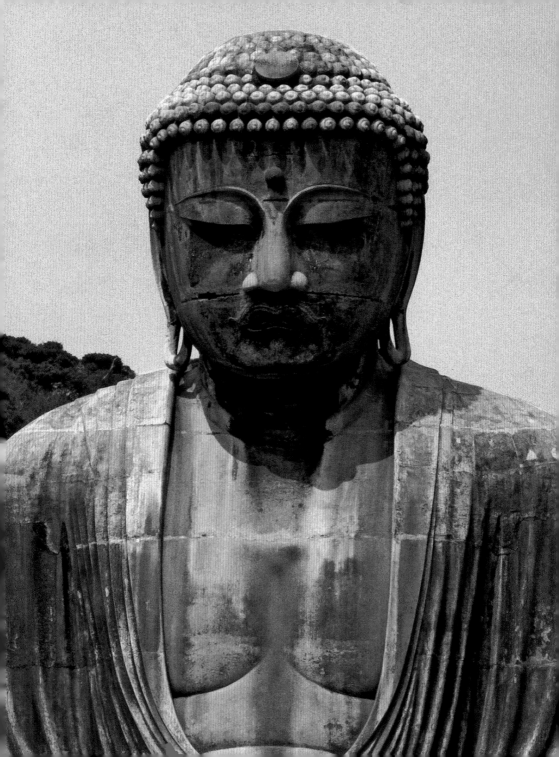

JAPAN
The time of men and the gods

A land created by the gods according to legend, Japan's unique characteristics have stood out since the beginning of its history. Faith, art and society have been influenced by the force of natural events, which continue to mould the territory, and Japanese art is a measure of this reality. Since the first consolidated tradition, the so-called Yayoi Culture in the 3rd century BCE, the use of natural materials, landscapes, and the concept of balance in works of art, have been the fruit of an aesthetic applied both to the arts as well as to everyday life.

JAPAN
Die Zeit der Menschen und der Götter

Als Land der von den Göttern geschaffenen Tradition weist Japan seit Beginn seiner Geschichte Merkmale von deutlicher Individualität auf. Glauben, Kunst und Gesellschaft sind von der Kraft der Naturereignisse, die noch heute das Gebiet heimsuchen, beeinflusst und die japanische Kunst spiegelt diese Realität wieder. Seit der ersten gefestigten Überlieferung aus der so genannten Kultur der Yayoi im 3. Jahrhundert vor Christus sind die Verwendung von natürlichen Materialien, das Einfügen in die Landschaft, die Ausgewogenheit der künstlerischen Darstellungen Ergebnis einer Ästhetik, die sowohl in den bildenden Künsten als auch im alltäglichen Leben angewendet werden.

4

JAPAN
Tijd van mensen en goden

Land van oudsher gemaakt door de goden, heeft Japan vanaf het begin van haar geschiedenis karakters gemerkt door individualiteit. Geloof, kunst en maatschappij worden beïnvloed door de kracht van natuurlijke gebeurtenissen die vandaag nog het grondgebied vormen, en Japanse kunst is een maat voor deze realiteit. Vanaf de eerste traditie, die van de zogenaamde Yayoi cultuur in de derde eeuw voor Christus, zijn het gebruik van natuurlijke materialen, de integratie in het landschap, de balans in de artistieke manifestaties het resultaat van een toegepaste esthetiek zowel voor de kunsten als voor het dagelijkse leven.

JAPÓN
El tiempo de los hombres y de los dioses

Tierra que, según la tradición, fue creada por los dioses, Japón presenta características de marcada individualidad desde el comienzo de su historia. Fe, arte y sociedad fueron influenciados por una fuerza de la naturaleza que forja todavía hoy el territorio, y el arte japonés es fiel reflejo de esta realidad. Desde la primera tradición consolidada, la de la llamada Cultura Yayoi en el siglo III a.C., el uso de materiales naturales, la inmersión en el paisaje y el equilibrio de las manifestaciones artísticas son fruto de una estética aplicada tanto a las artes cultas como a la vida cotidiana.

The Sengoku Period (1478-1604). The feudal groups of Japan in 1572
Sengoku-Epoche (1478-1604). Die größten Lehensgebiete Japans im Jahr 1572
Sengoku-periode (1478-1604). De grootste grondgebieden van Japan in 1572
Período Sengoku (1478-1604). Los feudos más grandes de Japón en 1572

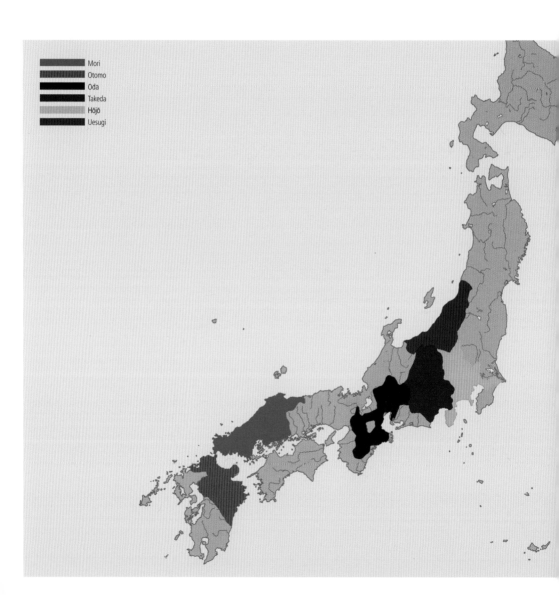

Mori
Otomo
Oda
Takeda
Hōjō
Uesugi

The Three Kingdoms of Korea (57 BCE - 668 CE)
Die Drei Reiche von Korea (57 v. Chr. - 668 n. Chr.)
De Drie Koninkrijken van Korea (57 v. Chr. - 668 na Chr.)
Los Tres Reinos de Corea (57 a.C. - 668 d.C.)

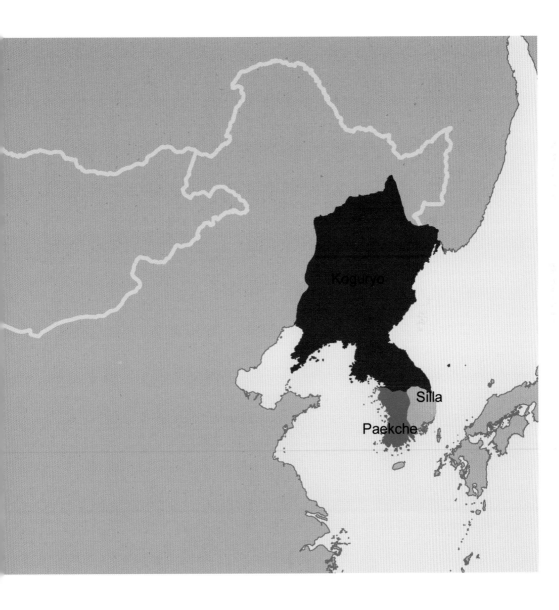

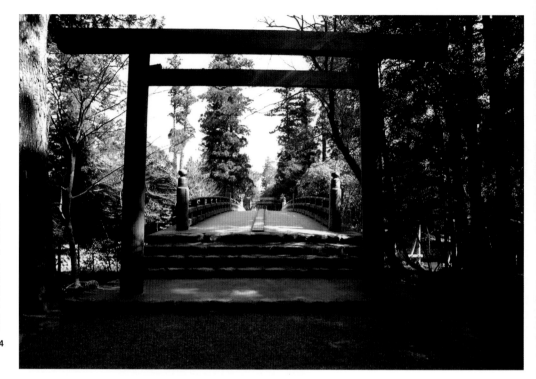

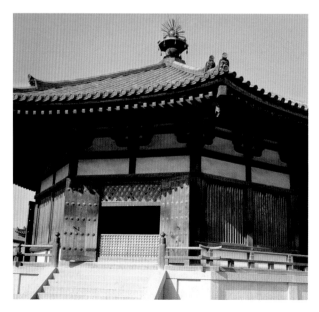

Ise
The Portal, *torii*, leading to the sacred area
Das Portal, *torii*, das Zugang zum Heiligen Gebiet verschafft
De *torii* poort, die toegang geeft tot een heiligdom
El portal, *torii*, a través del cual se accede al área sagrada

Nara
Yumedono, the Hall of Dreams,
octagonal pavilion in the Horyu-ji Temple
Yumedono, die Traumhalle,
achteckiger Pavillon im Horyu-ji Tempel
Yumedono, de Zaal van de Dromen,
achthoekig paviljoen in de tempel Horyu-ji
Yumedono, la Sala de los Sueños,
pabellón octogonal en el templo Horyu-ji
739

▶ **Nara**
Five-storied Pagoda of the Kofuku-ji
Fünfstöckigen Pagode des Kofuku-ji
Pagode van vijf op de Kofuku-ji
Pagoda de cinco pisos del Kofuku-ji verdiepingen

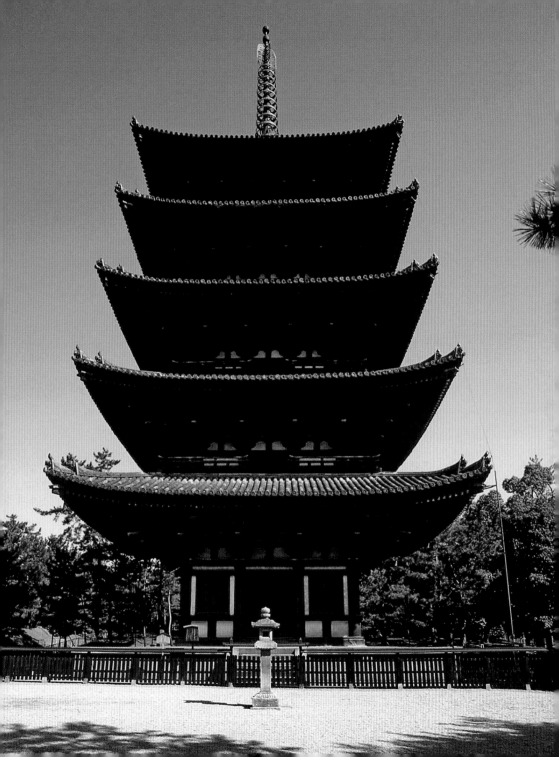

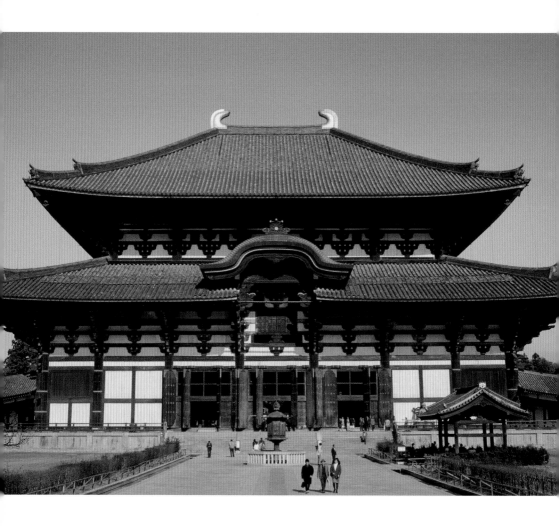

Nara
Façade of the Todai-ji, the largest wooden building in the world
Fassade des Todai-ji, dem größten Holzgebäude der Welt
Gevel van de Todai-ji, het grootste houten gebouw ter wereld
Fachada del Todai-ji, el edificio de madera más grande del mundo
710-794

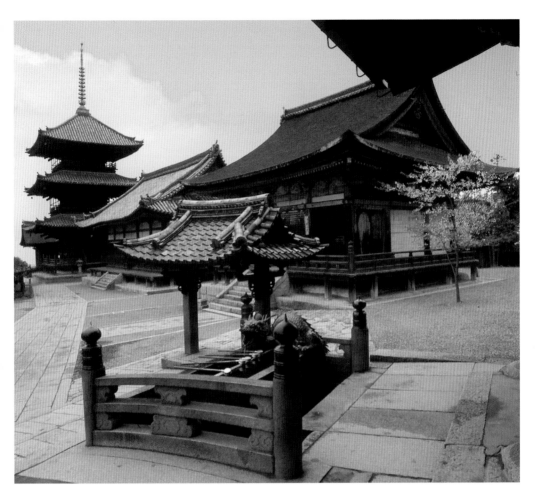

Kyoto
View of the Kyomizu-dera complex
Ansicht des Kyomizu-dera-Komplexes
Uitzicht op het Kyomizu-dera complex
Vista del complejo del Kyomizu-dera
798-1663

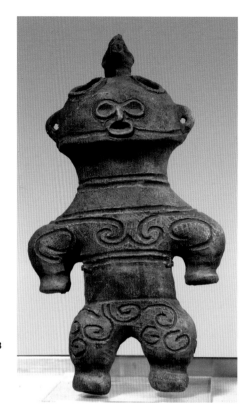 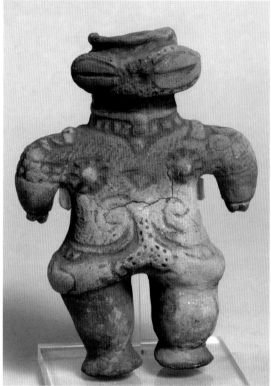

■ *The Dogu statuettes are the typical expression of the Jomon Period of Neolithic Japan. The uncertainty of their role tends to acknowledge a purely ritual use.*

■ *Die Dogu-Statuen sind ein typischer Ausdruck der Jomon-Epoche, in die die japanische Jungsteinzeit fällt. Über ihre Rolle ist man sich nicht sicher, allerdings neigt man dazu, sie vor allem als rituelle Gegenstände anzusehen.*

■ *De Dogu-beeldjes zijn typisch voor de Jomon-periode waarbinnen het Japanse Neolithicum valt. De functie van deze beeldjes is niet helemaal duidelijk, daarom wordt slechts het rituele gebruik ervan erkend.*

■ *Las estatuillas Dogu son la expresión típica del período Jomon, en el cual se sitúa el Neolítico japonés. Al no saber a ciencia cierta cuál es su función, se tiende a reconocerles un uso pura y exclusivamente ritual.*

Dogu statuette probably for ritual use, Jomon Period, terracotta
Dogu-Statue, wahrscheinlich zu ritueller Verwendung, Jomon-Epoche, Terrakotta
Dogu-beeldje waarschijnlijk voor ritueel gebruik, Jomon-periode, terracotta
Estatuilla *Dogu*, probablemente de uso ritual, período Jomon, terracota
8000-300 BCE
Musée Guimet, Paris

Ritual figurine of the late Jomon Period, terracotta
Rituelle Figur der späten Jomon-Epoche, Terrakotta
Ritueel beeldje uit de late Jomon-periode, terracotta
Estatuilla ritual del período Jomon tardío, terracota
2500-1200 BCE
Museo Nazionale d'Arte Orientale "G. Tucci", Roma

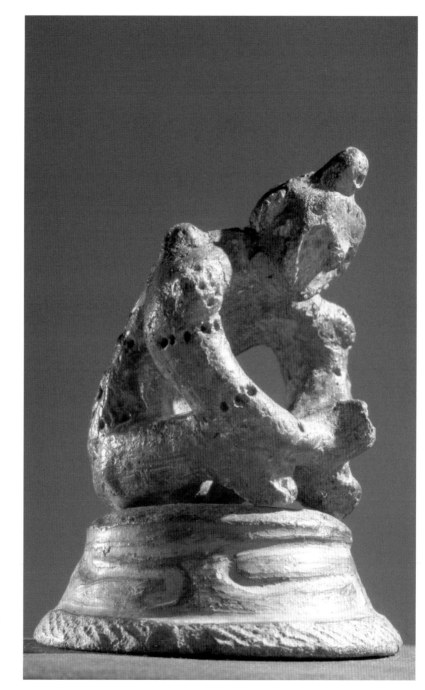

Dogu statuette of the late
Jomon Period, terracotta
Dogu-Statue der späten
Jomon-Epoche, Terrakotta
Dogu-beeldje uit de late
Jomon-periode, terracotta
Estatuilla *Dogu* del período
Jomon tardío, terracota
350-250 BCE
Private Collection / Private
Sammlung / Privécollectie
Colección privada

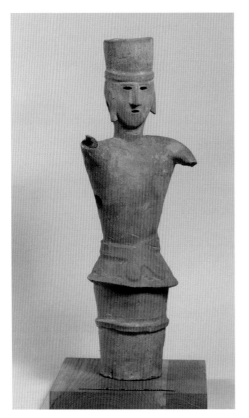

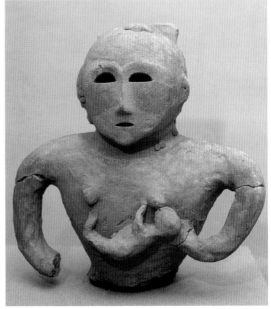

Haniwa funerary figurine, Kofun Period, terracotta
Haniwa Begräbnisfigur, Kofun-Epoche, Terrakotta
Haniwa-grafbeeldje, Kofun-periodo, terracotta
Estatuilla funeraria *Haniwa*, período Kofun, terracota
200-600
Museo Nazionale d'Arte Orientale "G. Tucci", Roma

Nursing mother, terracotta
Stillende Frau, Terrakotta
Vrouw die de borst geeft, terracotta
Mujer amamantando, terracota
300-700

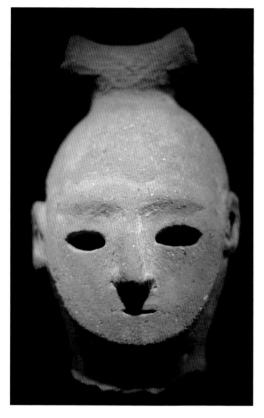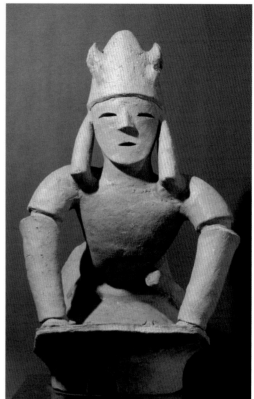

▮ *Placed around funerary tombs (Kofun) and in front of their entrance, the Haniwa statuettes are a lively and heterogeneous three-dimensional universe meant to accompany the deceased on his voyage to the hereafter.*
▮ *Die um die Grabmale (Kofun) und vor deren Eingang gestellten Haniwa-Statuen stellen ein lebendiges und heterogenes plastisches Universum dar, das den Verstorbenen auf seiner Reise ins Jenseits begleiten sollte.*
▮ *De Kofun die om de graftombes heen staan en de Haniwa-beeldjes bij de ingang zorgen voor een levendig en heterogeen universum om de overledene bij zijn reis naar het hiernamaals te vergezellen.*
▮ *Ubicadas en torno a los túmulos funerarios (Kofun) y delante de su ingreso, las estatuillas Haniwa son un vivaz y heterogéneo universo plástico destinado a acompañar al difunto en su viaje al más allá.*

Head of *Haniwa* figure, Kofun period, terracotta
Haniwa Figurenkopf, Kofun-Epoche, Terrakotta
Hoofd uit een *Haniwa*-graf, Kofun-periode, terracotta
Cabeza de figura *Haniwa*, período Kofun, terracota
500-600

Haniwa figure of man kneeling, maybe an officiant, terracotta
Haniwa Figur eines knieenden Mannes, vielleicht eines Offizianten, Terrakotta
Haniwa-figuur van een geknielde man, misschien een celebrant, terracotta
Figura *Haniwa* de hombre arrodillado, quizá un oficiante, terracota
500-600
Ono Collection, Osaka

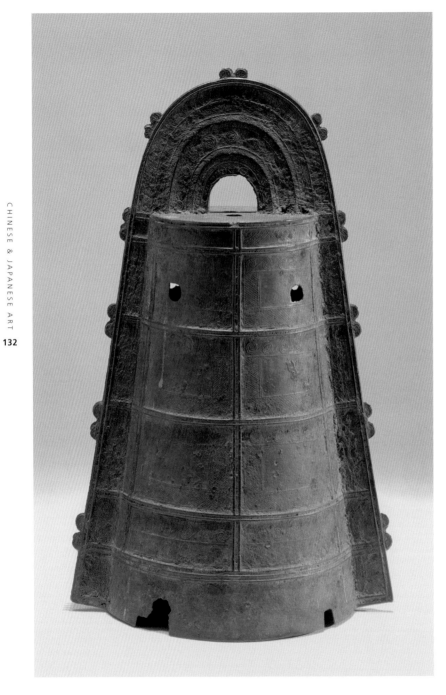

Bell in the characteristic
Kofun style, bronze
Glocke im charakteristischen
Kofun-Stil, Bronze
Klok in de karakteristieke
Kofun-stijl, brons
Campana de característico
estilo Kofun, bronce
400-500
Museum of Fine Arts, Boston

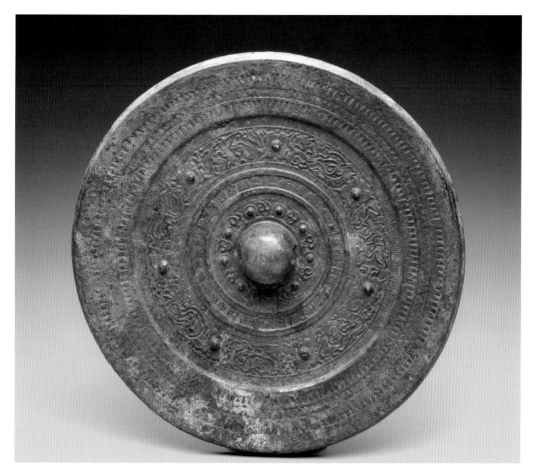

Mirror of the Kofun Period, bronze
Spiegel aus der Kofun-Epoche, Bronze
Spiegel uit de Kofun-periode, brons
Espejo del período Kofun, bronce
400-500
Museum of Fine Arts, Boston

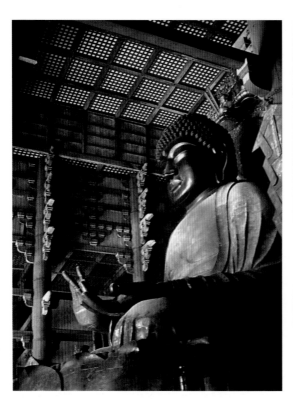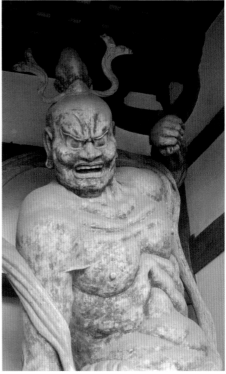

▌ *The two "guardian" statues, Nio, usually placed at the entrance of Buddhist temples are rich in symbolism. Among these are:*
the open mouth (Agyo statue), indicates the birth of the Universe; closed (Ugyo statue), indicates its destruction.
▌ *Die zwei "Wächter"-Statuen, Nio, die gewöhnlich am Eingang buddhistischer Tempel aufgestellt waren, sind reich an Symbolik.*
So weist der offene Mund (Agyo-Statue) auf die Geburt des Universums; der geschlossene Mund (Ugyo-Statue) auf dessen Auflösung.
▌ *Nio, de twee beelden die bewakers voorstellen en die normaliter bij de ingang van boeddhistische tempels staan,*
zitten vol symboliek. Onder andere betekent de open mond (Agyo-beeld) de geboorte van het Universum en een gesloten mond
(Ugyo-beeld) de ontbinding hiervan.
▌ *Las dos estatuas de "guardianes", Nio, ubicadas habitualmente en el ingreso de los templos budistas, son ricas de significados*
simbólicos. Entre ellos, la boca: abierta (estatua Agyo) indica el nacimiento del Universo; cerrada (estatua Ugyo), su disolución.

Statue of the guardian of the gates (*Nio*), terracotta
Wächterstatue der Türen (*Nio*), Terrakotta
Beeld van de poortbewaker (*Nio*), terracotta
Estatua de guardián de las puertas (*Nio*), terracota
711
Horyu-ji Temple, Nara

Detail of the Great Buddha, bronze
Detail des Großen Buddha, Bronze
Detail van de Grote Boeddha, brons
Detalle del Gran Buda, bronce
743-752
Todai-ji Temple, Nara

▶ Statue of one of the Twelve Heavenly Generals
Statue eines der Zwölf Heiligen Generäle
Beeld van één van de Twaalf Heilige Generalen
Estatua de uno de los Doce Generales Sagrados
To-ji Temple, Kyoto

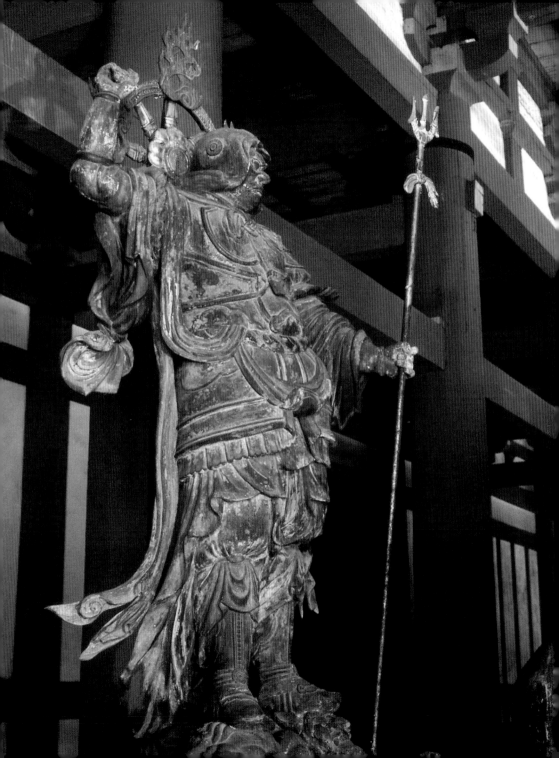

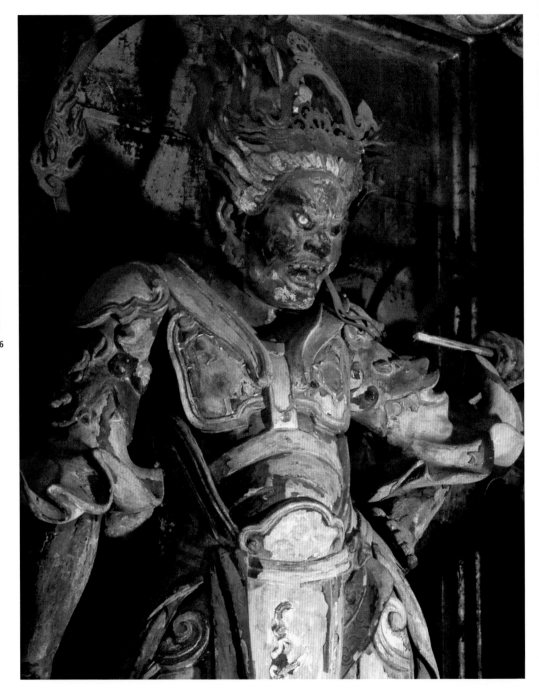

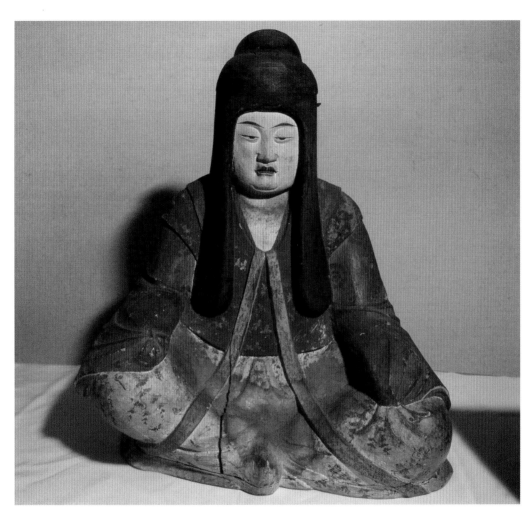

◀ **Kosho**
(1534 - 1621)
Detail of one of the Heavenly Twelve Generals
Detail eines der Zwölf Heiligen Generäle
Detail van één van de Twaalf Heilige Generalen
Detalle de uno de los Doce Generales Sagrados
1603
To-ji Temple, Kyoto

The deified princess Nakatsu Hime, painted wood
Die vergöttlichte Prinzessin Nakatsu Hime, bemaltes Holz
De vergoddelijkte prinses Nakatsu Hime, beschilderd hout
La princesa divinizada Nakatsu Hime, madera pintada
900-1000
Hachiman Shrine, Nara

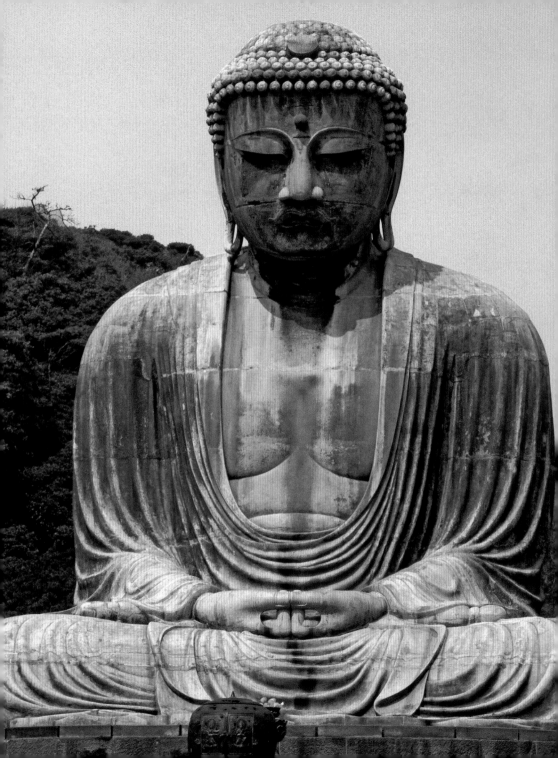

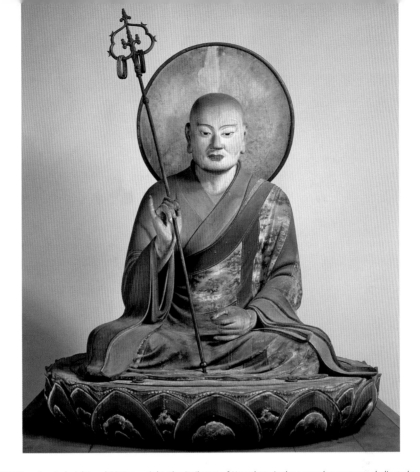

▌ With its 13.35 meters in height and 93 ton weight, the Daibutsu of Kamakura is the second monument dedicated to Buddha in Japan, in terms of size, after the one preserved in the Todai-ji.

▌ Mit seinen 13,35 Metern Höhe und 93 Tonnen Gewicht ist der Daibutsu von Kamakura nach dem im Todai-ji aufbewahrten das zweitgrößte Buddha gewidmete Monument in Japan.

▌ Met zijn hoogte van 13,35 meter en 93 ton aan gewicht, is de Daibutsu van Kamakura qua dimensies het tweede monument na dat van de Todai-ji dat in Japan aan Boeddha gewijd is.

▌ Con sus 13,35 metros de altura y 93 toneladas de peso, el Daibutsu de Kamakura es el segundo monumento en tamaño dedicado al Buda en Japón, después del que se encuentra custodiado en el Todai-ji.

◀ Great Buddha (*Daibutsu*), representation of Amida, bronze
Großer Buddha (*Daibutsu*), Darstellung von Amida, Bronze
Grote Boeddha (*Daibutsu*), afbeelding van Amida, brons
Gran Buda (*Daibutsu*), representación de Amida, bronce
1252
Kotoku-in, Kamakura

Kaikei
(1183 - 1236)
Hachiman, Shinto god of war dressed as a Buddhist monk, painted wood
Hachiman, shintoistische Kriegsgottheit in Gestalt
eines buddhistischen Mönchs, bemaltes Holz
Hachiman, shintoïstische oorlogsgod in het gewaad
van een boeddhistische monnik, beschilderd hout
Hachiman, divinidad guerrera sintoísta, representado
como un monje budista, madera pintada
ca. 1200
Todai-ji, Nara

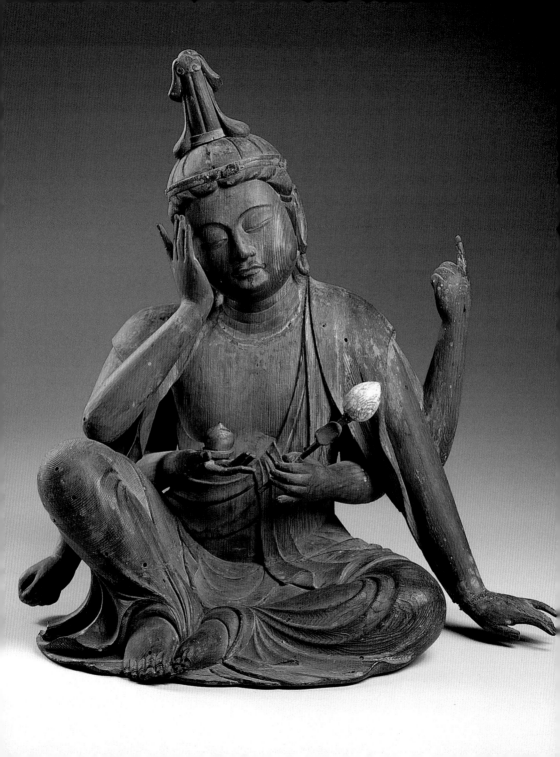

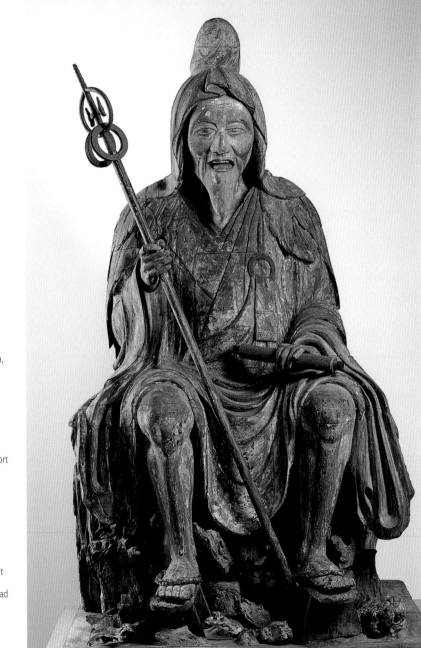

The ascetic En no Gyoja,
painted wood
Der Asket En no Gyoja,
bemaltes Holz
De asceet En no Gyoja,
beschilderd hout
El asceta En no Gyoja,
madera pintada
ca. 1300-1375
Kimbell Art Museum, Fort
Worth

◄ Nyorin Kannon,
Buddhist god with six
arms, wood
Nyorin Kannon,
buddhistische Gottheit
mit sechs Armen, Holz
Nyorin Kannon,
boeddhistische god met
zes armen, hout
Nyorin Kannon, divinidad
budista de seis brazos,
madera
ca. 1230-1250
Kimbell Art Museum,
Fort Worth

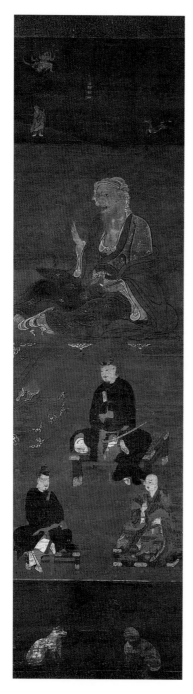

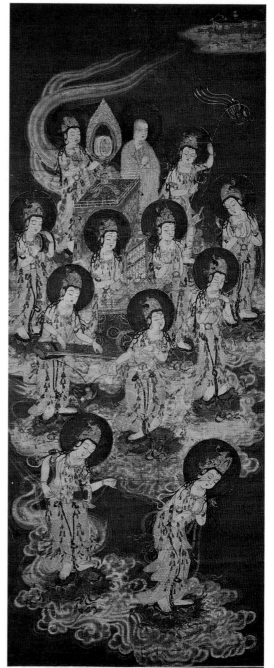

▮ *The* Tales of Ise *(Ise Monogatari) offer a rich series of suggestions for subsequent art. In particular for the Samurai society, the descriptions of the amorous relationships of the protagonists have given rise to works of exotic and in some ways unconventional art.*
▮ *Die* Erzählungen von Ise *(Ise Monogatari) bieten eine Reihe von Inspirationen für die spätere Kunst. Besonders für die Gesellschaft der Samurai haben die Liebesbeziehungen der Protagonisten Anlass zu fernöstlichen und irgendwie kühnen Kunstwerken gegeben.*
▮ *De* Verhalen van Ise *(Ise Monogatari) zijn voor de hiernavolgende kunst zeer inspirerend. De beschrijving van liefdesverhoudingen leidde vooral in de Samurai-maatschappij tot exotische en enigszins transgressieve kunstwerken.*
▮ *Los* Cantares de Ise *(Ise Monogatari) ofrecen una rica cantidad de sugerencias para el arte posterior. En particular para la sociedad samurái, la descripción de las relaciones amorosas de los protagonistas ha sido fuente de inspiración de obras de arte exóticas y, en cierto modo, transgresoras.*

◀ Shinto mandala of Yuima, paint and gold on silk
Shintoistisches Mandala von Yuima, Farbe und Gold auf Seide
Shintoïstische Mandala van Yuima, verf en goud op zijde
Mandala sintoísta de Yuima, color y oro sobre seda
ca. 1350
Kimbell Art Museum, Fort Worth

◀ Twentyfive Bodhisattva descending from paradise, gold and pigments on silk
Fünfundzwanzig Bodhisattva, die aus dem Himmel herabsteigen,
Gold und Pigmente auf Seide
Vijfentwintig Bodhisattva's die uit de hemel neerdalen, goud en pigment en zijde
Veinticinco Bodhisattva que bajan del empíreo, oro y pigmentos sobre seda
ca. 1300
Kimbell Art Museum, Fort Worth

Tosa Mitsuyoshi
(1539 - 1613)
Detail of panel with scene from the *Tales of Ise*
(*Ise Monogatari*), painting and lacquer
Tafeldetail mit einer Szene der *Erzählungen von Ise*
(*Ise Monogatari*), Malerei und Lack
Detail van een doek met een scène uit de *Verhalen van Ise*
(*Ise Monogatari*), verf en lak
Detalle de panel con una escena de los *Cantares de Ise*
(*Ise Monogatari*), pintura y laca
1500-1600
Dallas Museum of Arts, Dallas

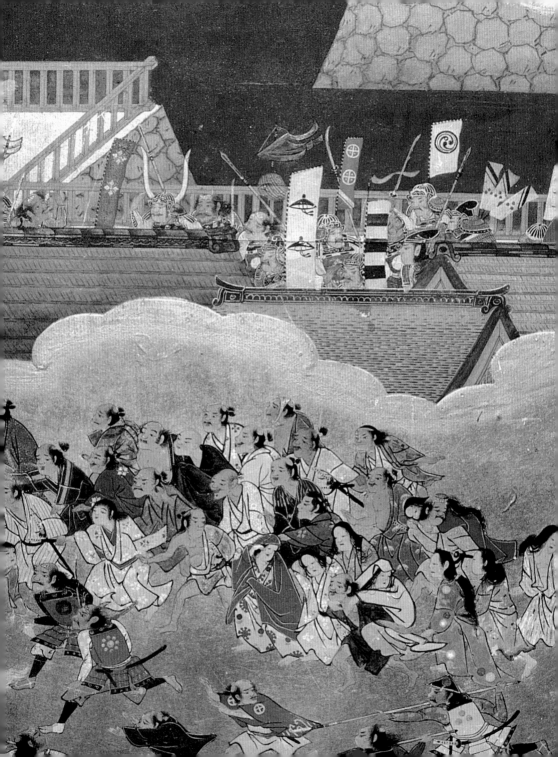

The epic of the samurai

With the establishment of local sects and forms of Buddhism and the end of the delegations in China, the role of the samurai caste grew stronger, acquiring power parallel to that of the emperor. The two traditions, noble (with its center first in Nara, then in Kyoto) and warrior (focused on the "eastern capital" of Tokyo) continued in parallel, giving life to a rich and unique artistic tradition. In a country closed off to the outside world by decree at the beginning of the 17th century, subject to the strict control of the shoguns, art and culture were able to develop along almost entirely independent lines.

Das Epos der Samurai

Gleichzeitig mit dem Entstehen lokaler Sekten und Formen des Buddhismus, gegen Ende der chinesischen Delegationen, nimmt die Macht Samurai zu und bildet eine Art Parallelmacht zu der des Kaisers. Die beiden Traditionen, einerseits die aristokratische (mit Schwerpunkt vor allem in Nara und in Kyoto), andererseits die militärische (die sich in der "östlichen Hauptstadt" Tokio konzentriert) verlaufen parallel und führen zu einer reichhaltigen und einzigartigen künstlerischen Produktion. In Folge eines Beschlusses aus dem 17. Jahrhundert isoliert sich das Land gegenüber der Außenwelt und unterwirft sich der strengen Kontrolle durch die Regierung der Shogun, allerdings können Kunst und Kultur sich entlang der Grenzen nahezu autonom entwickeln.

5

Epos van de Samoerai

Gelijktijdig met de geboorte van lokale vormen en sekten van het boeddhisme en het einde van de ambassades in China, verstevigt zich de rol van de samuraikaste, die macht verwerft die gelijk staat aan de keizerlijke macht. De twee tradities, de edele (met het zwaartepunt eerst in Nara en dan in Kyoto) en de krijger (die zich richten op de 'Oosterse hoofdstad' Tokyo) zal gelijk worden uitgevoerd resulterend in vruchtbare en originele kunst. In een land bij decreet, gesloten voor de buitenwereld, in de vroege zeventiende eeuw, onder strenge controle van de shogun-regering, hebben kunst en cultuur de mogelijkheid zich te ontwikkelen langs vrijwel volledig autonome lijnen.

La epopeya de los samuráis

Con el nacimiento de sectas locales y formas del budismo y el final de las delegaciones en China, se refuerza el rol de la casta de los samuráis, que adquiere un poder semejante al del emperador. Las dos tradiciones, la noble (con centro primero en Nara y luego en Kioto) y la guerrera (concentrada en la 'capital oriental', Tokio) proseguirán su desarrollo en forma paralela, dando vida a un arte fecundo y original. En un país cerrado al mundo externo por decreto a comienzos del siglo XVII, sometido a un rígido control del gobierno shogunal, arte y cultura encontraron las condiciones para desarrollarse siguiendo líneas casi totalmente independientes.

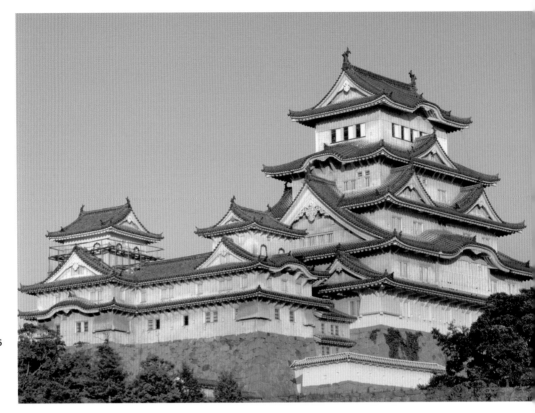

▌ *The Fortress of Himeji, built by the Akamatsu in the 14th century, today is one of the symbols of Japan.*
▌ *Die Burg Himeji, die im 14. Jahrhundert von den Akamatsu gebaut wurde, ist heute eines der Wahrzeichen von Japan.*
▌ *Het Himeji-kasteel dat in de 14e eeuw door de Akamatsu gebouwd is, is vandaag één van de symbolen van Japan.*
▌ *La fortaleza de Himeji, edificada por los Akamatsu en el siglo XIV, es hoy uno de los símbolos de Japón.*

Himeji
Himeji Castle, called "White Heron" because of its elegant shape
Die Burg Himeji wird wegen ihrer eleganten Form auch "Weißer Reiher" genannt
Het Kasteel van Himeji, ook wel "Witte Reiger" genoemd vanwege zijn
elegante vorm en witte buitenmuren
El Castillo de Himeji, llamado "Garza blanca" por su forma elegante
1333-1609

▶ **Himeji**
One of the interior rooms of Himeji Castle
Finer der Innenräume der Burg Himeji
Een van de binnenruimtes van het Kasteel van Himeji
Uno de los ambientes interiores del Castillo de Himeji

▶ **Kyoto**
The Nijo Castle, general quarters of the Tokugawa Shogunate
Die Burg Nijo, Hauptquartier des Tokugawa-Shogunats
Nijo-kasteel, het hoofdkwartier van het Tokugawa-shogunaat
El Castillo Nijo, cuartel general del shogunato Tokugawa
1600-1700

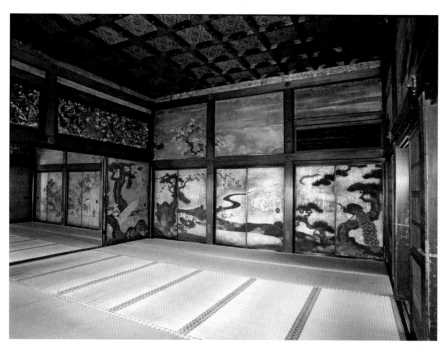

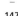

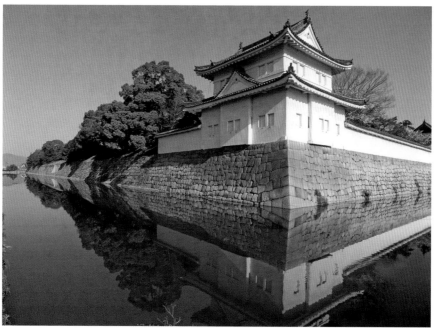

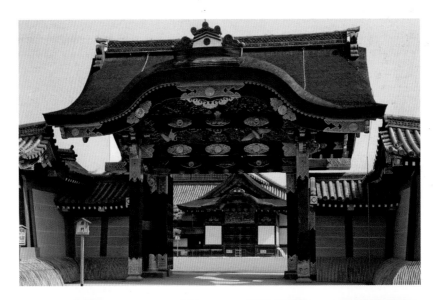

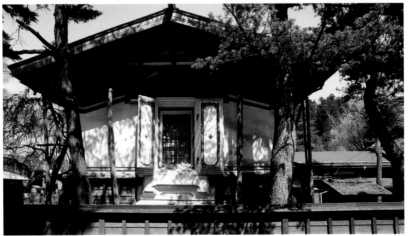

Kyoto
Entrance with sloping gable into the Ninomaru complex of Nijo Castle
Eingang mit dem zum Ninomaru-Gebäude abfallendem Tympanon der Burg Nijo
Ingang met neerhangend timpaan van het Ninomaru-gebouw in het Nijo-kasteel
Ingreso en forma de tímpano en pendiente del complejo Ninomaru del Castillo Nijo
1626

Kanazawa
Samurai residence
Wohnsitz der Samurai
Residentie van de Samurai
Residencia de samurái
1600-1700

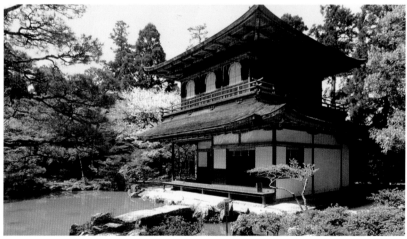

Kanazawa
Samurai house, characterized by functionality
and aesthetic sense
Haus der Samurai, gekennzeichnet durch
Funktionalität und ästhetischem Sinn
Huis van een samurai, kenmerkend zijn de
functionaliteit en de esthetiek ervan
Casa de samurái, caracterizada por la
funcionalidad y el sentido de la estética
1600-1700

Kyoto
The garden of the silver Pavilion (*Ginkaku-ji*)
Der Garten des Silberpavillons (*Ginkaku-ji*)
De tuin van het Zilveren Paviljoen (*Ginkaku-ji*)
El jardín del Pabellón de Plata (*Ginkaku-ji*)
1482

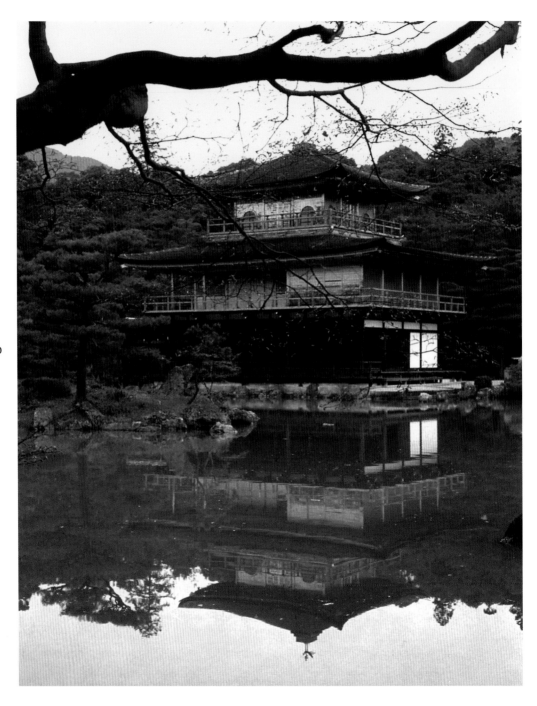

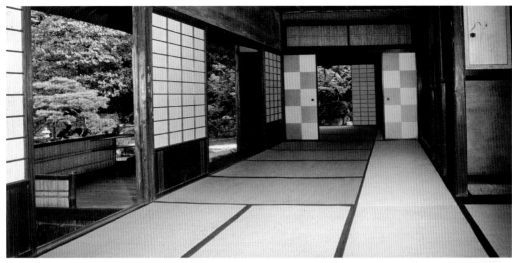

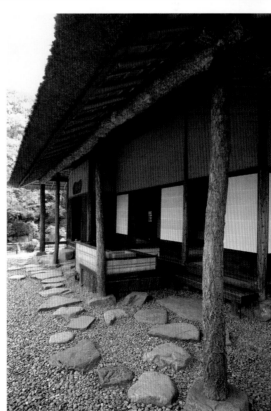

Kyoto
Views of the Shokin-tei tea house in the area
of the Imperial villa of Katsura
Ansicht des Teehauses Shokin-tei innerhalb
der kaiserlichen Residenz von Katsura
Uitzicht op het theehuis Shokin-tei bij
de keizerlijke villa van Katsura
Vistas de la casa de té Shokin-tei en el área
de la villa imperial de Katsura
ca. 1650

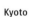 **Kyoto**
The Golden Pavilion (*Kinkaku-ji*)
Der Goldpavillon (*Kinkaku-ji*)
Het Gouden Paviljoen (*Kinkaku-ji*)
El Pabellón de Oro (*Kinkaku-ji*)
1397

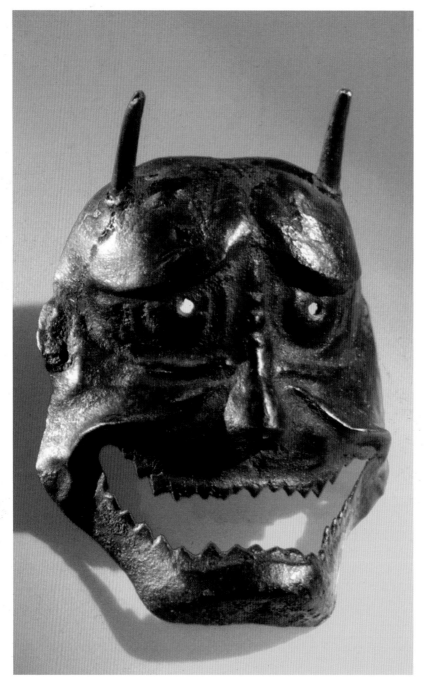

▶ *Netsuke* in the shape of
a tiger, one of the twelve
animals of the Japanese
Zodiac, ivory
Netsuke in Form eines
Tigers, einem der
zwölf japanischen
Tierkreiszeichen, Elfenbein
Netsuke in tijgervorm, een
van de twaalf dieren van de
Japanse dierenriem, ivoor
Netsuke en forma de tigre,
uno de los doce animales
del Zodíaco japonés, marfil
Victoria & Albert Museum,
London

Netsuke in the shape
of a demon's head, iron
Netsuke in Form eines
Dämonenkopfes, Eisen
Netsuke in de vorm
van een duivelshoofd, ijzer
Netsuke en forma de
cabeza de demonio, hierro
1100-1300
Private Collection
Private Sammlung
Privécollectie
Colección privada

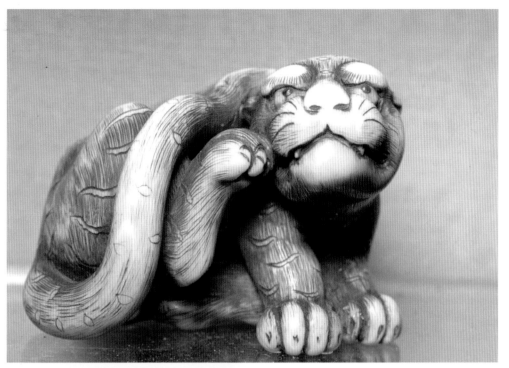

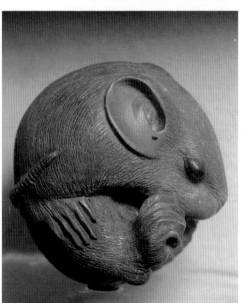

▐ The Netsuke have evolved from their practical use which allowed small containers to be hung from the sashes of the robes, generally without pockets, into objects of art.
▐ Die Netsuke haben sich von ihrer eigentlichen praktischen Verwendung als kleine Behälter, die an den Gürteln der in der Regel taschenlosen Kleidung befestigt wurden, zunehmend entfernt und wurden schließlich zu Kunstobjekten.
▐ De praktische Netsukes waarmee kleine recipiënten aan de riem gehangen werden bij kleding zonder zakken, hebben zich geëvolueerd in kunstvoorwerpen.
▐ Los Netsuke han evolucionado desde su primitivo uso práctico, que permitía colgar pequeños recipientes de los cinturones de los vestidos, generalmente sin bolsillo, a la dignidad de objetos de arte.

Netsuke depicting the mouse, another of the signs of the Zodiac, ivory
Netsuke in Form einer Maus, einem der Tierkreiszeichen, Elfenbein
Netsuke in de vorm van een rat, een dier uit de Japanse dierenriem, ivoor
Netsuke que representa al ratón, otro de los signos zodiacales, marfil
Victoria & Albert Museum, London

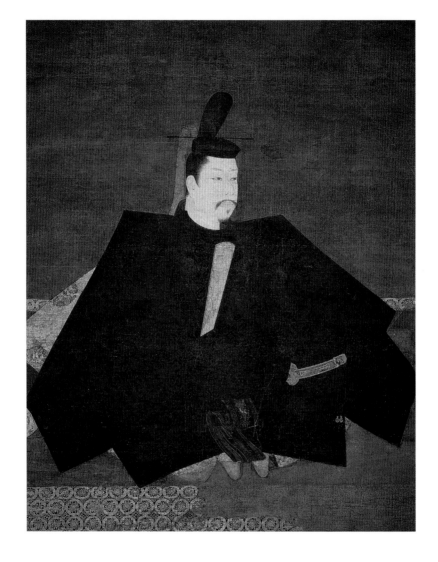

Fujiwara no Takanobu
(1142 - 1205)
Representation of Minamoto Yoritomo, founder of the Kamakura Shogunate, painting on silk
Darstellung von Minamoto Yoritomo, Gründer des Kamakura-Shogunats, Malerei auf Seide
Afbeelding van Minamoto Yoritomo, stichter van het Kamakura-shogunaat, verf op zijde
Representación de Minamoto Yoritomo, fundador del shogunato de Kamakura, pintura sobre seda
ca. 1179
Jingo-ji Temple, Kyoto

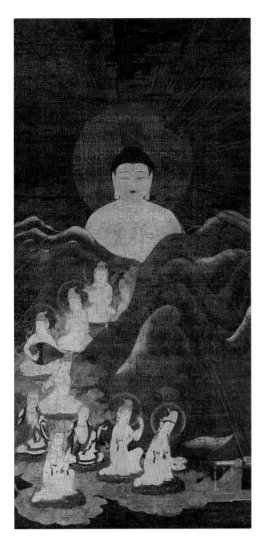

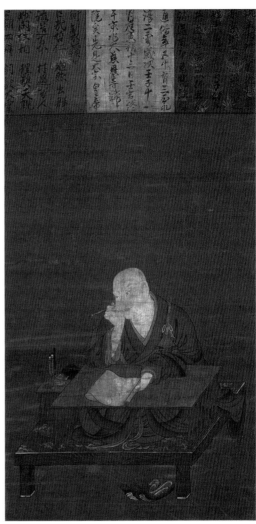

Amida preaches his doctrine to the Bodhisattva,
painting and gold on silk
Amida predigt den Bodhisattva seine Lehre,
Malerei und Gold auf Seide
Amida predikt zijn doctrine aan de Bodhisattva,
verf en goud op zijde
Amida predica a los Bodhisattva su doctrina,
pintura y oro sobre seda
1300-1400
Museum für Asiatische Kunst, Staatliche Museen, Berlin

Portrait of Jion Daishi, Buddhist patriarch, ink and paint on silk
Porträt von Jion Daishi, buddhistischer Patriarch, Tinte und Farbe auf Seide
Portret van Jion Daishi, boeddhistisch patriarch, inkt en verf op zijde
Retrato de Jion Daishi, patriarca budista, tinta y color sobre seda
1300-1400
Museum of Fine Arts, Boston

Bunsei
Landscape (*Sansuizu*), ink on paper
Landschaft (*Sansuizu*), Tinte auf Papier
Landschap (*Sansuizu*), inkt op papier
Paisaje (*Sansuizu*), tinta sobre papel
ca. 1450-1500
Museum of Fine Arts, Boston

Kano Chokichi
Landscape with pavilion, paintining on paper
Landschaft mit Pavillon, Malerei auf Papier
Landschap met paviljoen, verf op papier
Paisaje con pabellón, pintura sobre papel
ca. 1500
Museum für Asiatische Kunst, Staatliche Museen, Berlin

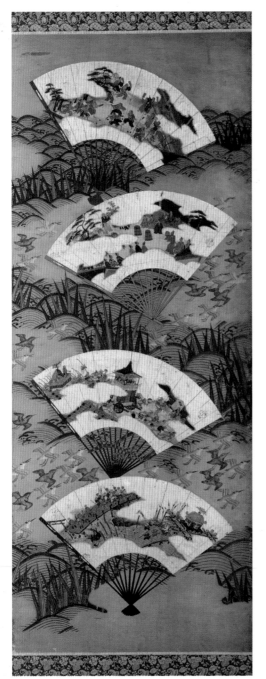

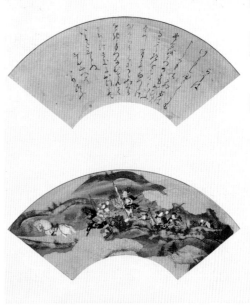

Fans from the series dedicated to the *Heike monogatari*
(Tale of the Heike), ink, paint and gold on paper
Fächer aus der Serie, die den *Heike monogatari*
(Geschichte der Heike) gewidmet ist, Tinte, Farbe und Gold auf Papier
Waaiers uit de serie voor *Heike monogatari*
(Geschiedenis van de Heike), inkt, verf en goud op papier
Abanicos de la serie dedicada al *Heike monogatari*
(Historia de los Heike), tinta, color y oro sobre papel
1600-1700
Museum für Asiatische Kunst, Staatliche Museen, Berlin

Kano Motonobu
(1476 - 1559)
Screen door with fans, ink, paint and gold on paper
Paraventante mit Fächer, Tinte, Farbe und Gold auf Papier
Paneel van een kamerscherm met waaiers, inkt, verf en goud op papier
Hoja de biombo con abanicos, tinta, color y oro sobre papel
1500-1600
Kouen-ji Temple, Kyoto

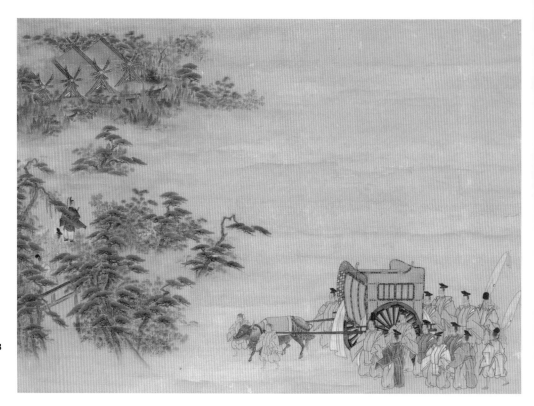

The Emperor Ichijo (980-1011) traveling, paint on paper
Der Kaiser Ichijo (980-1011) auf der Reise, Farbe auf Papier
Keizer Ichijo (980-1011) op reis, verf op papier
El emperador Ichijo (980-1011) en viaje, color sobre papel
1600
Ohara Shrine, Kyoto

▶ Detail of screen with pheasants
Detail eines Paravents mit Fasanen
Detail van een kamerscherm met fazanten
Detalle de mampara con faisanes
Museo Stibbert, Firenze

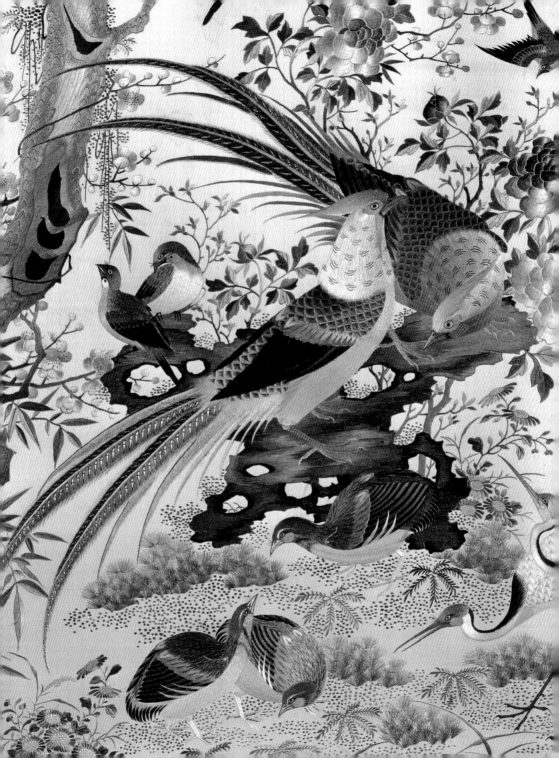

■ The Battle of Osaka (1614-1615) was the last Great War in Japan's history before the 19th century. With the Tokugawa clan's victory over the rival, Totyomi, a period of Shogun dominion began and lasted two and a half centuries.

■ Die Schlacht von Osaka (1614-1615) war das letzte große Kriegsereignis der Geschichte Japans vor dem 19. Jahrhundert. Mit dem Sieg des Tokugawa-Clans über die Rivalen Totoyomi begann das Zeitalter der Shogun-Herrschaft, das zweieinhalb Jahrhunderte andauerte.

■ De slag van Osaka (1614-1615) was de laatste grote oorlogsgebeurtenis in de Japanse geschiedenis voor de 19e eeuw. Met de overwinning van de Tokugawa-clan op hun rivalen Totoyomi begon een periode van Shogunale overheersing die twee en een halve eeuw zou duren.

■ La batalla de Osaka (1614-1615) fue el último gran evento bélico de la historia de Japón antes del siglo XIX. Con la victoria del clan Tokugawa sobre los rivales Totoyomi, se inauguraba el período de dominio shogunal que duró dos siglos y medio.

Detail of screen depicting *The Siege of Osaka Castle*
Detail eines Paravents, die Belagerung der Burg von Osaka darstellend
Detail van een kamerscherm met *De belaging van het Osaka-kasteel*
Detalle de biombo con imágenes de *El asedio al castillo de Osaka*
1600-1700
Kuroda Collection

Series of four sliding doors in the pavilion for pilgrims,
paper and painting on wood
Serie von vier Schiebetüren im Pavillon für Pilger,
Papier und Malerei auf Holz
Serie schuifdeuren in het paviljoen voor bedevaarders,
papier en verf op hout
Serie de cuatro puertas corredizas en el pabellón
para los peregrinos, papel y pintura sobre madera
Zuishin-in Temple, Kyoto

Series of sliding doors with landscape scene and detail, paper and painting on wood
Serie von vier Schiebetüren mit Landschaftsszenerie und Detail,
Papier und Malerei auf Holz
Serie schuifdeuren met landschapsafbeelding en detail, papier en verf op hout
Serie de puertas corredizas con escena de paisaje y detalle,
papel y pintura sobre madera
Zuishin-in Temple, Kyoto

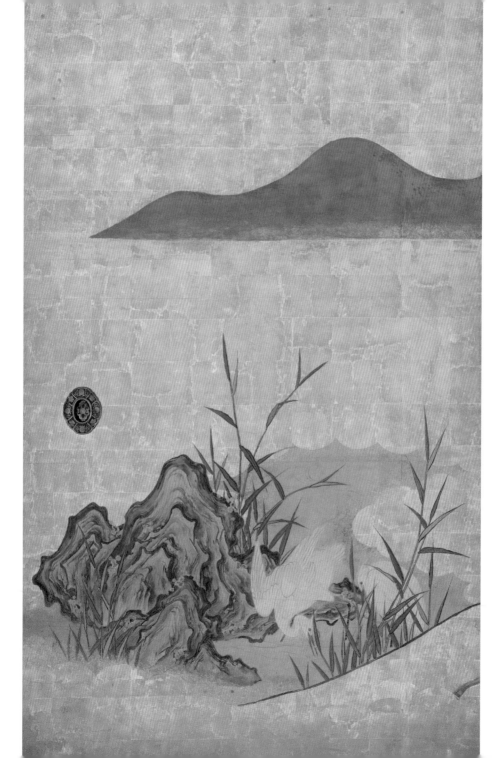

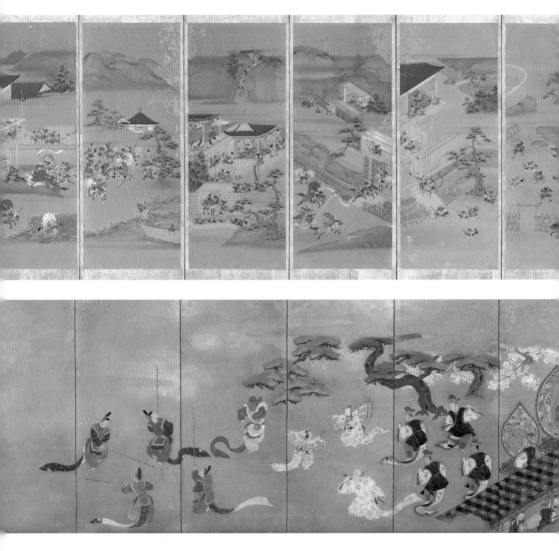

■ *The* bugaku, *a form of show that combines dance and music, has its origins on the continent; however, in Japan the original forms have evolved independently.*

■ *Der* Bugaku, *ein Spektakel, das Tanz und Musik vereint, hat seine Ursprünge auf dem Kontinent. In Japan haben sich seine ursprünglichen Formen autonom weiterentwickelt.*

■ *De* bugaku *is een dans- met muziekuitvoering en komt oorspronkelijk van het continent. De originele vormen hebben zich in Japan niettemin autonoom ontwikkeld.*

■ *El* bugaku, *forma de espectáculo que asocia danza y música, se originó en el continente; sin embargo, en Japón las formas originales evolucionaron de manera independiente.*

◀ Six panel screen
with images of war
(*Sentou no zu*),
painting on paper
Paravent mit
sechs Tafeln und
Schlachtendarstellungen
(Sentou no zu),
Malerei auf Papier
Kamerscherm met
zes panelen met
oorlogsafbeeldingen
(*Sentou no zu*),
verf op papier
Biombo de seis paneles
con imágenes de guerra
(*Sentou no zu*),
pintura sobre papel
Heian Jingu Shrine, Kyoto

◀ **Tanshin Kano**
Six panel screen with
bugaku dancers, painting
Paravent mit sechs Tafeln
und *Bugaku*-Tänzern,
Malerei
Kamerscherm met zes
panelen met *bugaku*-
dansers, verf
Biombo de seis paneles
con bailarines de
bugaku, pintura
Zuishin-in Temple, Kyoto

Detail of screen with
bugaku dancer, ink,
paint and gold on paper
Detail eines Paravents
mit *Bugaku*-Tänzer,
Tinte, Farbe und Gold
auf Papier
Detail van een
kamerscherm met
bugaku-dansers, inkt,
verf en goud op papier
Detalle de biombo con
bailarín de *bugaku*, tinta,
color y oro sobre papel
Iwashimizu Hachiman-gu

Portret van Ono no Komachi, beroemde hofdame en dichteres
Porträt von Ono no Komachi, berühmte Hofdame und Dichterin
Portret van Ono no Komachi, beroemde hofdame en dichter
Retrato de Ono no Komachi, célebre dama de corte y poetisa
1600-1700
Museo di Arte Orientale Chiossone, Genova

▶ **Torii Kiyomitsu**
(1735 - 1785)
Print with depiction taken from the drama *The Tale of the Soga Brothers*
Druck mit Darstellung aus der *Legende der Soga Brüder*
Print met een afbeelding uit het drama *Het verhaal van de Soga-broeders*
Estampa que representa una escena del drama *La venganza de los hermanos Soga*
1753-1759
The Newark Museum, Newark

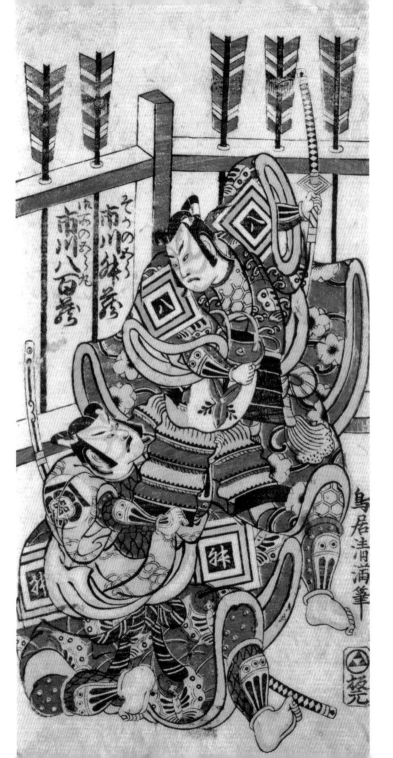

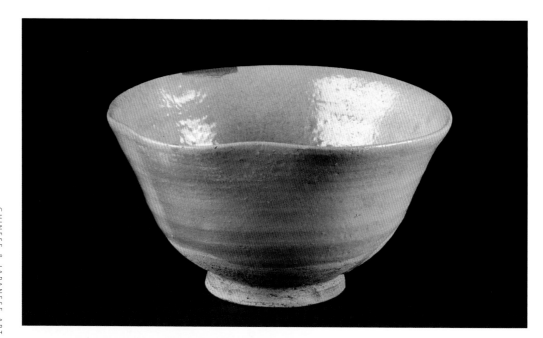

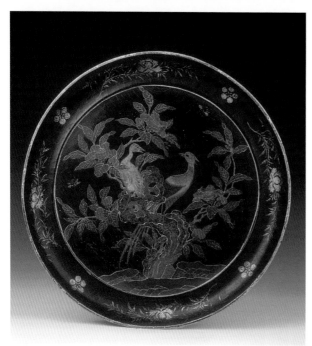

▌ The inrō are small containers that hang from sashes with toggles, netsuke. The practical origin did not prevent the use of precious materials which made them heavily collected.
▌ Die inrō sind kleine Behälter, die man mittels Anhänger, der Netsuke, an den Gürtel hängt. Ihre praktische Bestimmung hat jedoch nicht die Verwendung von kostbaren Materialien, die sie zum Gegenstand heißer Sammelleidenschaften machte, verhindern können.

Tea cup in the Izumo style, pottery
Teetasse im Izumo-Stil, Keramik
Theekopje in Izumo-stijl, keramiek
Taza de té en estilo Izumo, cerámica
1600-1700
Victoria & Albert Museum, London

Lacquered Ryukyu plate, pottery
Lackierter Ryukyu-Teller, Keramik
Gelakt Ryukyu bord, keramiek
Plato Ryukyu lacado, cerámica
1700-1730
Museum of East Asian Art, Bath

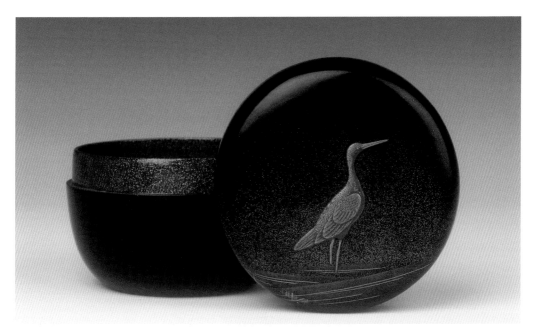

▊ *De* inrō *zijn kleine recipiënten die door middel van* netsuke, *een gordelknoop, aan de riem worden gehangen. De van oorsprong praktische functie heeft niet verhinderd dat er waardevolle materialen gebruikt werden waardoor de* inrō *bij kunstverzamelaars zeer gewild zijn.*

▊ *Los* inrō *son pequeños recipientes que penden de la cintura a través de colgantes,* netsuke. *Su origen práctico no ha impedido que el uso de materiales preciosos los hiciera objeto de un coleccionismo empedernido.*

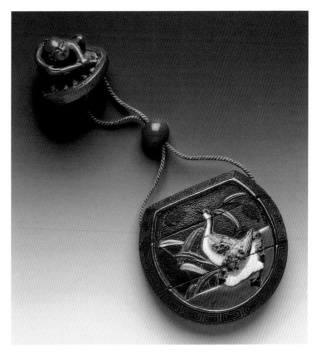

Small *inrō* container with *netsuke* in metal, lacquer
Kleiner *inrō*-Behälter mit *netsuke* in Metall, Lack
Kleine *inrō* met metalen *netsuke*, lak
Pequeño recipiente *inrō* con *netsuke* en metal, laca
1650-1700
Museum of East Asian Art, Bath

Inrō container with votive figurine and geese, lacquer
Inrō-Behälter mit Votivfigur und Gänsen, Lack
Inrō met Daruma en ganzen, lak
Recipiente *inrō* con estatuilla votiva y ocas, laca
ca. 1700-1747
Museum of East Asian Art, Bath

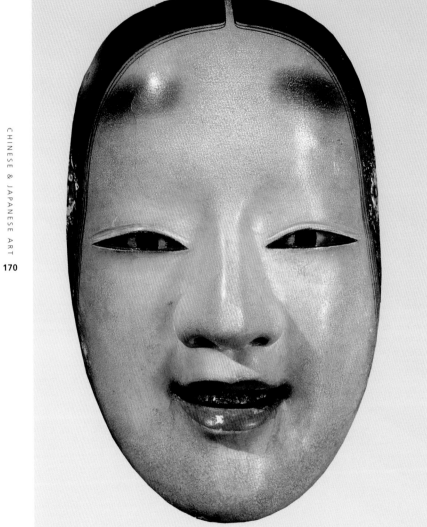

Mask of the Noh Theatre
depicting a young woman,
wood
Noh-Theatermaske in
Form einer jungen Frau,
Holz
Masker van een jonge
vrouw van het Nohtheater,
hout
Máscara del teatro Noh
que representa una mujer
joven, madera
Noh Theatre Collection
Kongo School, Kyoto

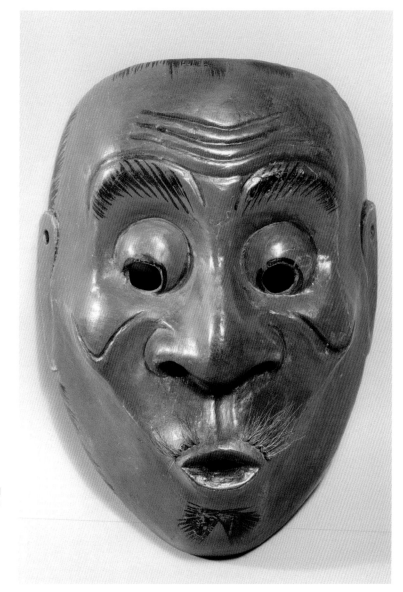

Mask for Noh in the
shape of a monkey, wood
Noh-Maske in Form eines
Affen, Holz
Apenmasker voor Noh,
hout
Máscara para Noh en
forma de mono, madera
Museo di Arte Orientale
Chiossone, Genova

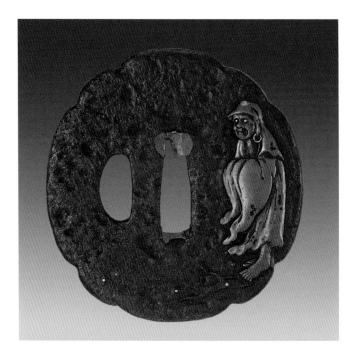

Japanese sword guard, *tsuba*, with design of votive *daruma* figurine, iron, copper and gold
Japanischer Schwertwächter, *tsuba*, mit Abbildung der Votivfigur *daruma*, Eisen, Kupfer und Gold
Japanse *tsuba*, met afbeelding van *daruma*, ijzer, koper en goud
Guardamanos de espada japonesa, *tsuba*, con dibujo de estatuilla votiva *daruma*, hierro, cobre y oro
ca. 1780-1810
Museum of Fine Arts, Boston

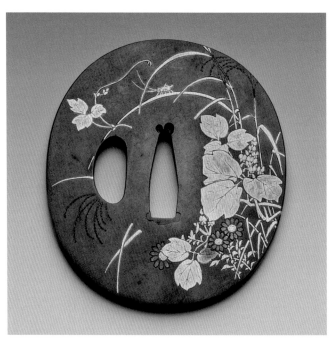

Tsuba decorated with grasses and crickets, alloy of copper and gold with gold applications
Tsuba mit Grillen- und Kräuterdekoration, Kupfer- und Goldlegierung mit Goldeinsätzen
Tsuba met versieringen van kruiden en krekels, koper- en goudlegering met gouden applicaties
Tsuba con decoraciones de hierbas y grillos, aleación de cobre y oro con aplicaciones en oro
ca. 1800-1820
Museum of East Asian Art, Bath

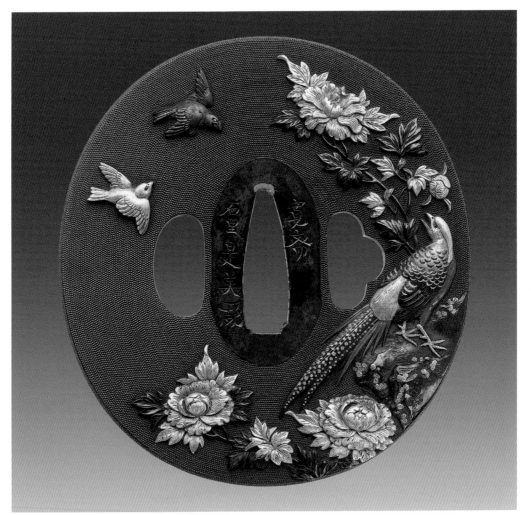

Ishiguro Koreyoshi
(1832 - 1887)
Tsuba with drawing of birds and flowers, metal alloy
Tsuba mit Abbildung von Vögeln und Blumen, Metalllegierung
Tsuba met afbeelding van vogels en bloemen, metaallegering
Tsuba con dibujo de pájaros y flores, aleación metálica
ca. 1850
Museum of Fine Arts, Boston

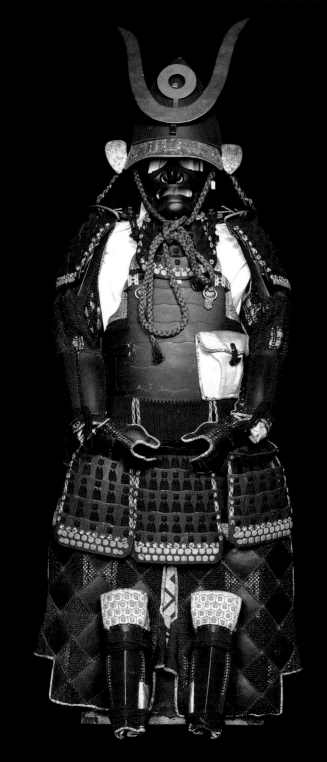

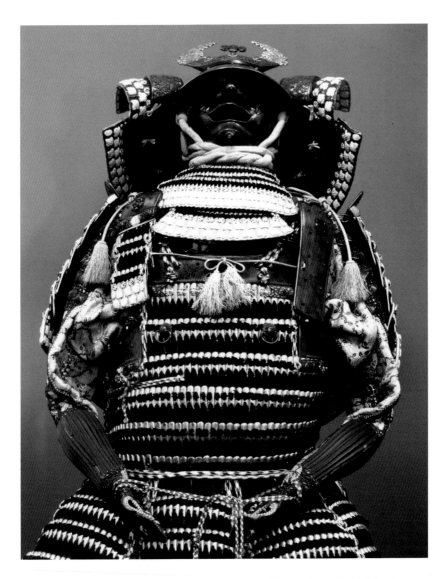

◄ Armour of the late Edo Period
for purely ceremonial use
Rüstung der späten Edo-Epoche mit rein
zeremonieller Funktion
Wapenuitrusting uit de late Edo-periode
met slechts een ceremoniële functie
Armadura del período Edo tardío con
función únicamente ceremonial
ca. 1800
Toyokuni Shrine, Kyoto

Armour of the Doi Clan, iron,
copper, leather and silk
Rüstung des Doi-Clans, Eisen,
Kupfer, Pelz und Seide
Wapenuitrusting van de Doi-clan,
ijzer, koper, leer en zijde
Armadura del clan Doi, hierro,
cobre, cuero y seda
ca. 1800-1820
Victoria & Albert Museum, London

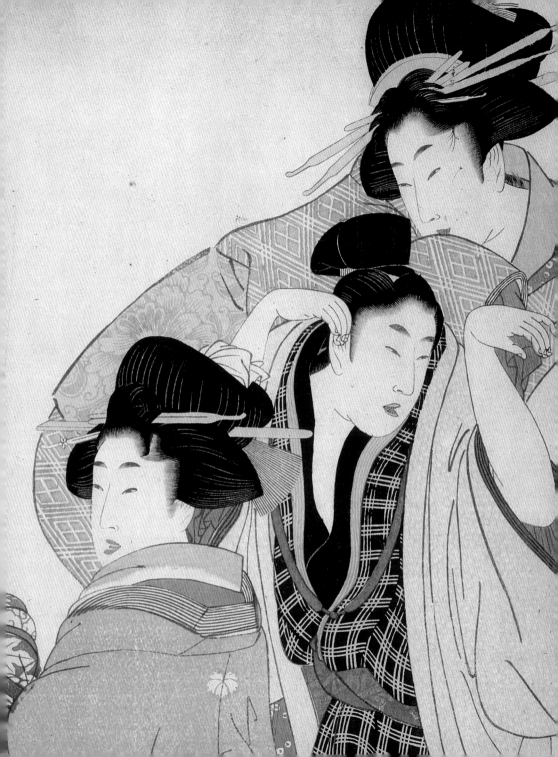

Tradition and modernity

In the 18th and 19th century, Japanese art was characterized by the emergence on a social level of a merchant class. Under the peace guaranteed by the Tokugawa shogunate, formally subject to the rule of the warriors, the merchants acquired a growing influence. Their vision of the world moulded the urban panorama, also stimulating new styles of art. In the "areas without night" of Osaka, Kobe, and Yokohama, new forms of painting and craftwork developed. The Ukiyo-e (pictures of the floating world) mirror the vitality of this new world.

Tradition und Moderne

Die japanische Kunst im 18. und 19. Jahrhundert ist geprägt von den gesellschaftlichen Ambitionen einer Handelsklasse. Der Frieden, den die der Herrschaft der Krieger unterstellten Shogun Tokugawa garantierten, brachte den Händlern zunehmenden Einfluss. Ihre Weltsicht prägt das Stadtbild und regt eine neue künstlerische Produktion an. In den 'nachtlosen Vierteln' von Osaka, Kobe und Yokohama entwickeln sich neue Formen der Malerei und des Kunsthandwerks. Ukiyo-e ('Bilder der fließenden Welt') reflektiert die Lebensfreude dieser neuen Welt.

6

Traditie en moderniteit

De Japanse kunst in de achttiende en negentiende eeuw werd gekenmerkt door de opkomst in de samenleving van een koopmanklasse. Onder de vrede gewaarborgd door de Tokugawa shogun, formeel geplaatst onder het domein van de krijgers, krijgen handelaars steeds meer invloed. Hun visie op de wereld vormt het stedelijk landschap, zo ook een nieuwe artistieke productie stimulerend. In de 'wijken zonder nacht' van Osaka, Kobe en Yokohama, ontwikkelen zich nieuwe vormen van schilderkunst en kunstnijverheid. De Ukiyo-e ('schilderij van de drijvende wereld "), weerspiegelt de vitaliteit van deze nieuwe wereld.

Tradición y modernidad

El arte japonés en los siglos XVIII y XIX se caracterizó por el surgimiento, en el plano social, de una clase mercantil. Bajo la paz garantizada por los shogunes Tokugawa, sometidos formalmente al dominio de los guerreros, los mercaderes adquieren un influjo creciente. Su visión del mundo forja el panorama urbano, estimulando también una nueva producción artística. En los 'barrios sin noche' de Osaka, Kobe y Yokohama, se desarrollan nuevas formas de pintura y de artesanado. El Ukiyo-e ('pintura del mundo fluctuante') refleja la vitalidad de este nuevo mundo.

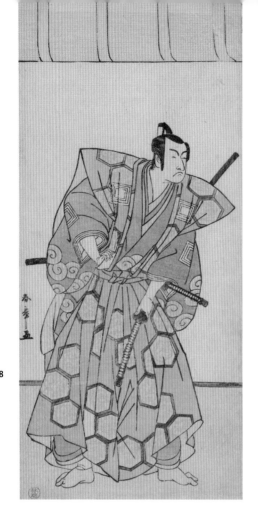
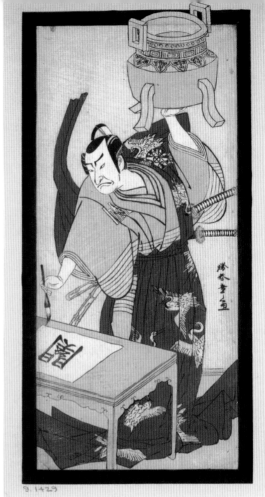

Katsukawa Shunshô
(1726 - 1792)
Kabuki actor, Ichikawa Danjuro V, playing Shigetada,
xylography on paper
*Der Kabuki-Schauspieler, Ichikawa Danjuro V,
der Shigetada darstellt*, Holzschnitt auf Papier
*Kabuki-acteu, Ichikawa Danjuro V,
die Shigetada vertolkt*, houtsnede op papier
*El actor kabuki, Ichikawa Danjuro V,
interpretando a Shigetada*, xilografía sobre papel
1781
Museum of Fine Arts, Boston

▌ *In contrast to the aristocratic Noh, the Kabuki was the prerogative
of the merchant class, which emerged during the Tokugawa period.
Kabuki actors and shows were the preferred subjects of Ukiyo-e prints.*
▌ *Im Gegensatz zum aristokratischen Noh, wurde der Kabuki
Kennzeichen der kaufmännischen Klasse, die während der
Tokugawa-Ära aufkommt. Schauspieler und Aufführungen des
Kabuki gehörten zu den Lieblingssujets der Ukiyo-e-Drucke.*
▌ *In tegenstelling tot de aristocratische Noh was de Kabuki een
voorrecht van de handelsklasse die tijdens het Tokugawa-tijdperk
opkwam. Kabuki-acteurs en voorstellingen waren geliefde
onderwerpen voor de Ukiyo-e pers.*
▌ *En contraposición al aristocrático Noh, el Kabuki era dominio
de la clase mercantil, emergente durante el período Tokugawa.
Los actores y el espectáculo del Kabuki estuvieron entre los temas
preferidos de la estampa Ukiyo-e.*

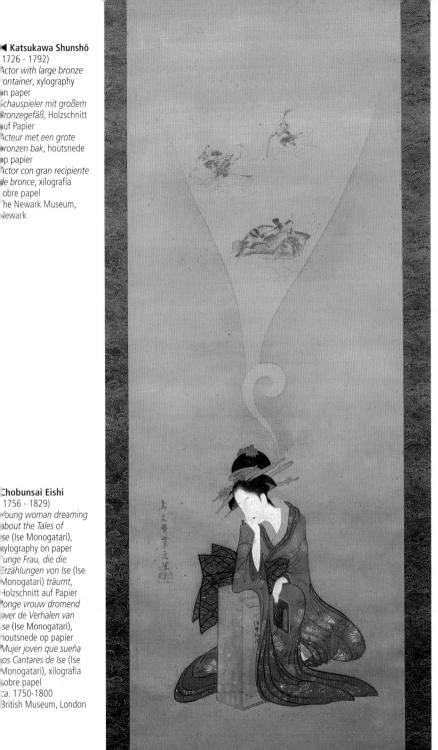

◀ Katsukawa Shunshô
(1726 - 1792)
Actor with large bronze container, xylography on paper
Schauspieler mit großem Bronzegefäß, Holzschnitt auf Papier
Acteur met een grote bronzen bak, houtsnede op papier
Actor con gran recipiente de bronce, xilografía sobre papel
The Newark Museum, Newark

Chobunsai Eishi
(1756 - 1829)
Young woman dreaming about the Tales of Ise (Ise Monogatari), xylography on paper
Junge Frau, die die Erzählungen von Ise (Ise Monogatari) träumt, Holzschnitt auf Papier
Jonge vrouw dromend over de Verhalen van Ise (Ise Monogatari), houtsnede op papier
Mujer joven que sueña los Cantares de Ise (Ise Monogatari), xilografía sobre papel
ca. 1750-1800
British Museum, London

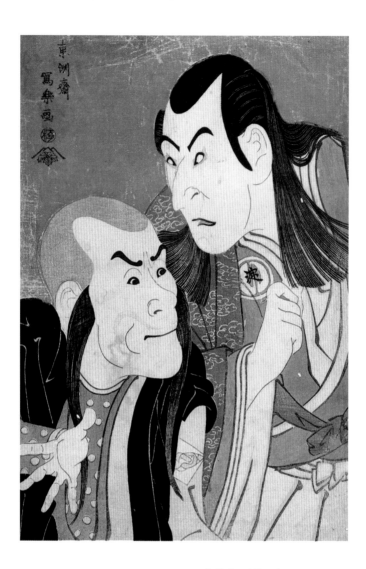

Toshusai Sharaku
(1770 - 1825)
Kabuki actors, xylography on paper
Schauspieler des Kabuki-Theaters, Holzschnitt auf Papier
Acteur van het Kabuki-theater, houtsnede op papier
Actores del teatro Kabuki, xilografía sobre papel
Museo di Arte Orientale Chiossone, Genova

▶ Toshusai Sharaku
(1770 - 1825)
Portrait of the actors Ichikawa Tomiemon and Sanokawa Ichimatsu,
xylography on paper
Porträt der Schauspieler Ichikawa Tomiemon und Sanokawa Ichimatsu,
Holzschnitt auf Papier
Portret van de acteurs Ichikawa Tomiemon en Sanokawa Ichimatsu,
houtsnede op papier
Retrato de los actores Ichikawa Tomiemon y Sanokawa Ichimatsu,
xilografía sobre papel
ca. 1794
Museum für Asiatische Kunst, Staatliche Museen, Berlin

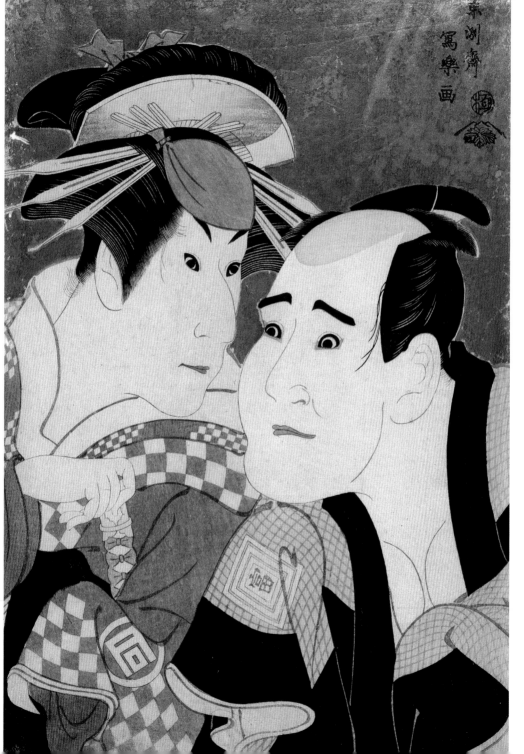

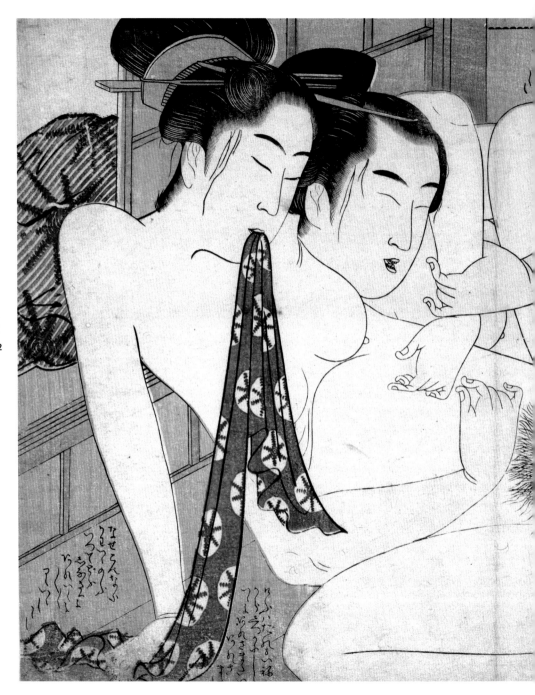

Kitagawa Utamaro
(? 1753 - Edo 1806)
Erotic scene, xylography on paper
Erotische Szene, Holzschnitt auf Papier
Erotische scène, houtsnede op papier
Escena erótica, xilografía sobre papel
ca. 1750-1800
Private Collection / Private Sammlung
Privécollectie / Colección privada

▮ Part of the new merchant culture, starting in the 18th century, life in the "pleasure quarters" becomes a central part of art as well starting in the 18th century.

▮ Als Teil der neuen Handelskultur gelangt das Leben der "Vergnügungsviertel" auch in der Kunst ab dem 18. Jahrhundert in den Mittelpunkt.

▮ Het leven in de "wijken van genot" maakte deel uit van de nieuwe handelscultuur en staat vanaf de 18e eeuw ook in de kunst centraal.

▮ Parte de la nueva cultura mercantil, la vida de los "barrios del placer" se convierte en protagonista también en el arte a partir del siglo XVIII.

Kitagawa Utamaro
(? 1753 - Edo 1806)
Couple flirting under the gaze of a servant, xylography on paper
Liebespaar, das unter dem Blick einer Bediensteten tändelt, Holzschnitt auf Papier
Flirtend stel in het bijzijn van een slaaf, houtsnede op papier
Pareja acariciándose ante la mirada de una sierva, xilografía sobre papel
ca. 1750-1800
Musée Guimet, Paris

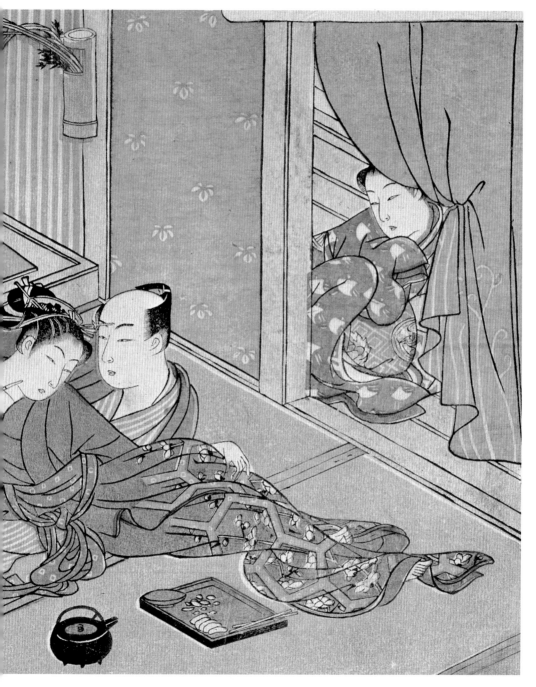

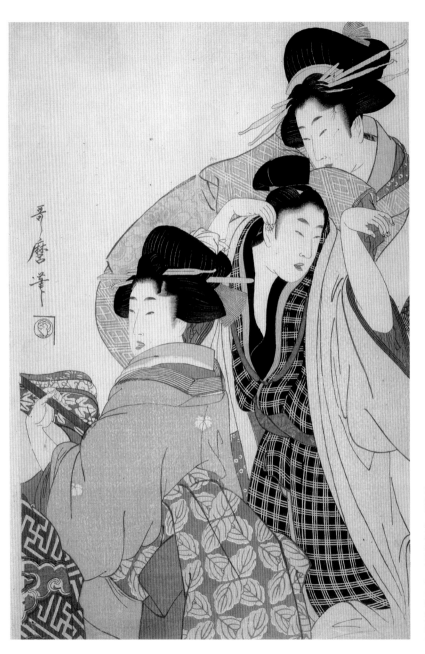

Kitagawa Utamaro
(? 1753 - Edo 1806)
Two geishas and a drunk client, xylography
Zwei Geisha und ein betrunkener Kunde, Holzschnitt
Twee geisha's en een dronken klant, houtsnede
Dos geishas y un cliente ebrio, xilografía
ca. 1805
Philadelphia Museum of Art, Philadelphia

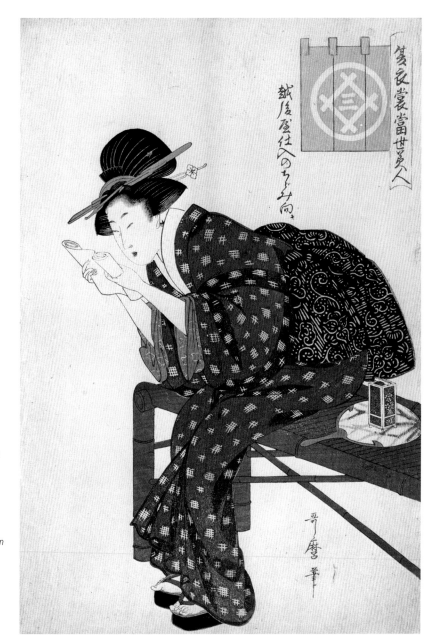

Kitagawa Utamaro
(? 1753 - Edo 1806)
Woman reading,
from the series *Beauties*
of our Times,
xylography on paper
Lesende Frau aus der
Serie *Schönheiten*
unserer Zeit,
Holzschnitt auf Papier
Lezende vrouw,
uit de serie *Schoonheden*
uit onze tijd, houtsnede
op papier
Mujer leyendo,
de la serie *Bellezas*
de nuestros tiempos,
xilografía sobre papel
1804-1806
Musée Guimet, Paris

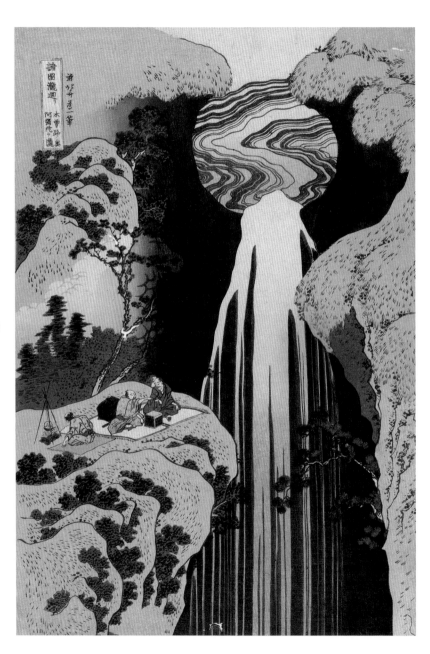

Katsushika Hokusai
(Edo 1760 - 1849)
*The Amida Waterfall
between the mountains
of the Kiso,*
xylography on paper
*Der Amida-Wasserfall
in den Bergen des Kiso,*
Holzschnitt auf Papier
*De waterval van Amida
in de bergen van Kiso,*
houtsnede op papier
*La cascada de Amida entre
las montañas del Kiso,*
xilografía sobre papel
1833
Museum für Asiatische
Kunst, Staatliche Museen,
Berlin

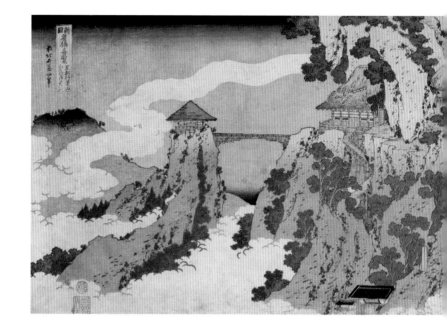

Katsushika Hokusai
(Edo 1760 - 1849)
View of Konodrai,
xylography on paper
Ansicht von Konodrai,
Holzschnitt auf Papier
Uitzicht op Konodrai,
houtsnede op papier
Vista de Konodrai,
xilografía sobre papel
Museo di Arte Orientale
Chiossone, Genova

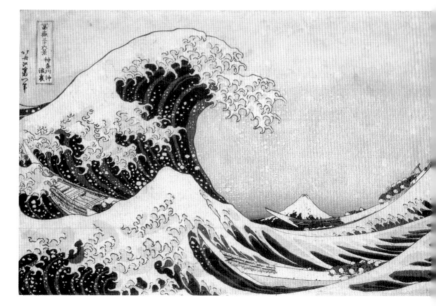

Katsushika Hokusai
(Edo 1760 - 1849)
The Great Wave,
xylography on paper
Die große Welle,
Holzschnitt auf Papier
De grote golf,
houtsnede op papier
La gran ola,
xilografía sobre papel
ca. 1830-1831
Victoria & Albert Museum,
London

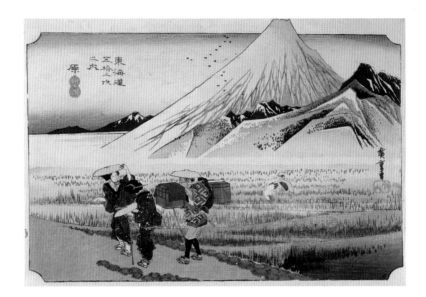

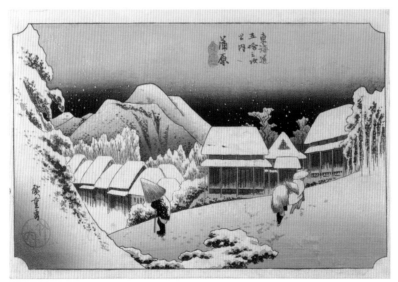

▌ *The fascination of the Tokaido (The East Sea Road) which connected Tokyo, center of the Shogun administration, to Kyoto, residence of theEmperor, led Utagawa Hiroshige to paint its most characteristic landscapes in the series "53 Stations of the Tokaido".*
▌ *Die Faszination des Tokaido (östlicher Seeweg), der Tokio, das Verwaltungszentrum der Shogun, mit Kioto, dem kaiserlichen Wohnsitz verband, hat Utagawa Hiroshige veranlasst, die charakteristischsten Landschaften in der Serie "53 Stationen des Tokaido" darzustellen*
▌ *De bekoring van de Tokaido (oostelijke zeeweg) die Tokyo, shogunaal bestuurscentrum, met Kyoto, de residentie van de keizer, verbond, heeft Utagawa Hiroshige ertoe aangezet de meest karakteristieke landschappen in de serie "53 halteplaatsen van de Tokaido" na te maker*
▌ *El encanto de la Tokaido (Ruta del mar oriental), que conectaba Tokio, centro de la administración shogunal, con Kioto, residencia del emperador, ha impulsado a Utagawa Hiroshige a reproducir sus paisajes más característicos en la serie "53 Estaciones de la Tokaido".*

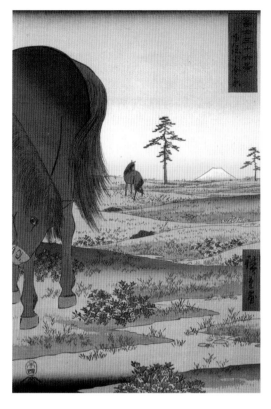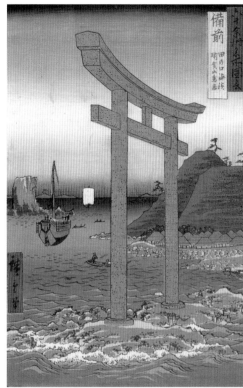

◄ **Utagawa (Andō) Hiroshige**
(Edo 1797 - 1858)
Mt. Fuji in the morning, from the series *Tokaido*, n. 14,
xylography on paper
Der Fuji am Morgen, aus der Serie *Tokaido*, Nr. 14,
Holzschnitt auf Papier
Fuji 's morgens, uit de serie *Tokaido*, n. 14, houtsnede op papier
El Fuji por la mañana, de la serie *Tokaido*, n. 14, xilografía sobre papel
1833-1834
The Newark Museum, Newark

◄ **Utagawa (Andō) Hiroshige**
(Edo 1797 - 1858)
A mountain village under the snow, from the series *Tokaido*, n. 16,
xylography on paper
Ein schneebedecktes Bergdorf, aus der Serie *Tokaido*, Nr. 16,
Holzschnitt auf Papier
Een bergdorp in de sneeuw, uit de serie *Tokaido*, n. 16,
houtsnede op papier
Un pueblo de montaña bajo la nieve, de la serie *Tokaido*, n. 16,
xilografía sobre papel
1833-1834
The Newark Museum, Newark

Utagawa (Andō) Hiroshige
(Edo 1797 - 1858)
Mt. Fuji from Koganegahara, Shimosa, xylography on paper
Der Fuji von Koganegahara, Shimosa, Holzschnitt auf Papier
Fuji, Koganegahara, Shimosa, houtsnede op papier
El Fuji desde Koganegahara, Shimosa, xilografía sobre papel
ca. 1858
The Newark Museum, Newark

Utagawa (Andō) Hiroshige
(Edo 1797 - 1858)
Stone entrance portal to the temple of Yuga
on the coast of Tanokuchi, xylography on paper
Steinernes Eingangsportal zum Yuga-Tempel
an der Küste von Tanokuchi, Holzschnitt auf Papier
Stenen poort bij de tempel van Yuga aan de kust
van Tanokuchi, houtsnede op papier
Portal de ingreso de piedra del templo de Yuga
en la costa de Tanokuchi, xilografía sobre papel
1853
Museum of Fine Arts, Boston

Utagawa Kunisada
(1786 - 1864)
Ono no Komachi,
famous court poet,
xylography on paper
Ono no Komachi,
berühmte Hofdichterin,
Holzschnitt auf Papier
Ono no Komachi,
beroemde hofdichteres,
houtsnede op papier
Ono no Komachi,
célebre poetisa de corte,
xilografía sobre papel
ca. 1845
Museum of Fine Arts,
Boston

Tsukioka Yoshitoshi
(1839 - 1892)
*Iga no Tsubone and
the ghost of Fujiwara
Nakanari,*
xylography on paper
*Iga no Tsubone und das
Gespenst von Fujiwara
Nakanari,*
Holzschnitt auf Papier
*Iga no Tsubone en de
geestesverschijning
van Fujiwara Nakanari,*
houtsnede op papier
*Iga no Tsubone y el
fantasma de Fujiwara
Nakanari,*
xilografía sobre papel
1865
Museum of Fine Arts,
Boston

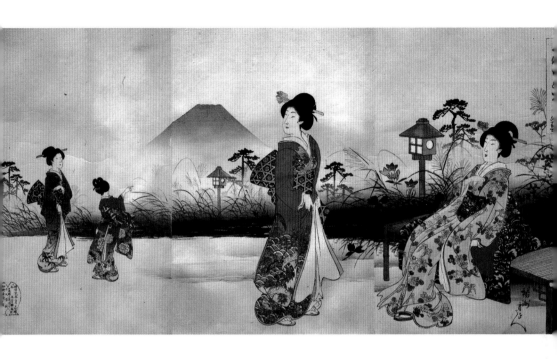

◄ Utagawa Kuniyoshi
(1797 - 1861)
A Samurai, xylography on paper
Samurai, Holzschnitt auf Papier
Een samurai, houtsnede op papier
Un samurái, xilografía sobre papel
ca. 1850
Museo Pedro Coronel, Zacatecas (México)

Toyohara Chikanobu
(1838 - 1912)
Young women in a garden, Mt. Fuji, from the series
The uses of the inner palace of Chiyoda Castle, xylography on paper
Junge Frauen in einem Garten der Fuji, aus der Serie
die Verwendungen des inneren Palasts der Burg von Chiyoda, Holzschnitt auf Papier
Jonge dames in een tuin bij de Fuji-berg, uit de serie
Paleisgebruiken binnen het Chiyoda-kasteel, houtsnede op papier
Mujeres jóvenes paseando frente al monte Fuji, de la serie
Los usos del palacio interno del castillo de Chíyoda, xilografía sobre papel
1896
Private Collection / Private Sammlung / Privécollectie / Colección privada

Tessai Tomioka
(1837 - 1924)
Houkoku shrine, paint on paper
Houkoku-Schrein, Farbe auf Papier
Houkoku shirine, verf op papier
Houkoku shrine, color sobre papel
Toyokuni Shrine, Kyoto

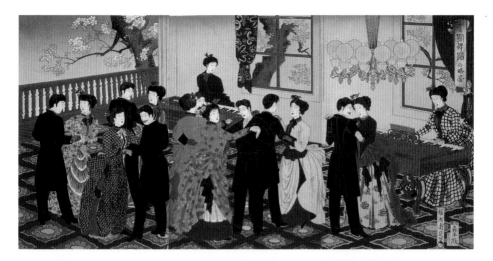

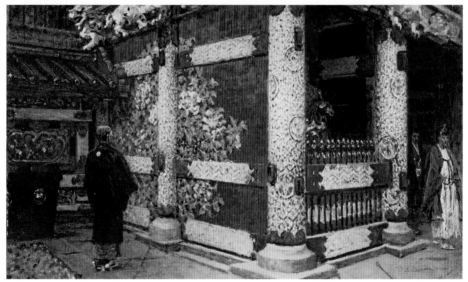

Yoshu Shuen
(1868 - 1920)
Relaxation and dances in a meeting place of the Meiji Period
Unterhaltung und Tänze in einem Lokal der Meiji-Epoche
Vertier en dans tijdens het Meiji-tijdperk
Diversión y bailes en un local del periodo Meiji
ca. 1890

Vasilij Vereshchagin
(1842 - 1904)
Shinto shrine at Nikko, oil on canvas
Shintoistisches Heiligtum in Nikko, Öl auf Leinwand
Shintoïstisch heiligdom in Nikko, olieverf op doek
Templo sintoísta en Nikko, óleo sobre lienzo
1903
The State Russian Museum, St. Petersburg

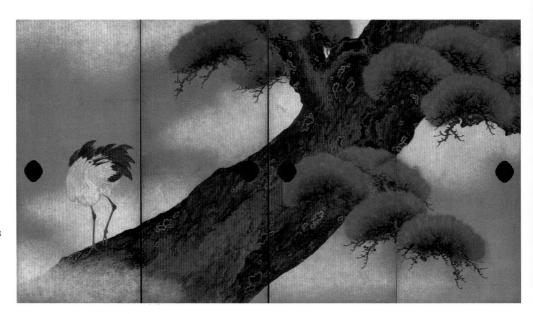

Mochizuki Gyokkei
(1874 - 1938)
Four sliding doors (*Syoubikan fusuma-e*) and detail, paint and gold on paper
Vier Schiebetütren (*Syoubikan fusuma-e*) und Detail, Farbe und Gold auf Papier
Vier schuifdeuren met details (*Syoubikan fusuma-e*), verf en goud op papier
Cuatro puertas corredizas (*Syoubikan fusuma-e*) y detalle, color y oro sobre papel
Heian-jingu Shrine, Kyoto

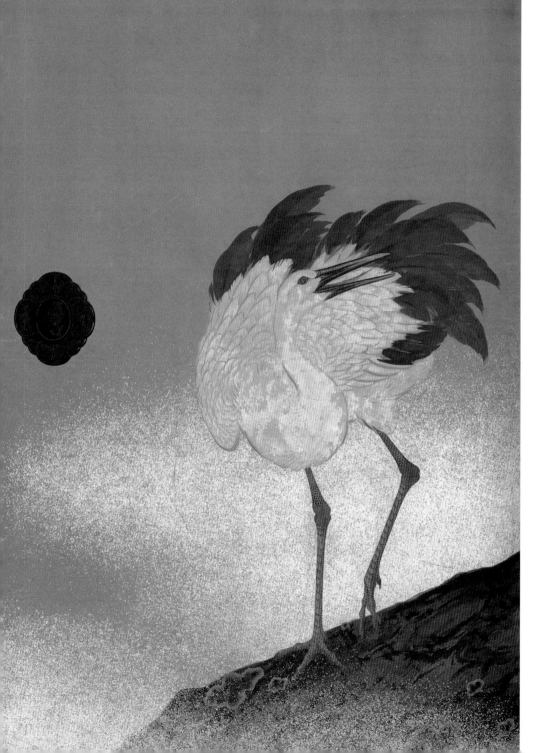

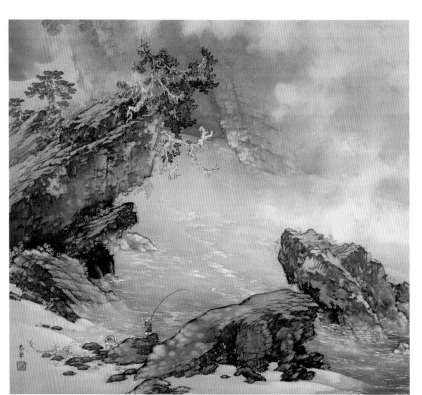

Yamamoto Shunkyo
(Shiga-ken 1871 - 1933)
*The clear waters of the
Sea of Hozu*, ink and
paint on silk
*Die klaren Wasser der
Gezeiten von Hozu*, Tinte
und Farbe auf Seide
*De heldere wateren van
het Hozu-getij*, inkt en
verf op zijde
*Las aguas claras de la
marea de Hozu*, tinta y
color sobre seda
1930
Museum für Asiatische
Kunst, Staatliche
Museen, Berlin

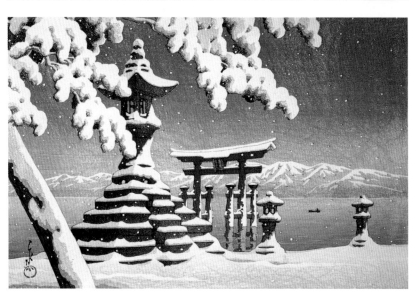

Kawase Hasui
(1883 - 1957)
*Torii portal of the
Itsukushima Temple
under the snow*,
xylography
*Torii-Portal des
Itsukushima-Tempels
im Schnee*, Holzschnitt
*Torii-poort van de
Itsukushima-tempel in de
sneeuw*, houtsnede
*Portal torii del templo
de Itsukushima bajo la
nieve*, xilografía
1932

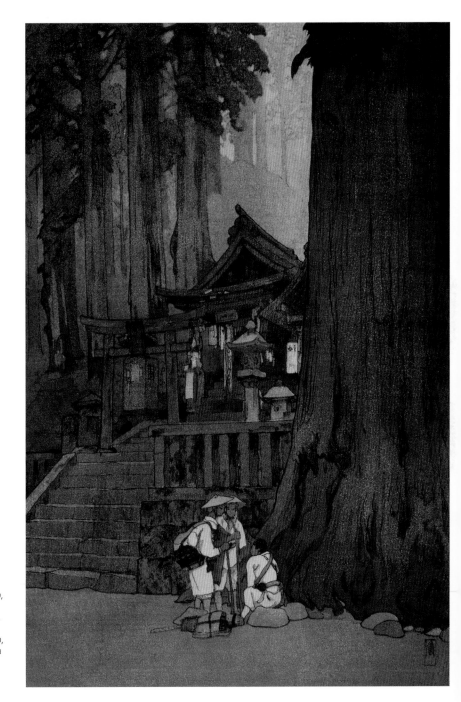

Hiroshi Yoshida
(1876 - 1950)
Foggy day at Nikko,
wood carving
Nebeliger Tag in Nikko,
Holzschnitt
Nevelige dag in Nikko,
gravure op hout
Día de niebla en Nikko,
grabado sobre madera
ca. 1940
The Newark Museum,
Newark

KOREA
The land of the morning calm

A land of transit and conquest, Korea has been affected by the wars fought on its territory. This influenced Art, mainly in regards to the immense losses sustained by the country's artistic artifacts. What survived, starting with the works of the first local dynasty in the 2nd century BCE, and passing through the "three dynasties": Silla (57 BCE - 935 CE), Koguryo (37 BCE - 668 CE), and Paekche (18 BCE - 660 CE), and the next unified Koryo dynasty (918-1392), shows a strong originality compared to Chinese art. Korea's distinct shamanic tradition, which distinguished its art, provided it with passion and originality.

KOREA
Das Land der Morgenfrische

Als Land des Transitverkehrs und der Eroberung hat Korea Kriege erleiden müssen, die auf seinem Territorium ausgetragen wurden. Davon ist auch die Kunst beeinflusst worden, vor allem wegen der großen Verluste, die das Kulturerbe davongetragen hat. Die erhaltenen Werke der ersten regionalen Dynastie im 2. Jahrhundert v. Chr. bis zu den 'drei Dynastien' der Silla (57 v. Chr. – 935 n.Chr.), Koguryo (37 v. Chr. – 668 n.Chr.), Paekche (18 v. Chr. – 660 n.Chr.) und der vereinten Dynastie der Koryo (918-1392), erscheint ausgesprochen eigenständig gegenüber der chinesischen Kunst. Darüber hinaus hat Korea in der schamanischen Tradition ein Unterscheidungsmerkmal, das seine Kunst charakterisiert und ihr Nachdruck und Authentizität verleiht.

7

KOREA
Land van de Ochtendrust

Land van doorvoer en verovering, Korea heeft te lijden van oorlogen die zijn uitgevochten op haar grondgebied. De kunst hebben zij op hun beurt beïnvloed, vooral door de enorme verliezen geleden door het artistieke erfgoed. Wat overleefd had, beginnend met de werken van de eerste lokale dynastie in de tweede eeuw voor Christus, doorgaand voor de "drie dynastieën ' Silla (57 v. Chr. - 935 na Chr.), Koguryo (37 v. Chr. – 668 na Chr.), Paekche (18 v. Chr. - 660 na Chr.), en de volgende verenigde dynastie, Koryo (918-1392), toont een sterke originaliteit ten opzichte van de Chinese kunst. Korea heeft ook in de sjamanistische traditie een onderscheidend kenmerk, die de kunst van het kenmerkt met kracht en originaliteit.

COREA
La Tierra de la Calma matinal

Tierra de tránsito y de conquista, Corea sufrió las consecuencias de las guerras que se combatieron en su territorio. El arte también fue influenciado por esta situación, sobre todo por las inmensas pérdidas sufridas en el patrimonio artístico. Lo que se ha salvado, a partir de las obras de la primera dinastía local en el siglo II a. C., pasando por las 'tres dinastías': Silla (57 a.C. - 935 d.C.), Koguryo (37 a.C. - 668 d.C.), Paekche (18 a.C. - 660 d.C.), y por la sucesiva dinastía unificada, Koryo (918-1392), manifiesta una fuerte originalidad respecto al arte chino. Corea posee, además, en la tradición chamánica un rasgo distintivo que caracteriza su arte, dándole vigor y originalidad.

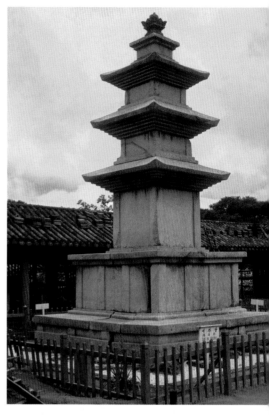

Kyongju
Chomsongdae, ancient astronomical observatory
Die alte Sternwarte Chomsongdae
Het oude sterrenkundig observatorium Chomsongdae
El antiguo observatorio astronómico Chomsongdae
600

Kyongju
Pulguksa Temple
Seokgatap Pagoda
Seokgatap-Pagode
Seokgatap-pagode
Pagoda Seokgatap
700

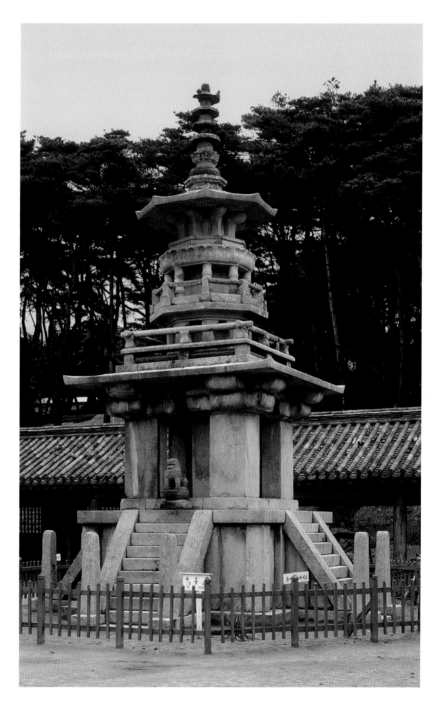

Kyongju
Pulguksa Temple
Dabotap Pagoda
Dabotap-Pagode
Dabotap-pagode
Pagoda Dabotap
600-700

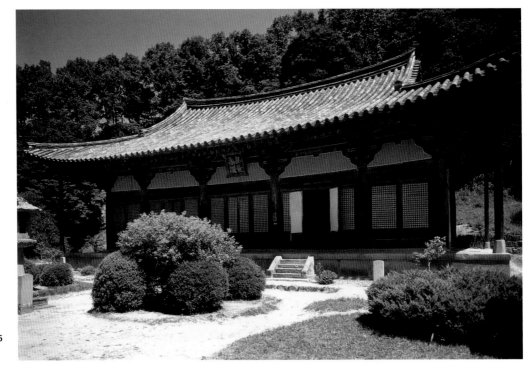

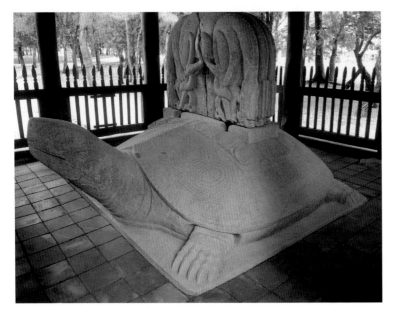

Yongju-Gun
Monastery of Pusok-sa
of the Koryo Period
Kloster Pusok-sa
aus der Koryo-Epoche
Monasterie van Pusok-sa
uit de Koryo-periode
Monasterio de Pusok-sa
del período Koryo
1358

Kyongju
Tombstone of Kind Muyol
from the Temple of Pulguksa
Gedenksteine des Königs Muyol
aus dem Pulguksa-Tempel
Grafsteen van koning Muyol
uit de tempel van Pulguksa
Lápida del rey Muyol del templo
de Pulguksa

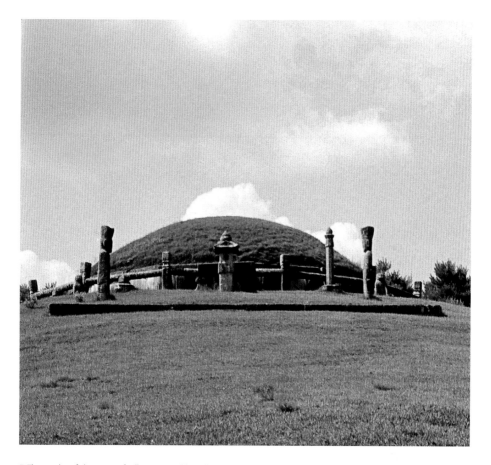

▌ *The tombs of the reign of Silla, surround by pillars carved with representations of the Zodiac and guardians, are typical of the dawn of the history of Korean art.*
▌ *Die Grabmale des Silla-Reichs, die von gemeißelten Säulen mit Darstellungen des Tierkreiszeichens und der Wächter umgeben sind, kennzeichnen die Frühzeit der koreanischen Kunstgeschichte.*
▌ *De graftombes van het Silla-rijk zijn omgeven door pilaren die de dierenriem en bewakers voorstellen en zijn kenmerkend in het begin van de Koreaanse kunst.*
▌ *Los túmulos sepulcrales del reino de Silla, rodeados de pilares esculpidos con representaciones del Zodíaco y de los guardianes, son característicos de los albores del arte coreano.*

Kyongju
Tomb of General Kim Yusin characteristic of the Silla Period
Grabmal des Generals Kim Yusin, charakteristisch für die Silla-Epoche
Graf van generaal Kim Yusin kenmerkend voor de Silla-periode
Tumba del general Kim Yusin característica del período Silla
676-936

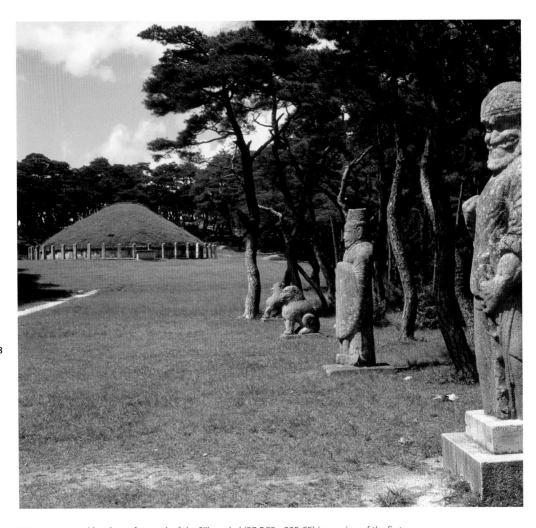

❚ *Kwaerung, considered a perfect tomb of the Silla period (57 BCE - 935 CE) is a review of the first
but already evolved sculpture techniques.*
❚ *Kwaereung gilt als vollkommenes Grabmal der Silla-Epoche (57 v. Chr. - 935 n. Chr.)
und bietet einen Überblick über die ersten bereits entwickelten bildhauerischen Techniken.*
❚ *Kwaereung, de perfecte tombe uit de Silla-periode (57 v. Chr. - 935 na Chr.) geeft een beeld
van de eerste maar reeds ver ontwikkelde beeldhouwtechnieken.*
❚ *Kwaereung, considerada una tumba perfecta del período Silla (57 a.C. - 935 d.C.),
constituye una reseña de las primeras, aunque ya avanzadas, técnicas escultóricas.*

Kyongju
Statues from the tomb of King Wonssung Kwae Nung (785-798)
Statue aus dem Grabmal des Königs Wonssung Kwae Nung (785-798)
Grafbeelden van koning Wonssung Kwae Nung (785-798)
Estatuas de la tumba del rey Wonssung Kwae Nung (785-798)

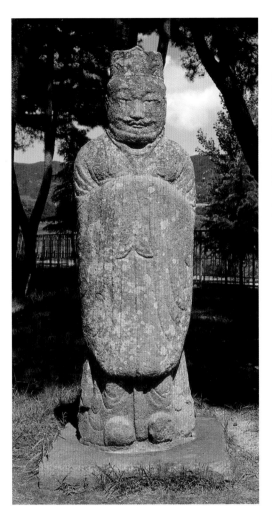

Kyongju
Front view of the statues that surround the tomb of King Wonssung Kwae Nung (785-798)
Vorderansicht der Statuen, die das Grabmal des Königs Wonssung umgeben Kwae Nung (785-798)
Beelden die het graf van koning Wonssung omringen Kwae Nung (785-798)
Vista frontal de las estatuas que rodean la tumba del rey Wonssung Kwae Nung (785-798)

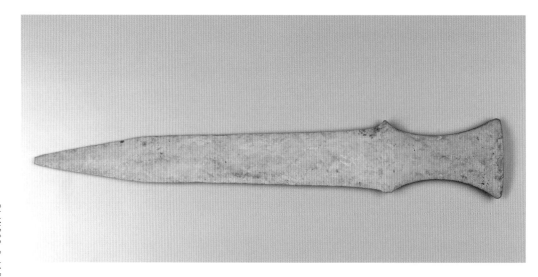

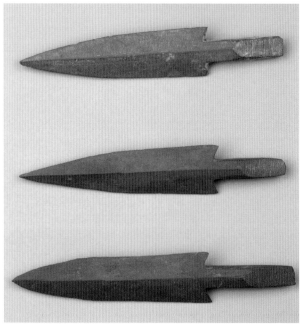

Dagger for ritual use, slate
Dolch für rituellen Gebrauch, Schiefer
Daga voor ritueel gebruik, leisteen
Daga para uso ritual, pizarra
1000-300 BCE
Museum of Fine Arts, Boston

▶ Container with wide pedestal, stoneware
Behältnis mit breitem Sockel, Steingut
Bak met breed voetstuk, gres
Recipiente con amplio pedestal, gres
400-600
The Metropolitan Museum of Art, New York

▶ Ceremonial vase with pedestal, stoneware
Zeremonienvase mit Sockel, Steingut
Ceremoniële vaas met voetstuk, gres
Jarrón ceremonial con pedestal, gres
400-600
Kimbell Art Museum, Fort Worth

Arrowheads, stone
Pfeilspitzen, Stein
Speerpunten, steen
Puntas de flecha, piedra
1000-300 BCE
Museum of Fine Arts, Boston

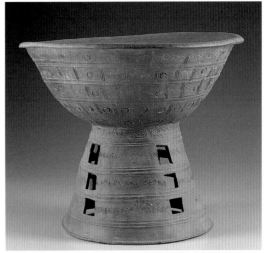

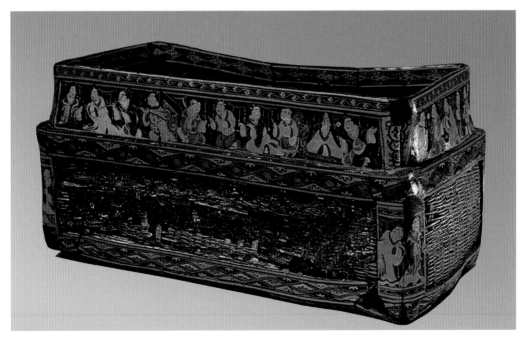

Basket from a tomb of the Chinese Colony of Lelang with depiction of exemplary children, lacquered wood
Korb aus einem Grabmal der chinesischen Kolonie von Lelang mit Darstellung der vorbildlichen Söhne, lackiertes Holz
Kist uit een graftombe uit de Lelang-kolonie met afbeeldingen van modelzonen, gelakt hout
Cesta de una tumba de la colonia china de Lelang con representación de hijos ejemplares, madera lacada
206 BCE - 220 CE
Central History Museum, Pyongyang

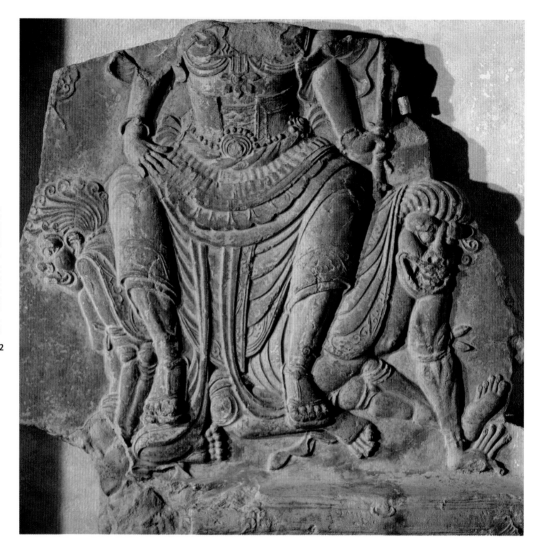

Tile that represents a victorious nobleman or god over the forces of evil, terracotta
Kachel, die einen über die Kräfte des Bösen siegreichen Adeligen oder Gottheit darstellt, Terrakotta
Steen met een edelman of godheid die het kwaad meester is, terracotta
Ladrillo que representa a un noble o a una divinidad victoriosa sobre las fuerzas del mal, terracota
600-700
National Museum of Korea, Seoul

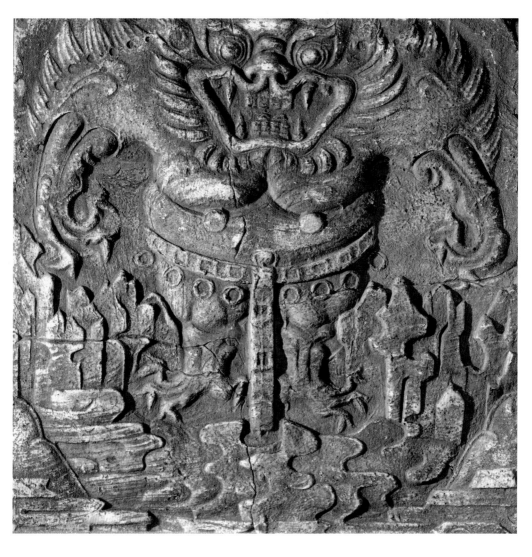

Tile with depiction of demon, terracotta
Kachel mit Dämonendarstellung, Terrakotta
Steen met een afbeelding van de duivel, terracotta
Ladrillo con representación del demonio, terracota
600-700
National Museum of Korea, Seoul

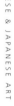

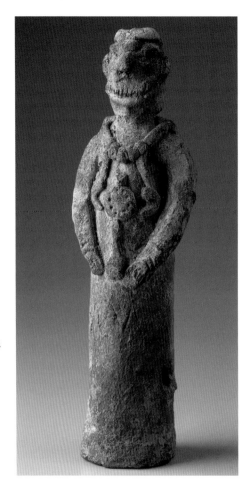

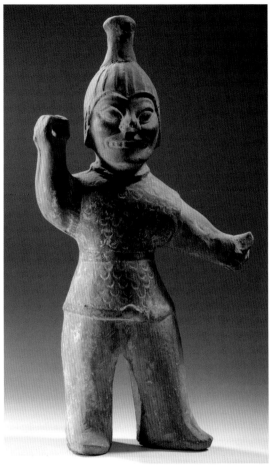

▌ Soon overthrown by Buddhism as institutional faith, Korean shamanism represents
one of the most persistent and widespread ancestral religions in the Far East.
▌ Der früh vom Buddhismus als institutionelle Glaubensrichtung übertroffene koreanische Schamanismus
stellt eines der ausdauerndsten und verbreitetsten Beispiele von Ahnenreligion im Fernen Osten dar.
▌ Het Koreaanse sjamanisme dat als institutioneel geloof spoedig overtroffen wordt door het boeddhisme,
vormt één van de langdurigste en meest verspreide oude godsdiensten in het Verre Oosten.
▌ Pronto superado por el budismo como religión institucional, el chamanismo coreano
representa uno de los ejemplos más persistentes y difundidos de las religiones ancestrales en el Lejano Oriente.

Small figure probably for funerary use, clay
Kleine Figur, wahrscheinlich zu Begräbniszwecken, Ton
Klein beeld waarschijnlijk voor grafgebruik, klei
Pequeña figura, probablemente de uso funerario, arcilla
700-900
Museum of Fine Arts, Boston

Figurine of exorcist
Exorzistenfigur
Beeld van een exorcist
Estatuilla de exorcista
Musée Cernuschi, Paris

Crown originally decorated with semi-precious stones, copper
Eine ursprünglich mit Halbedelsteinen verzierte Krone, Kupfer
Kroon oorspronkelijk versierd met semi-edelstenen, koper
Corona originalmente decorada con incrustaciones de piedras semipreciosas, cobre
500-600
San Francisco Museum of Asiatic Art, San Francisco

Gold earrings
Goldohrringe
Gouden oorbellen
Aretes de oro
ca. 400-420
The Metropolitan Museum of Art, New York

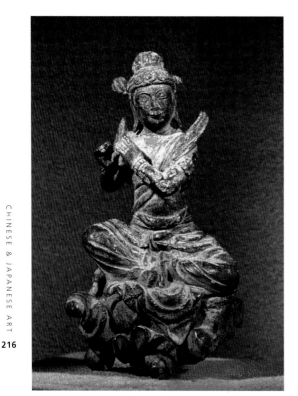

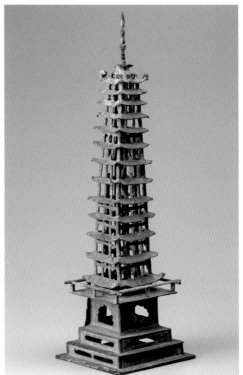

A depiction of Apsara, heavenly nymph, gilt bronze
Darstellung der Apsara, einer himmlischen Nymphe, vergoldete Bronze
Afbeelding van Apsara, blauwe nimf, verguld brons
Representación de Apsara, ninfa celestial, bronce dorado
600-900
National Museum of Korea, Seoul

A pagoda in miniature of the Koryo Period, bronze
Miniaturpagode aus der Koryo-Epoche, Bronze
Miniatuur pagode uit de Koryo-periode, brons
Pagoda en miniatura del período Koryo, bronce
918-1392
Museum of Fine Arts, Boston

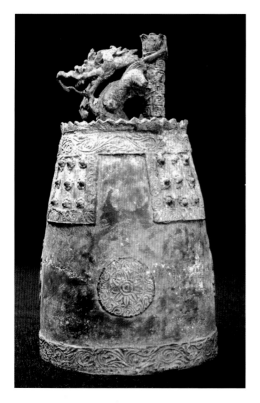

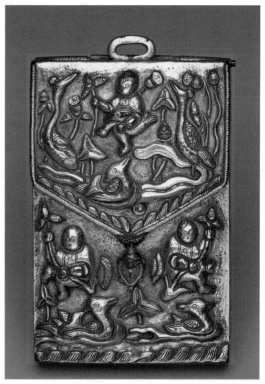

Bell used to beat time, bronze
Eine zum Bestimmen der Zeit verwendete Glocke, Bronze
Klok die gebruikt werd om het tijdstip van de diensten aan te
geven, brons
Campana utilizada para marcar los tiempos, bronce
ca. 1330
Central History Museum, Pyongyang

Decorated sutra container, bronze
Verzierter Sutrabehälter, Bronze
Versierde sutra-houder, brons
Recipiente para sutra decorado, bronce
1000-1200
Museum of Fine Arts, Boston

Ritual mirror, bronze
Ritueller Spiegel, Bronze
Rituele spiegel, brons
Espejo ritual, bronce
918-1392
Museo Nazionale d'Arte Orientale "G. Tucci", Roma

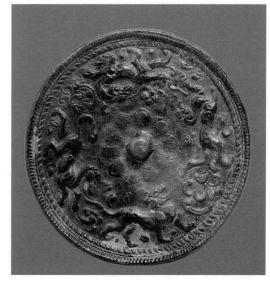

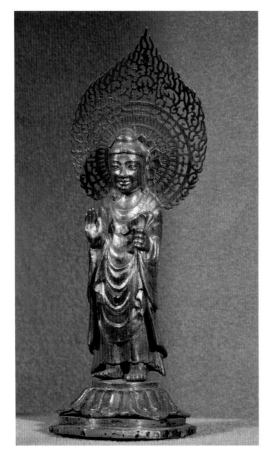
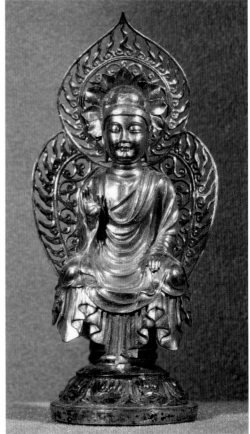

▮ *From the 7ᵗʰ century, Buddhism becomes a constant presence in figurative art, as well as in architecture.*
▮ *Seit dem 7. Jahrhundert ist der Buddhismus eine konstante Präsenz in der figürlichen Kunst, sowie in der Architektur.*
▮ *Het boeddhisme is vanaf de 7e eeuw zowel in de figuratieve kunst als in architectuur constant aanwezig.*
▮ *Desde el siglo VII, el budismo se vuelve una presencia constante tanto en el arte figurativo como en la arquitectura.*

Statuette of the Buddha Amitabha, gold
Buddha-Statuette Amitabha, Gold
Beeldje van de Amitabha boeddha, goud
Estatuilla del Buda Amitabha, oro
600-700
National Museum of Korea, Seoul

Buddha Amitabha in the lotus position, gold
Buddha Amitabha in der Lotusstellung, Gold
Amitabha boeddha in de lotushouding, goud
Buda Amitabha en posición de loto, oro
700-900
National Museum of Korea, Seoul

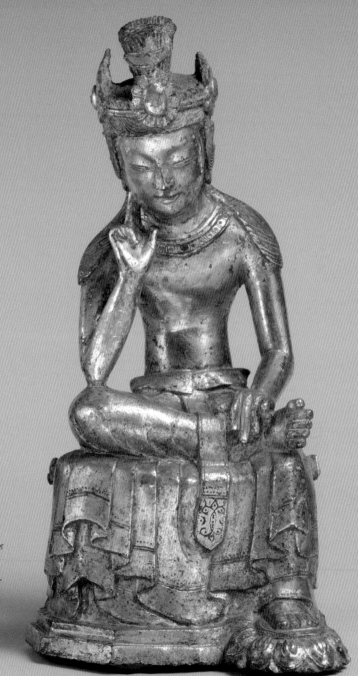

Figure of *Bodhisattva* in
meditation, gilt bronze
Bodhisattva-Figur bei der
Meditation, vergoldete
Bronze
Mediterend *Bodhisattva*-
figuur, verguld brons
Figura de *Bodhisattva*
en meditación, bronce
dorado
ca. 650
The Metropolitan
Museum of Art,
New York

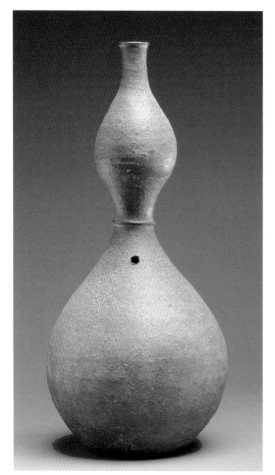

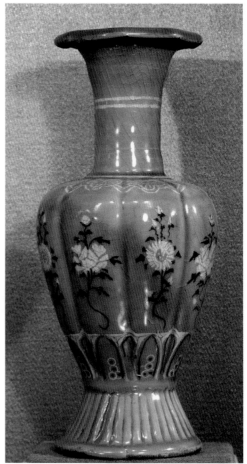

Bottle in the shape of a pumpkin, stoneware
Flasche in Kürbisform, Steingut
Pompoenvormige fles, gres
Botella en forma de calabaza, gres
1100-1200
The Metropolitan Museum of Art, New York

Vase decorated with floral motifs, pottery
Mit Blumenmotiven verzierte Vase, Keramik
Vaas met bloemversiering, keramiek
Jarrón decorado con motivos florales, cerámica
1100-1200
Duksoo Palace Museum of Fine Arts, Seoul

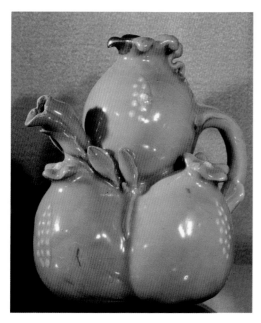

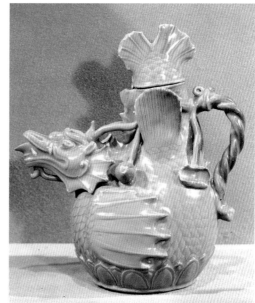

Vase for wine in the shape of a pomegranate, pottery
Weinkrug in Form eines Granatapfels, Keramik
Granaatappelvormige wijnvaas, keramiek
Jarrón para el vino en forma de granadas, cerámica
1000-1100
Duksoo Palace Museum of Fine Arts, Seoul

Jug in the shape of a sea dragon, pottery
Krug in Form eines Meeresdrachens, Keramik
Karaf in de vorm van een zeedraak, keramiek
Jarra en forma de dragón marino, cerámica
1100-1200
National Museum of Korea, Seoul

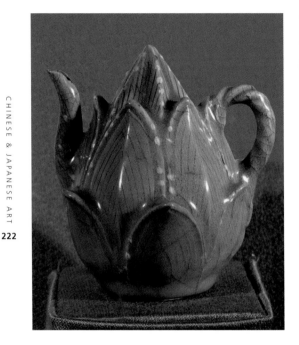 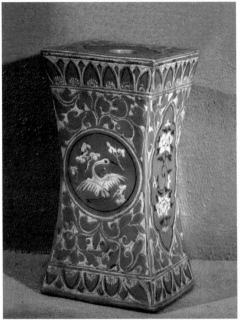

▋ *Despite the Chinese influence, which it was second to in Asia for a long time, the Korean ceramic production finds its own shapes and techniques, which spread successfully also to nearby Japan.*
▋ *Trotz des chinesischen Einflusses, den sie am zweitmeisten in ganz Asien erlebt hat, besaß die Keramikherstellung Koreas eigene Formen und Techniken, die erfolgreich im benachbarten Japan verbreitet wurden.*
▋ *De Koreaanse keramiekproductie ontwikkelt, ondanks de Chinese invloed, waarachter zij in Azië de tweede plaats innam, haar eigen vorm en techniek en heeft veel succes in het buurland Japan.*
▋ *A pesar de la influencia china, detrás de la cual fue segunda en importancia en Asia por un largo tiempo, la producción cerámica coreana posee formas y técnicas propias, difundidas con éxito también en el vecino Japón.*

Jug in the shape of a lotus flower, pottery
Krug in Form einer Lotusblüte, Keramik
Karaf in de vorm van een lotusbloem, keramiek
Jarra en forma de flor de loto, cerámica
1180-1200
National Museum of Korea, Seoul

Cushion, pottery
Kissen, Keramik
Kussen, keramiek
Almohada, cerámica
1180-1200
Duksoo Palace Museum of Fine Arts, Seoul

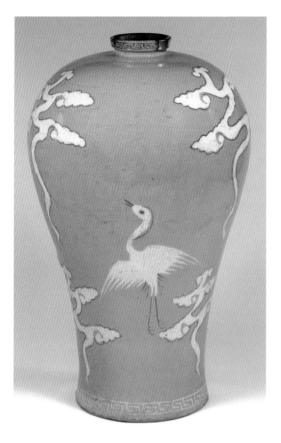

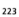

Bottle decorated with chrysanthemum and lotus petals,
glazed pottery
Mit Chrysanthemen- und Lotusblütenblättern verzierte Flasche,
glasierte Keramik
Fles versierd met chrysanten- en lotusblaadjes,
geglazuurd keramiek
Botella decorada con pétalos de crisantemo y de loto,
cerámica vidriada
ca. 1290-1310
The Metropolitan Museum of Art, New York

Vase of the *maebyong* type, pottery
Vase des *Maebyong*-Typs, Glasierte Keramik
Maebyong-vaas, geglazuurd keramiek
Jarrón de tipo *maebyong*, cerámica vidriada
ca. 1290-1310
The Metropolitan Museum of Art, New York

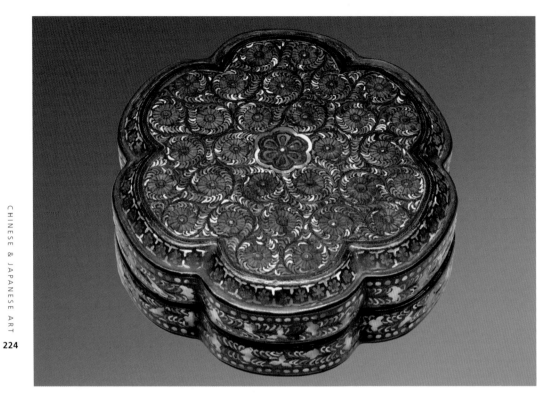

Box in the shape of a flower, lacquered wood, mother-of-pearl and shell
Schatulle in Blumenform, lackiertes Holz, Perlmutt und Muscheln
Bloemvormig doosje, gelakt hout, parelmoer en schelp
Caja en forma de flor, madera lacada, madreperla y concha
1200-1300
Museum of Fine Arts, Boston

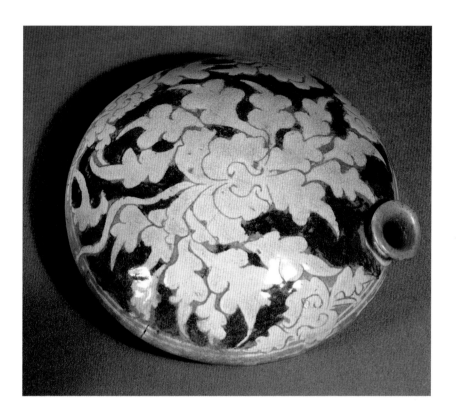

Container for wine, pottery
Weinbehältnis, Keramik
Wijnhouder, keramiek
Recipiente para el vino, cerámica
1300-1400
National Museum of Korea, Seoul

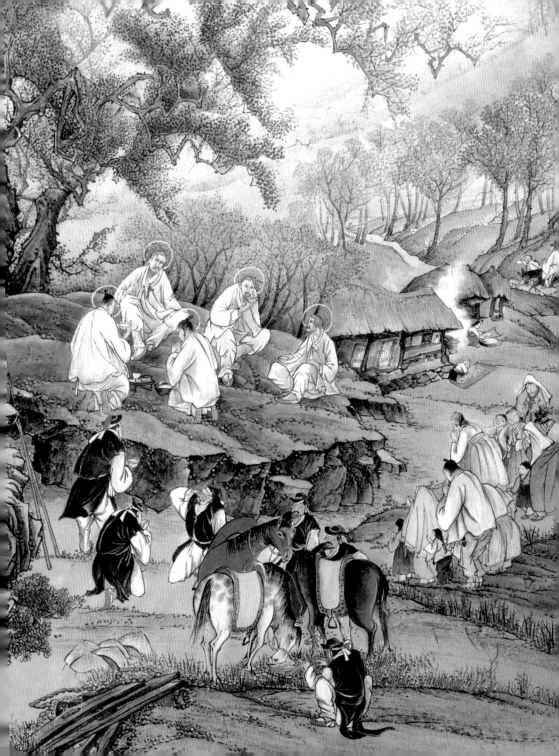

Art amid originality and fusion

With the end of the Koryo dynasty (918-1392) and the start of the Choson dynasty, which would last until 1910, the tension that characterized historical relations with China and Japan did not prevent Korea from expressing its unique identity – although in a less original way – through a very refined style of art. After taking in external influences, Korea was a model for techniques and crafts, contributing to the development of ceramics, porcelain, and metalworking.

Kunst zwischen Originalität und Synthese

Mit dem Ende der Dynastie der Koryo (918-1392) und dem Beginn der Choson-Dynastie, die bis 1910 dauerte, haben die historisch bedingten Spannungen in den Beziehungen zu China und Japan Korea nicht daran gehindert, mittels einer extrem raffinierten Kunst seine - wenn auch weniger authentische - eigene Identität zu wahren. Nach der Aufnahme äußerer Einflüsse wurde Korea zu einem Vorbild für die Techniken und das Kunsthandwerk, wobei es zur Entwicklung der Keramik, des Porzellan und des Hüttenwesens beitrug.

8

Kunst tussen originaliteit en synthese

Met het einde van de Koryo-dynastie (918-1392) en het begin van de Choson die tot 1910 zal duren, heeft de spanning die de historische betrekkingen met China en Japan kenmerkt Korea niet belemmerd haar bijzondere identiteit te uiten - zij het minder origineel - door middel van een uiterst verfijnde kunst. Na externe invloeden herbewerkt te hebben, heeft Korea model gestaan voor de technieken en ambachten, die bijgedragen hebben aan de ontwikkeling van keramiek, porselein, en metaal.

Un arte entre originalidad y síntesis

Con el ocaso de la dinastía Koryo (918-1392) y el inicio de la Choson, que durará hasta 1910, la tensión que caracteriza las relaciones históricas con China y Japón no impidieron a Corea expresar su particular identidad – si bien en modo menos original – a través de un arte muy refinado. Después de haber reelaborado las influencias externas, Corea ha sido un modelo tanto en las técnicas como en el artesanado, contribuyendo al desarrollo de la cerámica, de la porcelana y de la metalurgia.

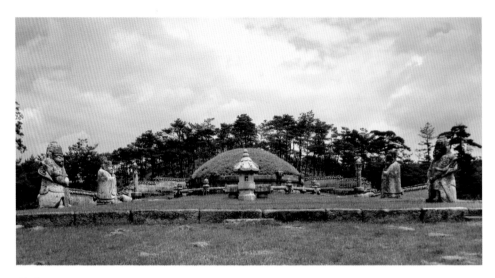

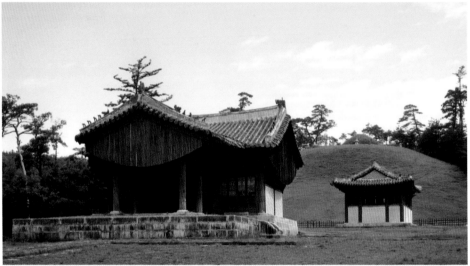

Tonggunung (Seoul)
Top part of the sepulchral complex of the Yi dynasty (1392-1910)
Oberer Teil des Grabkomplexes der Yi-Dynastie (1392-1910)
Hoger gedeelte van het grafcomplex van de Yi-dynastie (1392-1910)
Parte alta del complejo sepulcral de la dinastía Yi (1392-1910)

Tonggunung (Seoul)
Royal tomb of the Yi Dynasty (1392-1910)
Königliches Grab der Yi-Dynastie (1392-1910)
Koningsgraf van de Yi-dynastie (1392-1910)
Tumba real de la dinastía Yi (1392-1910)

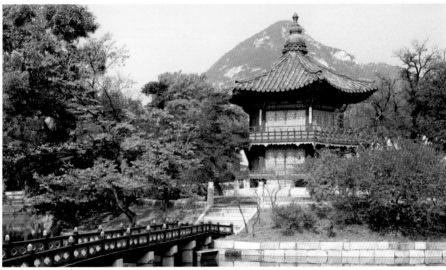

Suwon
Entrance door and walls of the city
which has had an important role in Korean history
Zugangstor und Mauern der Stadt, die in der koreanischen Geschichte
eine wichtige Rolle gespielt hat
Toegangspoort en muren van een stad
die in de geschiedenis van Korea een belangrijke rol heeft gespeeld
Puerta de acceso y muros de la ciudad,
que ha tenido un importante rol en la historia coreana

Seoul
Hyangwonjons Pavilion,
part of the Imperial Palace of Gyeongbokgung
PavillonHyangwonjons,
Teil des Kaiserpalasts von Gyeongbokgung
Hyangwonjons-paviljoen,
deel van het keizerlijk paleis van Yeongbokgung
Pabellon Hyangwonjons,
parte del palacio imperial de Gyeongbokgung
1394

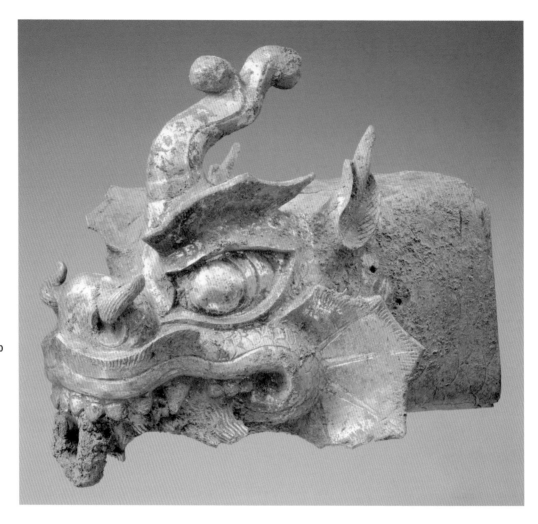

End for beam in the shape of a dragon's head, gilt bronze
Balkenende in Form eines Drachenkopfs, vergoldete Bronze
Balkeinde in de vorm van een drakenhoofd, verguld brons
Terminal para viga en forma de cabeza de dragón, bronce dorado
918-1000
The Metropolitan Museum of Art, New York

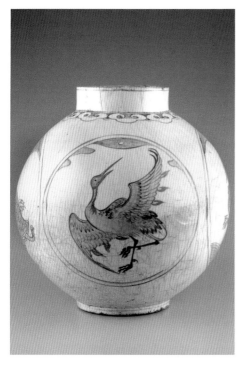

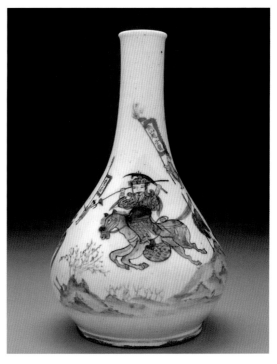

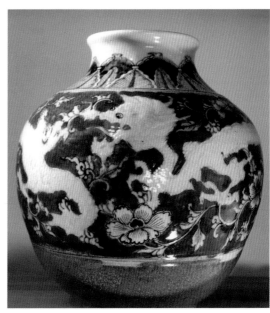

Jar, porcelain
Großer Krug, Porzellan
Aarden kruik, porselein
Tinaja, porcelana
1780-1800
Museum of Fine Arts, Boston

Bottle with battle scene of the late Chosŏn Period, porcelain
Flasche mit Schlachtenszene
aus der späten Chosŏn-Epoche, Porzellan
Fles met afbeelding van een veldslag
uit de late Chosŏn-periode, porselein
Botella con escena de batalla
del período Chosŏn tardío, porcelana
1800-1900
Museum of Fine Arts, Boston

Jar with Taoist symbols of the dragon and the peony
Großer Krug mit taoistischen Symbolen des Drachens
und der Pfingstrose
Aarden kruik met Taoïstische symbolen van de draak
en de pioenroos
Tinaja con los símbolos taoístas del dragón y de la peonía
1800-1900?
Private Collection / Private Sammlung
Privécollectie / Colección privada

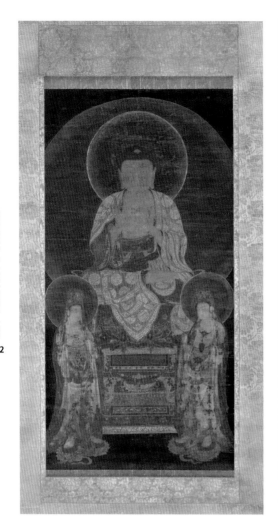

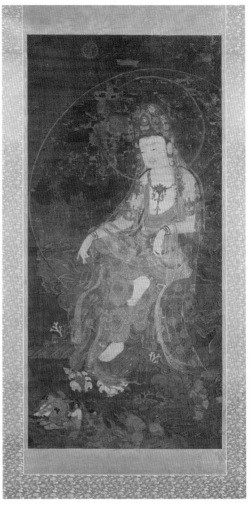

Amitabha Triad, ink and paint on silk
Triade Amitabha, Tinte und Farbe auf Seide
Amitabha-triade, inkt en verf op zijde
Tríada Amitabha, tinta y color sobre seda
ca. 1200-1300
The Metropolitan Museum of Art, New York

Avalokiteshvara. The Bodhisattva of Compassion
was also widespread in Korea, ink and paint on silk
Avalokiteshvara. Der Bodhisattva des Mitgefühls
war auch in Korea weit verbreitet, Tinte und Farbe auf Seide
Avalokiteshvara. De Bodhisattva van het medelijden
was ook in Korea wijd verspreid, inkt en verf op zijde
Avalokiteshvara. El Bodhisattva de la compasión ha tenido
una gran difusión también en Corea, tinta y color sobre seda
1349
The Metropolitan Museum of Art, New York

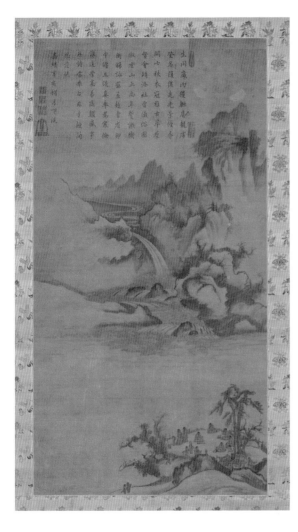

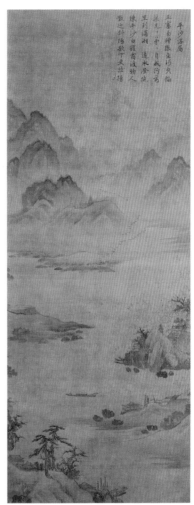

Meeting of scholars, ink and paint on silk
Gelehrtenversammlung, Tinte und Farbe auf Seide
Geleerdenbijeenkomst, inkt en verf op zijde
Reunión de estudiosos, tinta y color sobre seda
ca. 1551
The Metropolitan Museum of Art, New York

Wild geese coming down to the river, ink on silk
Wildgänse, die zum Fluss herabgehen, Tinte auf Seide
Wilde ganzen die naar de rivier afdalen, inkt op zijde
Ocas salvajes que bajan al río, tinta sobre seda
ca. 1535
The Metropolitan Museum of Art, New York

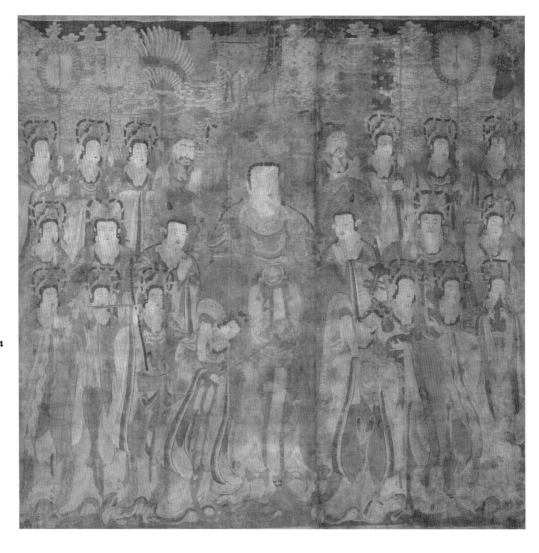

Brahma with assistants and musicians, ink and paint on canvas
Brahma mit Assistenten und Musikern, Tinte und Farbe auf Hanf
Brahma met assistenten en musici, inkt en verf op canape
Brahma con asistentes y músicos, tinta y color sobre cáñamo
1580-1600
The Metropolitan Museum of Art, New York

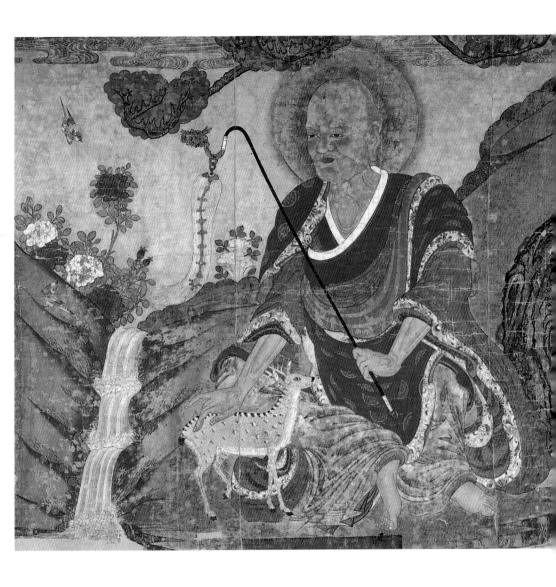

A hermit (*arhat*) and a stag, ink, pigments and gold on silk
Ein Eremit (*arhat*) und ein Hirsch, Tinte, pigmenti e Gold auf Seide
Een kluizenaar (*arhat*) en een hert, inkt, pigment en goud op zijde
Un eremita (*arhat*) y un ciervo, tinta, pigmentos y oro sobre seda
ca. 1680-1700
Kimbell Art Museum, Fort Worth

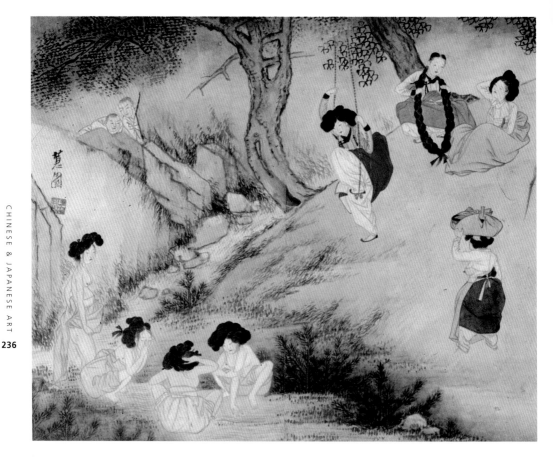

■ With the crisis of the Ming Dynasty, Korean art acquires greater autonomy. Painting, in particular, is enriched with local themes and expressions, while society opens up to other influences, such as the Japanese and Western ones.
■ Mit der Krise der Ming-Dynastie erwirbt die koreanische Kunst größere Autonomie. Die Malerei insbesondere bereichert sich an Themen und lokalen Ausdrucksformen, während die Gesellschaft sich anderen Einflüssen wie die japanische und westliche Gesellschaft öffnet.
■ De Koreaanse kunst krijgt met de crisis van de Ming-dynastie meer autonomie. De schilderkunst in het bijzonder verrijkt zich met lokale thema's en uitdrukkingen, terwijl de maatschappij openstaat voor andere invloeden zoals die van Japan en het Westen.
■ Con la crisis de la dinastía Ming, el arte coreano adquiere mayor autonomía. La pintura, en particular, se enriquece con temas y expresiones locales, mientras la sociedad se abre a otras influencias, como la japonesa y la occidental.

Sin Yun Bok
(ca. 1758 - post 1813)
Print depicting women grooming and women having fun
Druck mit Frauen bei der Toilette und Frauen, die sich amüsieren
Print van vrouwen die zich opmaken en die zich vermaken
Estampa que representa mujeres bañándose y mujeres divirtiéndose
ca. 1750-1800
Hyung-pil Chun Collection

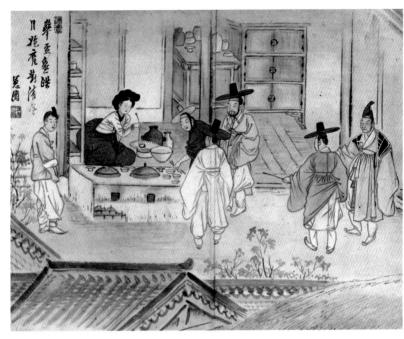

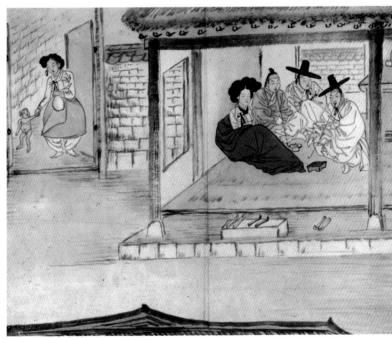

Colour prints depicting
scenes in the house of a
geisha
Farbdrucke mit Szenen im
Haus einer Geisha
Kleurenprint met scènes
uit het huis van een geisha
Estampas a color que
representan escenas en la
casa de una geisha
1758
Private Collection / Private
Sammlung / Privécollectie
Colección privada

Portrait of So-San Tessa, ink and paint on fabric
Porträt von So-San Tessa, Tinte und Farben auf Stoff
Portret van So-San Tessa, inkt en verf op stof
Retrato de So-San Tessa, tinta y colores sobre tela
ca. 1780-1820
The Newark Museum, Newark

Portrait of a young Korean dressed as a geisha
Porträt einer jungen, als Geisha gekleideten Koreanerin
Portret van een jonge Koreaanse als geisha gekleed
Retrato de joven coreana vestida de geisha
1758
Private Collection / Private Sammlung
Privécollectie / Colección privada

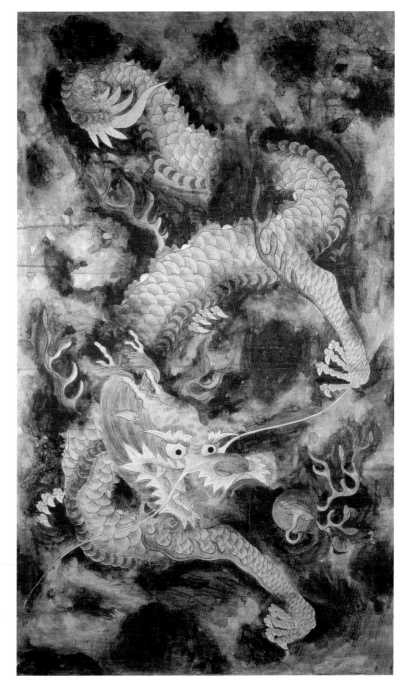

Dragon hunting the blazing pearl
in the clouds
Drachen, der die glühende Perle
zwischen den Wolken fängt
Draak die jaagt op de
roodgloeiende parel in de wolken
Dragón cazando la perla
llameante entre las nubes
1800-1900
Victoria & Albert Museum,
London

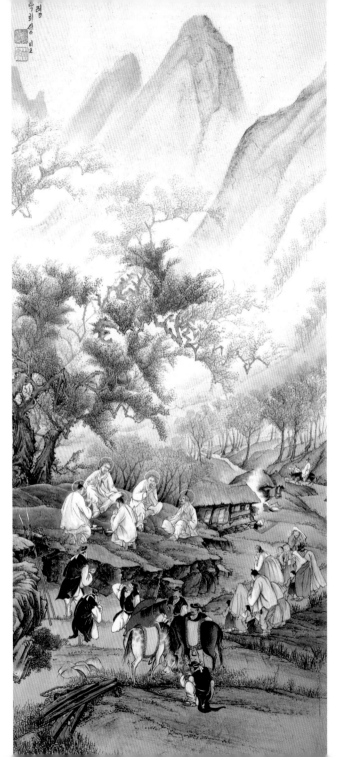

Thak Hi Seong
Koreans paying homage to European Catholic
missionaries killed during the repression against
Evangelization
Koreaner weisen katholischen Missionaren aus
Europa, die während der Unterdrückung der
Evangelisierung umgekommen sind, die Ehre
Koreanen die hulde brengen aan katholieke
missionarissen die tijdens de onderdrukking van
de evangelisatie vermoord werden
Coreanos rindiendo homenaje a misionarios
católicos europeos asesinados durante la
represión contra la evangelización
1835
Mission Etrangère, Paris

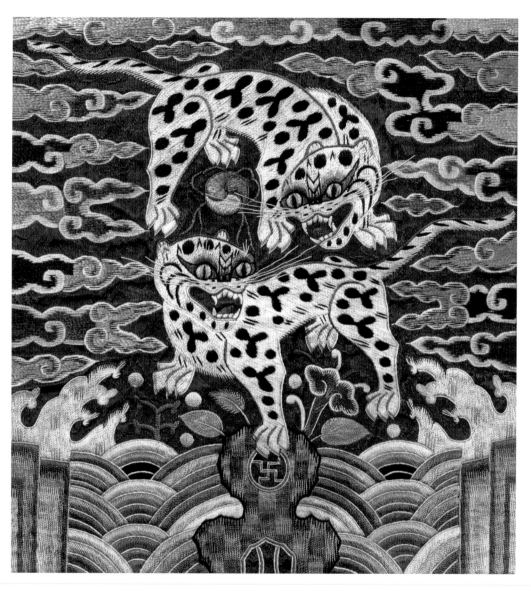

Ebroidered flag (*hyungbae*) of high-ranking military officer at the Court of Chosŏn, silk
Gesticktes Abzeichen (*hyungbae*) von hohem militärischem Rang am Hofe der Chosŏn, Seide
Geborduurd onderscheidingsteken (*hyungbae*) van een hoge militaire rang aan het Chosŏn-hof, zijde
Enseña bordada (*hyungbae*) de alto rango militar de la corte de Chosŏn, seda
1800-1900
Victoria & Albert Museum, London

Calligraphy
Kalligraphie
Schoonschrift
Caligrafía

Spring
Frühling
Voorjaar
Primavera

An ideogram is a composition of strokes, extremely complex at times, which has phonetic significance. In ideographic writing, the order in which each line is drawn is essential, starting with the "radicals", which suggest the basic meaning of the ideogram and are indispensible for identification in dictionaries. The main rules (despite numerous local exceptions) indicate that the reading of a single ideogram goes from top to bottom and from left to right, with horizontal strokes, first, then vertical. Various ideograms are aligned from top to bottom and from right to left: today this is often modified based on the example of Western writing. In China, ideographic writing is still an essential element; in Japan it is associated with the three alphabets: Latin, hiragana, and katagana (the latter two come from ideograms or partially from them); in Korea, after the introduction of the Hangul alphabet in the 15th century, the use of ideograms was slowly lost. The total number of ideograms is around 50,000, but current use is about 5,000 in China, 4,000 in Japan, and about 2,000 are considered essential.

Das Schriftzeichen ist eine Kombination von grafischen, zum Teil sehr komplexen Linien mit phonetischer Bedeutung. In der ideografischen Schrift ist die Anordnung, in der die Zeichen ausgeführt werden, entscheidend. Angefangen bei den "radikalen" Linien, die die Grundbedeutung des Schriftzeichens darstellen und für die Ermittlung in den Wörterbüchern unabdingbar sind. Die Hauptregeln (lokale Ausnahmen ausgenommen) bedeuten, dass das einzelne Schriftzeichen von oben nach unten und von links nach rechts, zuerst die horizontalen und dann die vertikalen Linien, gelesen werden muss. Die verschiedenen Schriftzeichen sind ihrerseits von oben nach unten und von rechts nach links angeordnet. Heute ist dies oftmals nach dem Beispiel der westlichen Schrift abgeändert. In China ist die ideografische Schrift noch heute ein wesentliches Element. In Japan ist sie mit den drei Alphabeten, dem Lateinischen, Hiragan und Katakana, verbunden (die Beiden Letztgenannten basieren auf Schriftzeichen oder Teilen von ihnen). In Korea ist die Verwendung der Schriftzeichen nach der Einführung des Hangul-Alphabets im 15. Jahrhunderts nach und nach verloren gegangen. Die Gesamtzahl der Ideogramme beläuft sich auf 50.000, aber gewöhnlich werden in China 5.000 und in Japan 4.000 verwendet, wovon ca. 2.000 als wichtig gelten.

Het karakter is een samenspel van grafische behandeling, soms zeer complex, met syllabische waarde. Bij karakterschrijven is de volgorde waarin je de tekens tekent essentieel, beginnend met de "radicalen", die de fundamentele betekenis van het karakter weergeven en zijn onmisbaar voor de indeling in de woordenboeken. De basisregels (maar er zijn lokale uitzonderingen) geven aan dat het lezen van elk karakter van boven naar beneden is en van links naar rechts, eerst de horizontale eigenschappen en vervolgens de verticale. Op hun beurt zijn de verschillende karakters uitgelijnd in de volgorde van boven naar beneden en van rechts naar links, nu vaak veranderd naar het voorbeeld van het westerse schrift. In China is het karakterschrift nu nog steeds een essentieel onderdeel, in Japan wordt het geassocieerd met de drie Latijnse alfabetten, Hiragana en Katakana (de laatste twee afgeleid van karakters of een deel daarvan). In Korea, na de invoering van het alfabet van Hangul in de vijftiende eeuw is het gebruik van karakters geleidelijk verloren gegaan. Het totale aantal karakters komt op 50.000, maar het huidige gebruik is rond 5000 op het vasteland van China en 4000 in Japan, waarvan ongeveer 2000 van essentieel belang worden geacht.

El ideograma es un conjunto de trazos gráficos, a veces muy complejos, que tienen valor silábico. En la escritura ideográfica es esencial el orden en el que se dibujan los símbolos, a partir de los trazos "radicales", que sugieren el significado de base del ideograma y son indispensables para la identificación en los diccionarios. Las reglas principales (pero no faltan excepciones locales) indican que la lectura de un ideograma se realiza de abajo hacia arriba, y de izquierda a derecha, primero los trazos en sentido horizontal y luego aquellos en sentido vertical. A su vez, los distintos ideogramas están alineados según el orden de arriba hacia abajo y de derecha a izquierda, aunque hoy en día a menudo esto se ha modificado siguiendo el ejemplo de la escritura occidental. En China la escritura ideográfica sigue siendo, todavía hoy, un elemento esencial; en Japón está asociada a los tres alfabetos: latino, hiragana y katakana (los últimos dos derivados de ideogramas o de parte de ellos); en Corea, después de la introducción del alfabeto Hangul en el siglo XV, el uso de los ideogramas se ha ido perdiendo. La cantidad total de ideogramas llega a 50.000, pero los de uso corriente son en realidad unos 5.000 en la China popular, y 4.000 en Japón, de los cuales unos 2.000 son considerados esenciales.

Glossary

Ancestors
Historical or mythological characters, often with a divine status. Complex rituals are dedicated to ancestors with regular occurrences; often they are called upon during times of need. In China, the so-called "cult of the ancestors", which invokes the favour of the deceased and the gods of the family, is an extension of filial duties, at the center of Confucian relationships. Similar traditions with local variations are seen in Japan (for example with the Obon festival), and in Korea, with the Jesa ritual.

Avalokitesvara
The bodhisattva of compassion – Kannon in Japan and Guan-Yin in China –, the main divinity for Mahayana Buddhists, at the center of infinite artistic representations.

Bodhisattva
In the Mahayana Buddhist tradition, this indicates those who renounce their definitive liberation to help others save themselves and to achieve enlightenment.

Buddhism
Born in India in the 6th century BCE, originally it was a philosophical doctrine; during its evolution and geographic diffusion, it influenced a large part of Asia. While in India it has almost disappeared, elsewhere in Asia it has become widespread, also thanks to its ability to adapt and assimilate, which has given rise to numerous currents and sects.

Confucius
K'ung-fu-tzu or Kongfuzi, "Maestro Kong", lived in China between the 6th and 5th century BCE. He outlined the essential elements of the moral doctrine that was named after him (Confucianism). In his Analects, he outlined a system of social relationships whose aim was harmony, based on the principle of an equal authority and respect for rules as instruments of collective and individual order and wellbeing.

Dragon
A symbol in China of imperial power, in the tradition of the Far East it represents a mythological animal with beneficial powers, a symbol of strength and fortune.

The Forbidden City
For five centuries, starting in 1420, the year it was built, until the coup in 1924, the Forbidden City was the imperial palace in Beijing under the Ming and Qing Dynasties.

The Great Wall
Built between the 3rd century BCE and the 16th century CE with the objective of uniting the people of China and keeping out external threats, it is the largest man-made construction in history and is almost 9,000 km long.

The Immortals
The Eight Immortals (Chang Kuo-lao, Lu Tung-pin, Chung-li Chuan, Li Tieh-Kuai, Lan Tsai-ho, Ho Hsien-ku, Han Hsiang-tsu, Tsao Kuo-chiu) are a group of extremely popular divinities, present in China not only in religious history, but also in the figurative arts and literary tradition.

Kami
The divinity of Japan's ancestral religion, with a strong shamanist influence. The kami are the focus of creation myths and today are part of the popular religious culture, which assimilates Shinto and Buddhist practices.

Kamikaze
"Divine wind": the typhoon sent from heaven that in 1274 and 1281 annihilated the Mongolian-Chinese

fleet off the coast of southern Japan. By extension, it is also a force capable of vanquishing one's enemy.

Kanji
"Chinese characters", or a system of ideograms imported to Japan from China, which provided the country with a system of writing. This system did not blend well a language other than Chinese like Japanese, to the point that today, two or three letters exist for each *kanji*.

Kimono
The term, which literally means "dress", as time went on and mainly with a constant specialization of clothing types, began to indicate a traditional article of clothing for women, whose colors, characteristics and style differed according to the season and occasion.

Land of the Morning Calm
A late definition of historical Korea derived from the term "Joseon", a sovereign state of modern Korean founded and led for almost five centuries (1392-1910) by the same dynasty.

Middle Kingdom
"Zhongguo", China. Due to its geographic and cultural immensity, but also its historical role, since the distant past the Chinese have identified themselves as a people at the center of the known world, and through the emperor (Son of the Heaven), at the center of the Universe.

Neo-Confucianism
A revision of the teachings of Confucius, due mainly to commentators such as Menciu (370 - 289 BCE) and Zhu Xi (1130-1200). Neo-Confucianist doctrine – with an emphasis on the concept of loyalty – was intended to provide a base to manage power in the Far East, starting in the 14th century.

Nihon/Nippon
"(Land of) the Rising Sun": Japan was given this name due to its position in the extreme eastern part of Asia and due to the fact that it was created by the Sun god, Amaterasu-o-mikami.

Paper
Developed by the Chinese more than 20 centuries ago using various materials, in Eastern Asia, paper was essential in passing down traditions and events to future generations, but it was, and still is, an essential element in a series of cultural practices, especially calligraphy.

Rice
The basic foodstuff for most of Eastern Asia in ancient times, with its seasonal cycles and its requirements to be cultivated, it is at the foundation of community life for a majority of the region.

Shakyamuni
The historic Buddha, born as a prince of noble lineage, named of Siddhartha Gautama. He lived in the 6th century BCE between what is now Nepal and northern India.

Shamanism
Present in eastern Asia since ancient times as an extension of traditions in central Asia and Siberia, it survived more or less in its original state in the most remote regions of China, Japan, and Korea, but also influenced later religious practices including expressions of Taoism and different religious sects in China, Shintoism and Shugendo in Japan, tantric forms of Buddhism, and ceremonies involving exorcism (*gut*) in Korea.

Shogun
A term that indicates the political-military head of the feudal system that dominated Japan between

1192 and 1868. The hereditary shogun line in reality was independent from imperial power, although it did formally depend on it.

Son of Heaven
This was the name given to the Chinese emperor (and, through cultural influence, to the Japanese emperor and Korean ruler), where Heaven symbolized the cosmic order.

Taoism
A philosophy (*Daode jing*, *Tao Te Ching*) based on the teachings of Laozi (Lao-tzu), who lived in the 6th century BCE. In a certain sense, it is the anti-thesis of Confucianism, with an emphasis on individual freedom, mystical experience, and the possibility of sublimating the body through the control of one's energy (qi, chi) and through magical-alchemical and psycho-physical practices.

Tea
An invigorating drink used to assist in meditative and religious practices, which until recent times was only widely used by the upper classes. Tea is at the foundation of important artistic and popular traditions, in addition to aesthetic practices associated with its use on a daily and ceremonial basis.

Wa
"Harmony", it is an essential element in Japanese society, which was modified by imperial and Confucian China, from the 6th century. An attitude that is rooted in common work on farms and rice fields; it later became a primary social element, opposed to individualism.

Yin and Yang
Opposites that unite. This is a concept that evolved from the ancient dualistic system of Chinese philosophy, which starting from the celestial bodies (Sun-Moon) involves all human knowledge. Yang is positive, active, and strong, while Yin is negative, passive, and weak. All that is found in the universe comes from their dynamic interaction. South Korea has placed Yin and Yang (*Eum-Yang*) in the center of their flag.

Zen
A sect of Buddhism that developed in China under the master Bodhidharma, but later spread also into Japan and Korea. Zen is against intellectualism; it transcends common logic and involves observation of nature and man (under the guide of a master) as an essential element.

Zodiac
An extremely ancient practice that dates back to 2637 BCE. Chinese astrology is founded on 60-year cycles, which are subdivided into five 12-year cycles. The shortest cycles are based on 12 animals, both real and mythological (mouse, ox, tiger, hare, snake, horse, sheep, monkey, rooster, dog, wild boar), each of which combine each year with one of the five traditional elements (wood, fire, earth, iron, water), resulting in a cycle lasting 60 years. For example: 14 February 2010 marked the beginning of the year of the iron tiger.

Glossar

Ahnen

Den Ahnen, oftmals vergötterten, historischen oder mythologischen Personen, werden komplexe Riten in regelmäßigen Abständen gewidmet. Zumeist werden sie dann angerufen, wenn sie gebraucht werden. In China ist der so genannte "Ahnenkult", der das Wohlwollen der Verstorbenen und der Götter gegenüber der Familie bringt, eine Erweiterung der Pflicht eines Kindes und im Mittelpunkt der konfuzianischen Beziehungen. Ähnlich, aber im Bund mit eher lokalem Brauchtum ist er auch in Japan (zum Beispiel in den Feiern der O-Bon) und in Korea in den Riten Jesa wiederzufinden.

Avalokiteshvara

Der Bodhisattva des Mitgefühls – Kannon in Japan, Guan-Yin in China –, steht als die wichtigste Gottheit des buddhistischen Pantheon Mahayana im Zentrum unzähliger künstlerischer Darstellungen.

Bodhisattva

In der buddhistischen Tradition Mahayana wird so eine Person bezeichnet, die auf die eigene endgültige Befreiung verzichtet, um die anderen dabei zu unterstützen, sich zu retten und die Erleuchtung zu erlangen.

Buddhismus

Im 6. Jahrhundert v. Chr. in Indien entstanden ist er die Grundlage einer philosophischen Lehre und hat in seiner geographischen Entwicklung und Verbreitung große Teile des asiatischen Kontinents beeinflusst. Während er in Indien beinahe verschwunden ist, konnte er sich in anderen Gebieten Asiens auch Dank seiner Anpassungs- und Angleichungsfähigkeit weit verbreiten. Aus dieser Fähigkeit heraus entstammen auch zahlreiche Strömungen und Sekten.

Drache

In China das Symbol der kaiserlichen Macht. In der Tradition des äußersten Ostens stellt er ein mythologisches Tier mit guten Kräften dar, ein Zeichen der Stärke und des Glücks.

Große Mauer

Erbaut zwischen dem 3. Jahrhundert v. Chr. und dem 16. Jahrhundert n. Chr. mit dem Ziel, die Völker Chinas zu vereinen und die äußeren Bedrohungen abzuhalten, ist sie mit ihren 9.000 km Länge das größte je errichtete Kunstwerk.

Kami

Gottheiten der Urreligion Japans mit starken schamanischen Prägungen. Die Kami stehen im Mittelpunkt der Schaffungsmythen und gehören heute zur Volksreligion, die shintoistische und buddhistische Praktiken vereint.

Kamikaze

"Göttlicher Wind": der günstige Taifun, der 1274 und 1281 die mongolisch-chinesische Schiffsflotte an den Küsten in Südjapan vernichtet hat. Im erweiterten Sinn, eine Macht, die in der Lage ist, den Feind zu zerschlagen.

Kanji

"Chinesische Schriftzeichen" oder das von China nach Japan importierte Schriftsystem, das dem Land ermöglichte, sich mit einer Schrift zu versehen. Dieses System war jedoch wenig für das Japanische, einer anderen als der chinesischen Sprache, geeignet, so dass heutzutage von jedem *kanji* zwei oder mehr Leseweisen existieren.

Kimono

Der Begriff, der wörtlich übersetzt "Anziehsache" bedeutet, bezeichnet im Laufe der Zeit und vor allen nach einer beständigen Spezialisierung der verschiedenen Kleidungstypen ein traditionelles Kleidungsstück für Frauen, das nach Jahreszeit und Gelegenheit unterschiedliche Farben, Merkmale und Stilrichtungen aufweist.

Konfuzius

K'ung-fu-tzu oder Kongfuzi, "Meister Kung", der in China zwischen dem 6. und 5. Jahrhundert v. Chr.

lebte, hat die wesentlichen Elemente der moralischen Lehre, die ihren Namen von ihm hat, umrissen (Konfuzianismus). In seinen Analekten zeichnet er ein System gesellschaftlicher Beziehungen, das auf Harmonie abzielt und auf dem Prinzip einer gleichen Macht und der Einhaltung von Regeln als Instrumente für die Ordnung und das persönliche und gemeinschaftliche Wohlergehen beruht.

Land der Mitte
"Zhongguo", China. Aufgrund seiner geografischen und kulturellen Unendlichkeit, aber auch aufgrund seiner historischen Rolle, zeigten die Chinesen sich schon seit der ältesten Vergangenheit als ein Volk, das im Mittelpunkt der bekannten Welt steht und mit dem Kaiser (Sohn des Himmels) gar im Mittelpunkt des Universums.

Land der Morgenstille
Eine späte Benennung des historischen Koreas, die aus dem Begriff "Joseon", einem souveränen Statt des modernen Korea hervorgeht, der von der gleichnamigen Dynastie gegründet und über 5 Jahrhunderte (1392-1910) beherrscht wurde.

Neokonfuzianismus
Eine Aktualisierung der Lehren des Konfuzius, die vor allem Kritikern wie Menciu (370-289 v. Chr.) und Zhu Xi (1130-1200) zu verdanken sind. Die neokonfuzianischen Lehren – mit ihrer Betonung der Loyalität - mussten eine Grundlage für die Machtausübung im Fernen Osten ab dem 14. Jahrhundert bieten.

Nihon/Nippon
"Land der aufgehenden Sonne": Japan, dem der Namen wegen seiner Lage im äußersten Osten des asiatischen Kontinents und wegen seiner Frschaffung durch die Göttin der Sonne, Amaterasu-o-mikami, gegeben wurde.

Papier
Das Papier wurde von den Chinesen vor mehr als 20 Jahrhunderten erfunden, indem sie verschiedene Materialien verwendet haben. Im Osten Asiens hat es grundlegend dazu beigetragen, Traditionen und Ereignisse zu überliefern. Es war und ist noch heute ein wesentliches Element für eine Reihe von kulturellen Verfahren, angefangen bei der Kalligraphie.

Reis
Das Grundnahrungsmittel eines Großteils Ostasiens in der Vergangenheit, das wegen seiner jahreszeitlichen Zyklen und seinen vegetativen Erfordernisse die Grundlage für das Gemeinschaftsleben eines großen Teils der Region ist.

Schamanismus
Den Schamanismus gibt es in Ostasien seit dem Altertum als Erweiterung des zentralasiatischn und des sibirischen Schamanismus. Er hat auf mehr oder minder authentische Art in den entferntesten Gebieten Chinas, Japans und Koreas überlebt, aber er hat auch folgende religiöse Praktiken beeinflusst: die Erscheinungen des Taoismus und der Sektenkulte in China, den Shintoismus und den Shugendo in Japan, die tantrischen Formen des Buddhismus und Exorzismus-Zeremonien (*gut*) in Korea.

Shakyamuni
Der historische Buddha, der als Prinz eines Königsgeschlechts mit dem Namen Siddhartha Gautama geboren wurde, lebte im . Jahrhundert v. Chr. zwischen dem heutigen Nepal und Nordindien.

Shogun
Ein Begriff, der die politisch-militärische Leitung des Feudalsystems bezeichnet, das Japan zwischen 1192 und 1868 regierte. Das erbliche Amt des Shoguns war unabhängig gegenüber der kaiserlichen Macht, von der es aber formell abhing.

Sohn des Himmels
Der Herrschertitel des chinesischen Kaisers (und wegen der kulturellen Verschmelzung auch des japanischen und koreanischen Herrschers), wobei der Himmel die kosmische Ordnung symbolisiert.

Taoismus

Philosophie (*Daode jing*, *Tao Te Ching*), die auf den Lehren des Laozi (Lao-tzu) beruhen, der im 6. Jahrhundert v. Chr. lebte. In gewissem Sinne widerspricht er dem Konfuzianismus, indem er die persönliche Freiheit, die mystische Erfahrung und die Möglichkeit, den eigenen Körper über die Energielenkung und mit magisch-alchemistischen und psychisch-physischen Verfahren zu sublimieren, betont.

Tee

Stärkendes Getränk zur Unterstützung der meditativen und religiösen Praktiken, das bis in die jüngste Zeit nur in den höheren Schichten der Bevölerung verbreitet war. Der Tee ist die Basis wichtiger handwerklicher und künstlerischer Traditionen, sowie ästhetischer Verfahren, die an seine Anwendung gebunden sind, im alltäglichen Umfeld und in Zeremonien.

Unsterbliche

Die acht Unsterblichen (Chang Kuo-lao, Lu Tung-pin, Chung-li Chuan, Li Tieh-Kuai, Lan Tsai-ho, Ho Hsienku, Han Hsiang-tsu, Tsao Kuo-chiu) sind eine Gruppe bekannter Gottheiten, die in China nicht nur in der Religionsgeschichte, sondern auch in den bildenden Künsten und in der literarischen Tradition präsent sind.

Verbotene Stadt

Fünf Jahrhunderte lang, von 1420, dem Jahr seiner Erbauung, bis zum Staatsstreich von 1924, war der Kaiserpalast in Peking unter den Dynastien Ming und Qing die verbotene Stadt.

Wa

"Harmonie" ist ein wesentliches Element der japanischen Gesellschaft, das wiederum dem kaiserlichen und konfuzianischen China seit dem 6. Jahrhundert entlehnt ist. Eine Haltung, die ihre Wurzeln in der gemeinschaftlichen Arbeit auf den (Reis)Feldern hat und später als wichtigstes gesellschaftliches Element im Gegensatz zum Individualismus befürwortet wurde.

Yin und Yang

Die Gegensätze, die sich vereinen. Hierbei handelt es sich um ein Konzept, das sich aus dem alten dualistischen System der chinesischen Philosophie entwickelt hat, das ausgehend von den Himmelskörpern (Sonne-Mond) das ganze menschliche Wissen einbezieht. Yang ist positiv, aktiv und stark, während Yin negativ, passiv und schwach ist. Alles, was im Universum zu finden ist, entstammt ihrer dynamischen Interaktion. Südkorea trägt Yin und Yang (*Eum-Yang*) in der Mitte seiner Flagge.

Zen

Eine Strömung des Buddhismus, die sich in China unter dem Meister Bodhidharma entwickelt hat, sich aber daraufhin in Japan und Korea verbreitet hat. Zen scheut das Intellektuelle, übertreibt die allgemeine Logik und macht aus der Beobachtung der Natur und des Menschen (unter der Leitung eines Meisters) ein wesentliches Element.

Zodiak

Die chinesische Astrologie, ein sehr altes Verfahren, daas auf das Jahr 2637 v. Chr. zurückgeht, beruht auf Zyklen von 60 Jahren, die wiederum in 5 Zyklen von 12 Jahren unterteilt sind. Die kürzesten Zyklen basieren auf 12 realen und mythologischen Tieren (Maus, Ochse, Tiger, Hase, Drache, Schlange, Pferd, Schaf, Affe, Hahn, Hund, Wildschwein), von denen jedes Jahr jeweils eins mit einem der 5 traditionellen Elemente (Holz, Feuer, Erde, Eisen, Wasser) kombiniert wird und so den 60-jährigen Zyklus bildet. Zum Beispiel: am 14. Februar 2010 hat das Jahr des Tigers des Eisens begonnen.

Woordenlijst

CHINESE & JAPANESE ART

Avalokiteshvara
De bodhisattva van mededogen - Kannon in Japan, Kuan-Yin in China - de belangrijkste godheid van de boeddhistische pantheon Mahayana, het centrum van talloze artistieke voorstellingen.

Bodhisattva
De Mahayana boeddhistische traditie duidt op diegene, die afstand doet van zijn definitieve vrijlating om anderen te helpen zichzelf te redden en zo verlichting te bereiken.

Boeddhisme
Ontstaan in India in de zesde eeuw voor Christus, was oorspronkelijk een filosofische leer; in haar evolutie en geografische spreiding is veel van het Aziatische continent beïnvloed. Terwijl het in India bijna verdwenen is, is het elders in Azië wijd verspreid, dankzij het aanpassingsvermogen en de mogelijkheid tot assimilatie, die aanleiding heeft gegeven voor talrijke stroompjes en sekten.

Chinese Muur
Gebouwd tussen de derde eeuw voor Christus en de zestiende eeuw na Christus met het doel de bevolking van China te verenigen en te beschermen tegen externe bedreigingen, het grootste artefact ooit, met zijn lengte van bijna 9000 kilometer.

Confucius
K'ung-fu-tzu of Kongfuzi, "Maestro Kung", leefde in China tussen de zesde en de vijfde eeuw voor Christus en schetste de essentiële elementen van de morele doctrine waar zijn naam aan werd gegeven (Confucianisme).
In zijn Analecten schetst hij een systeem van sociale relaties, die harmonie zoekt op basis van het principe van gelijke autoriteit en respect en op basis van de regels als instrumenten van orde en individueel en collectief welzijn.

Draak
Embleem van de keizerlijke macht in China, in de traditie van het Verre Oosten is het een mythologisch dier van goede krachten, symbool van kracht en geluk.

Kami
Goddelijkheid uit de voorouderreligie van Japan, met een sterke sjamanitische kant. De Kami zijn het centrum van de scheppingsmythen en zijn tegenwoordig onderdeel van de volksreligie, die shintoïstische en boeddhistische praktijken samenbrengt.

Kamikaze
"Goddelijke wind": De voorzienige tyfoon die in 1274 en 1281 de Mongools-Chinese marineschepen voor de kust van zuidelijk Japan vernietigde. En verder, een kracht die in staat is de vijand op de vlucht te jagen.

Kanji
"Chinese karakters", ofwel het karaktersysteem ingevoerd in Japan uit China, die het land toestaat zich een schrift toe te eigenen. Dit systeem was echter nauwelijks sympathiek met een andere taal dan de Chinese zoals Japans, zodat nu elke kanji uit twee of meer lezingen bestaat.

Kimono
De term, die letterlijk "jurk" betekent, is met de tijd en vooral door een voortdurende verbetering van de soorten van kleding gegroeid tot een traditioneel kledingstuk voor vrouwen, met verschillende kleuren, kenmerken en stijlen, afhankelijk van het seizoen en gelegenheid.

Land van de Ochtendrust
Een oude definitie van het vroege Korea, afkomstig van de term "Joseon", een soevereine staat in het

moderne Korea, opgericht en geleid voor ongeveer vijf eeuwen (1392-1910) uit de gelijknamige dynastie.

Middenland
"Zhongguo", China. Vanwege de geografische en culturele uitgestrektheid, maar ook door de historische rol, al van oudsher werden de Chinezen geïdentificeerd als het volk in het centrum van de bekende wereld en, door de keizer (zoon van de hemel), in het centrum van het Heelal.

Neo-Confucianisme
Modernere versie van de leer van Confucius, voornamelijk als gevolg van commentatoren als Menciu (370-289 v. Chr.) en Zhu Xi (1130-1200). De neoconfucianistische doctrines - met de nadruk op het concept van loyaliteit – moesten een basis bieden voor het beheer van de macht in het Verre Oosten, vanaf de veertiende eeuw.

Nihon/Nippon
"(Land van de) rijzende Zon": Japan, zo genoemd vanwege de ligging aan het oostelijke einde van het Aziatische continent en het feit dat het werd geschapen door de godin van de zon, Amaterasu-o-Mikami.

Onsterfelijken
De Acht Onsterfelijken (Chang Kuo-lao, Tung-Pin Lu, Chung-Li Chuan, Li Tiehi-Kuai Lan Tsai-Ho, Ho Hsien-ku, Han Hsiang-tsu, Tsao Kuo-Chiu) zijn een vrij populaire groep van goden in China, niet alleen in de religieuze geschiedenis, maar ook in de beeldende kunsten en de literaire traditie.

Papier
Ontwikkeld door de Chinezen meer dan twintig eeuwen geleden met behulp van verschillende materialen, heeft in Oost-Azië het papier een fundamentele rol gespeeld bij het doorgeven van tradities en evenementen, maar was ook, en is nog steeds, een essentieel onderdeel van een reeks culturele praktijken, om te beginnen met de kalligrafie.

Rijst
Basisvoedsel van een groot deel van Oost-Azië in de oudheid, met haar seizoensgebonden cycli en haar vegetatieve behoeften staat het aan de basis van het leven in de maatschappij van een groot deel van de regio.

Shakyamuni
De historische Boeddha, geboren als een prins van een koninklijk geslacht met de naam van Siddhartha Gautama, die leefde in de zesde eeuw voor Christus tussen Nepal en Noord India.

Shogun
Term die de politiek-militaire leider van het feodale systeem aanduidt, dat Japan tussen 1192 en 1868 domineerde. De macht van de Shogun, erfelijk, was in feite de autonoom voor de keizerlijke macht, waarvan het officieel afhing.

Sjamanisme
Aanwezig in Oost-Azië sinds de oudste geschiedenis, als een verlengstuk van centraal Azie en Syberië, heeft in min of meer originele staat overleefd in de meer afgelegen regio's in China, Japan en Korea, maar heeft ook latere religieuze praktijken beïnvloed: uitdrukkingen van Taoïsme en sekten en culten in China, het Shintoïsme en Shugendo in Japan, tantrische vormen van boeddhisme en de ceremonies van exorcisme (gut) in Korea.

Taoisme
Filosofie (Daode Jing, Tao Te Ching), gebaseerd op de leer van Laozi (Lao-tzu), die leefde in de zesde

eeuw voor Christus. In zekere zin staat het in contrast met het Confucianisme, de nadruk op individuele vrijheid, mystieke ervaring en de mogelijkheid het eigen lichaam te controleren door energiebeheer (*qi*, *chi*) en via alchemistische en magische en psychofysieke praktijken.

Thee

Verkwikkend drankje ter ondersteuning van religieuze en meditatieve praktijken, tot voor kort alleen voor de hogere klassen van de bevolking. Thee behoorde oorspronkelijk tot grote artistieke en ambachtelijke tradities, evenals esthetische praktijken in verband met het gebruik ervan, zowel binnen het dagelijkse als in het ceremoniële.

Verboden Stad

Vijf eeuwen lang, vanaf 1420, het jaar van de stichting, tot de coup in 1924, was het keizerlijk paleis in Peking, onder de dynastie van Ming en Qing.

Voorouders

Historische of mythologische personages, vaak vergoddelijkt, ingewikkelde rituelen op regelmatige basis worden gewijd aan voorouders, vaak ingeroepen in tijden van nood. In China, de zogenaamde "voorouderverering", die de gunsten van de overledene en zijn familie draagt, is een uitbreiding van kinderlijke plicht, binnen de confuciaanse relaties. Op dezelfde manier, maar met plaatselijke verschillen, is dit te vinden in Japan (bijvoorbeeld het Feest van O-Bon) en Korea, met de riten van Jesa.

Wa

"Harmonie", een essentieel onderdeel van de Japanse samenleving, op zijn beurt weer geleend van keizerlijk China en het confucianisme, tot de zesde eeuw. Houding die wortels heeft in het gemeenschappelijke werk in de velden en rijstvelden, werd vervolgens bepleit als een primair sociaal element, in tegenstelling tot het individualisme.

Yin e Yang

Tegengestelden die verenigen. Dit is een concept ontwikkeld in het oude dualistische stelsel van de Chinese filosofie, die uitgaat dat de hemellichamen (Zon-Maan) alle menselijke kennis omvat. Yang is positief, actief en sterk, terwijl Yin negatief is, passief en zwak. Alles wat zich in het universum bevindt komt uit hun onderlinge dynamische interactie. Zuid-Korea heeft Yin en Yang (Eum-Yang) in het midden van de vlag geplaatst.

Zen

Stroming van het boeddhisme ontwikkeld in China onder de Meester Bodhidharma, maar later ook uitgebreid tot Japan en Korea. Zen is tegen intellectualisme, overstijgt de gemeenschappelijke logica en maakt de observatie van de natuur en van de mens (onder begeleiding van een docent) een essentieel element.

Zodiac

Oude praktijk die teruggaat tot 2637 voor Christus, Chinese astrologie is gebaseerd op cycli van 60 jaar, op zijn beurt verdeeld in 5 cycli van 12 jaar De kortere cycli zijn gebaseerd op 12 dieren, echte en mythologische (rat, os, tijger, haas, draak, slang, paard, schaap, aap, haan, hond, zwijn), elk van hen combineert ieder jaar met een van de 5 traditionele elementen (hout, vuur, aarde, ijzer, water) die aanleiding geven tot de cyclus van 60 jaar. Bijvoorbeeld: op 14 februari 2010 begon het jaar van de tijger in ijzer.

Zoon van de Hemel

Naam gegeven aan de Chinese keizer (en, door culturele verontreiniging, ook aan de Japanse en Koreaanse heerser), waar de hemel symbool staat voor de kosmische orde.

Glosario

Antepasados
Personajes históricos o mitológicos, a menudo divinizados, a los antepasados se les dedican ritos complejos con frecuencia regular; a menudo son invocados en ocasión de necesidad. En China el denominado "culto a los antepasados", que concede favores de los difuntos y de los dioses a la familia, es una extensión del deber filial, en el centro de las relaciones confucianas. De manera similar, pero con prácticas locales, se encuentra en Japón (por ejemplo en la festividad de O-Bon) y en Corea, con los ritos Jesa.

Arroz
Alimento base de buena parte del Asia oriental en la antigüedad. Con sus ciclos estacionales y sus necesidades de desarrollo, es un elemento básico en la vida comunitaria de buena parte de la región.

Avalokiteshvara
El bodhisattva de la compasión – Kannon en Japón, Guan-Yin en China –, principal divinidad del panteón budista Mahayana, es protagonista de infinitas representaciones artísticas.

Bodhisattva
En la tradición budista Mahayana indica a quien renuncia a su propia liberación definitiva para ayudar a los otros a salvarse y a alcanzar la iluminación.

Budismo
Nacido en India en el siglo VI a. C., ha sido en sus orígenes una doctrina filosófica; en su evolución y difusión geográfica ha influenciado gran parte del continente asiático. Mientras en India casi ha desaparecido, en el resto de Asia se ha difundido ampliamente, también gracias a su capacidad de adaptación y asimilación, que ha dado lugar a innumerables corrientes y sectas.

Chamanismo
Presente en Asia oriental desde la más remota antigüedad, como extensión del chamanismo centroasiático y siberiano, ha sobrevivido de manera más o menos original en las regiones más remotas de China, Japón y Corea, pero también ha tenido influencia sobre prácticas religiosas posteriores: expresiones del Taoísmo y cultos sectarios en China, el Sintoísmo y el Shugendo en Japón, las formas tántricas del Budismo y las ceremonias de exorcismo (*gut*) en Corea.

Ciudad prohibida
Durante cinco siglos, desde 1420, año de su realización, hasta el golpe de estado de 1924, ha sido el palacio imperial de Pekín, bajo las dinastías Ming y Qing.

Confucio
K'ung-fu-tzu o Kongfuzi, "Maestro Kung", que vivió en China entre el siglo VI y el siglo V a. C., ha definido los elementos esenciales de la doctrina moral que de él ha tomado nombre (Confucianismo). En sus *Analecta* especifica un sistema de relaciones sociales que apunta a la armonía, basado en el principio de una autoridad justa y del respeto de las reglas como herramientas de orden y de bienestar individual y colectivo.

Dragón
Emblema en China del poder imperial, en la tradición del Extremo Oriente representa un animal mitológico de poderes benéficos, símbolo de fuerza y de fortuna.

Gran Muralla
Construida entre el siglo III a. C. y el siglo XVI d. C. con el objetivo de unificar los pueblos de la China y contener las amenazas externas, es la obra más grande jamás construida por el hombre, con sus casi 9.000 kilómetros de longitud.

Hijo del Cielo
El apelativo dado al emperador chino (y, por contaminación cultural, al emperador japonés y al soberano coreano), donde el Cielo simboliza el orden cósmico.

Inmortales

Los Ocho Inmortales (Chang Kuo-lao, Lu Tung-pin, Chung-li Chuan, Li Tieh-Kuai, Lan Tsai-ho, Ho Hsien-ku, Han Hsiang-tsu, Tsao Kuo-chiu) son un grupo de deidades muy populares, presentes en China no sólo en la historia de las religiones, sino también en las artes figurativas y en la tradición literaria.

Kami

Deidad de la religión ancestral del Japón, de fuerte impronta chamánica. Los *kami* se encuentran en el centro de los mitos de la creación y hoy forman parte de la religiosidad popular, que asimila prácticas sintoístas y budistas.

Kamikaze

"Viento divino": el providencial tifón que en 1274 y en 1281 aniquiló la expedición naval de chinos y mongoles sobre las costas meridionales del Japón. Por extensión, una fuerza en grado de dispersar al enemigo.

Kanji

"Caracteres chinos", o sea, el sistema ideográfico importado a Japón desde China, que permitió al país contar con un sistema de escritura. Este sistema, sin embargo, congeniaba poco con una lengua distinta al chino como es el japonés, hasta el punto de que hoy de cada *kanji* existen dos o más lecturas.

Kimono

El término, que significa literalmente "cosa para vestir", con el tiempo, y sobre todo con una continua especialización de los tipos de vestuario, ha pasado a indicar una tradicional prenda de vestir femenina, de distintos colores, características y estilo según la estación y la ocasión.

Neo-Confucianismo

Actualización de las enseñanzas de Confucio, debidas sobre todo a comentaristas como Menciu (370 - 289 a.C.) y Zhu Xi (1130-1200). Las doctrinas neo confucianas – con énfasis en el concepto de la lealtad – debían ofrecer una base para la gestión del poder en Extremo Oriente a partir del siglo XIV.

Nihon/Nippon

"(País del) Sol Naciente": Japón, definido así por su posición en el extremo oriental del continente asiático, y por el hecho de haber sido creado por la diosa del Sol, Amaterasu-o-mikami.

País de la calma matinal

Una tardía definición de la Corea histórica derivada del término "Joseon", un estado soberano de la moderna Corea fundado y guiado alrededor de cinco siglos (1392- 1910) por la homónima dinastía.

País del Medio

"Zhongguo", China. Por su inmensidad geográfica y cultural, pero también por su rol histórico, desde un pasado lejano los chinos se identificaron como el pueblo ubicado en el centro del mundo conocido y, a través del emperador (Hijo del Cielo), en el centro del Universo.

Papel

Elaborado por los chinos hace más de veinte siglos utilizando distintos materiales, en Asia Oriental el papel ha sido fundamental para transmitir tradiciones y hechos, pero ha sido también, y es todavía hoy, elemento esencial de una serie de prácticas culturales, partiendo de la caligrafía.

Shakyamuni

El Buda histórico, nacido como príncipe de una estirpe real con el nombre de Siddhartha Gautama, vivió en el siglo VI a.C. entre los actuales Nepal e India septentrional.

Shogun
Término que designa al jefe político-militar del sistema feudal que dominó a Japón entre 1192 y 1868. El cargo shogunal, hereditario, era de hecho independiente del poder imperial, del cual dependía formalmente.

Taoísmo
Filosofía (*Daode jing*, *Tao Te Ching*) basada en las enseñanzas de Laozi (Lao-tzu), que vivió en el siglo VI a.C. En un cierto sentido se ubica en antítesis al Confucianismo, con el énfasis puesto en la libertad individual, en la experiencia mística y en la posibilidad de sublimar el propio cuerpo a través de la gestión de la energía (*qi*, *chi*) y a través de prácticas mágico-alquímicas y psico-físicas.

Té
Bebida reconfortante, usada como apoyo en las prácticas meditativas y religiosas, hasta tiempos recientes difundida sólo entre las clases más altas de la población. El té dio origen a muchas tradiciones artesanales y artísticas, además de prácticas estéticas relacionadas con su uso, tanto en el ámbito cotidiano como ceremonial.

Wa
"Armonía", es un elemento esencial de la sociedad japonesa, a su vez tomado prestado de la China imperial confuciana, hasta el siglo VI. Actitud que tiene origen en el trabajo común en los campos y en los arrozales, ha sido propugnada posteriormente como elemento social primario, opuesto al individualismo.

Yin e Yang
Los opuestos que se atraen. Se trata de un concepto que evolucionó desde el antiguo sistema dualista de la filosofía china, que a partir de los cuerpos celestes (Sol-Luna) involucra todo el conocimiento humano. Yang es positivo, activo y fuerte; mientras Yin es negativo, pasivo y débil. Todo lo que se encuentra en el universo surge de su interacción dinámica. Corea del Sur tiene el Yin y Yang (*Eum-Yang*) en el centro de su bandera.

Zen
Corriente del Budismo desarrollada en China bajo el maestro Bodhidharma, pero difundida posteriormente también en Japón y en Corea. El Zen es contrario al intelectualismo, trasciende la lógica común y hace de la observación de la naturaleza y del hombre (bajo la guía de un maestro) un elemento esencial.

Zodíaco
Práctica antiquísima que data del 2637 a.C., la astrología china se basa en ciclos de 60 años a su vez subdivididos en 5 ciclos de 12 años. Los ciclos más breves se basan en 12 animales, reales o mitológicos (rata, buey, tigre, conejo, dragón, serpiente, caballo, cabra, mono, gallo, perro, cerdo) cada uno de los cuales se combina cada año con uno de los 5 elementos tradicionales (madera, fuego, tierra, hierro, agua) dando vida al ciclo de 60 años. Por ejemplo: el 14 de febrero de 2010 ha comenzado el año del tigre de hierro.